The Artistic Touch 2

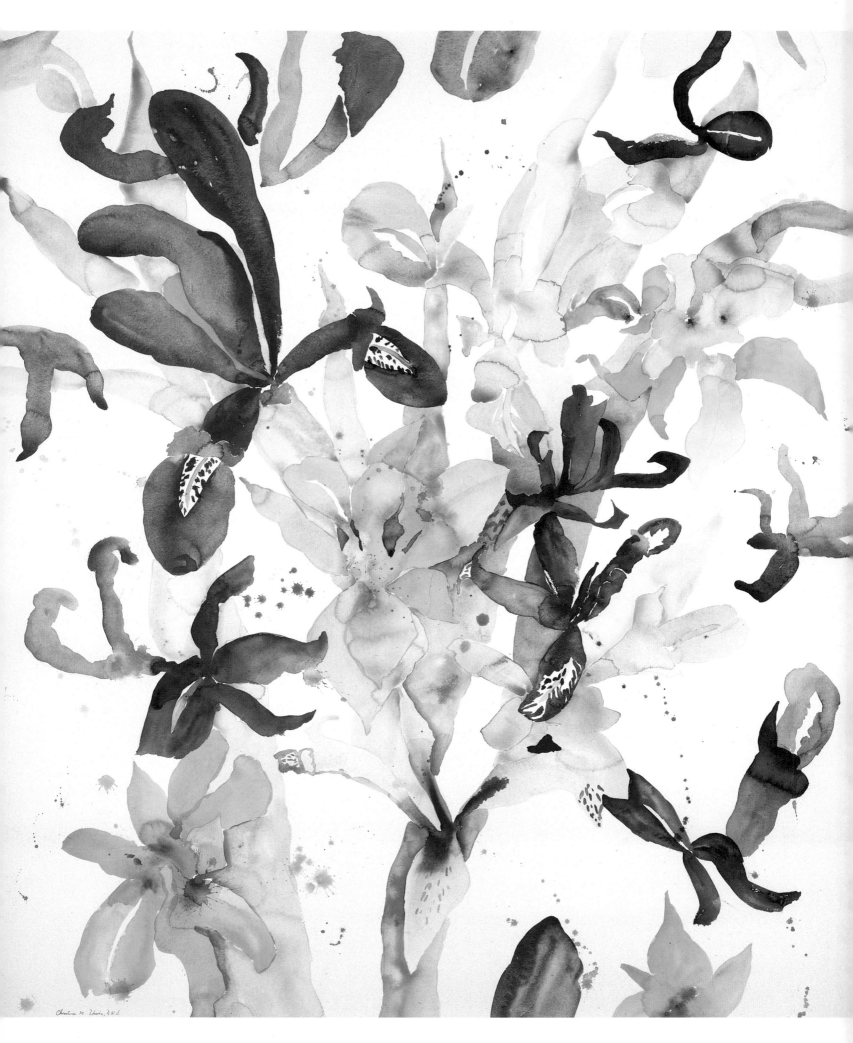

Christine M. Unwin, NWS *Iris* 48" x 48" Watercolor

The Artistic Touch 2

By Christine M. Unwin, NWS

Creative Art Press
West Bloomfield, Michigan

Acknowledgments

Special thanks to my husband, Don, who worked tirelessly on this book with me. While I made all of the selections appearing in **The Artistic Touch 2** and decided where each painting should be placed, Don was responsible for the layout, preliminary editing, negotiating, correspondence and general planning necessary to bring the idea of the book to its fulfillment.

Thank you, Don!

Many thanks, also, to my dear friends, Jack and Christel Sanecki who edited and proofed the text of **The Artistic Touch 2** through its many revisions. I wish Jack could repair my failed paintings as well as he rewrites my copy.

To my daughter Susan Vitali, an accomplished artist whose work appears in this book, her husband, Angelo Vitali, and my beautiful grandchild, Olivia Vitali, to my daughter Laura Olds and her husband, Dr. Gregory Olds, to my son David Unwin and my daughters, Carol Unwin and Diana Unwin, and to my parents, Walter and Wanda Rudy.

Last, but never least, a very special acknowledgment to you wonderful Artists whose paintings make up **The Artistic Touch 2**.

The Artistic Touch 2

Copyright © 1997 by Creative Art Press

ISBN 0-9642712-1-4
Library of Congress Catalog Card Number 96-85691

Cataloging data for this book is available from the Library of Congress

Manufactured in Hong Kong

First Edition, 1997

Table Of Contents

Christine M. Unwin, NWS *Santa Fe* 22" x 30" Watercolor

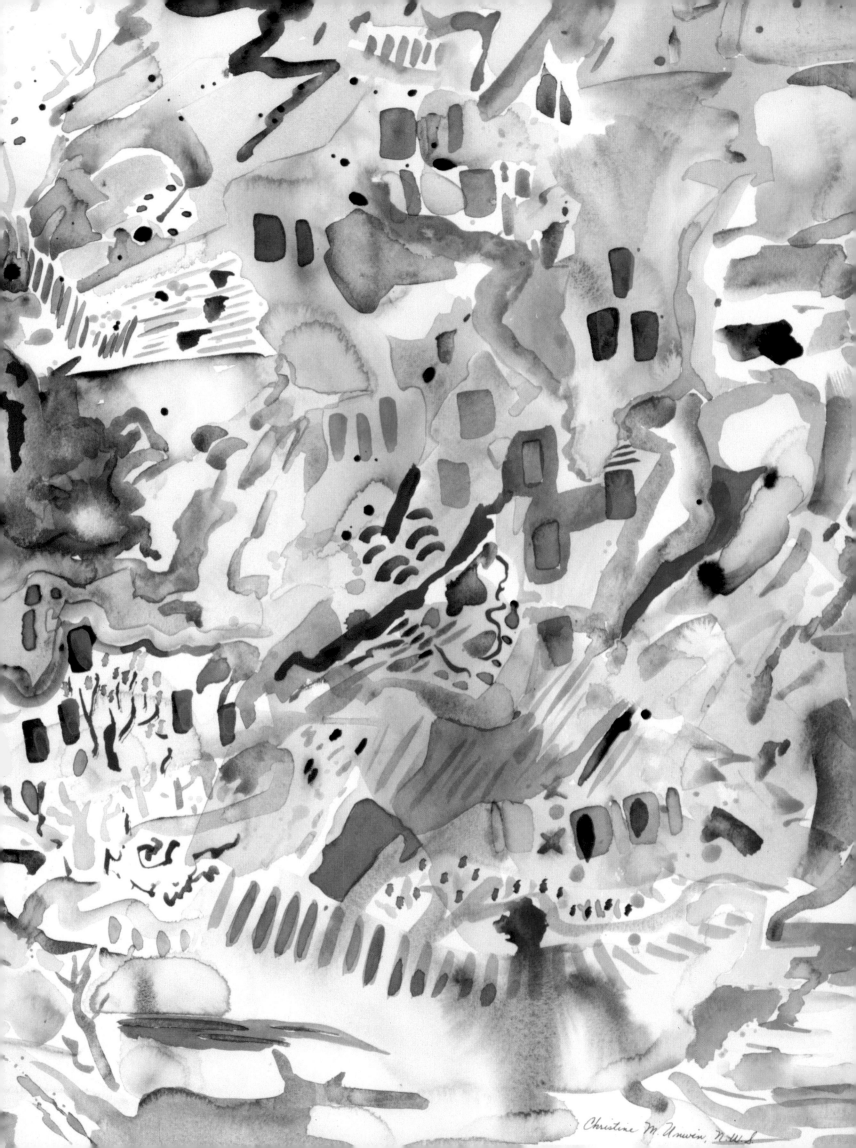

Christine M. Unwin, N.W.S.

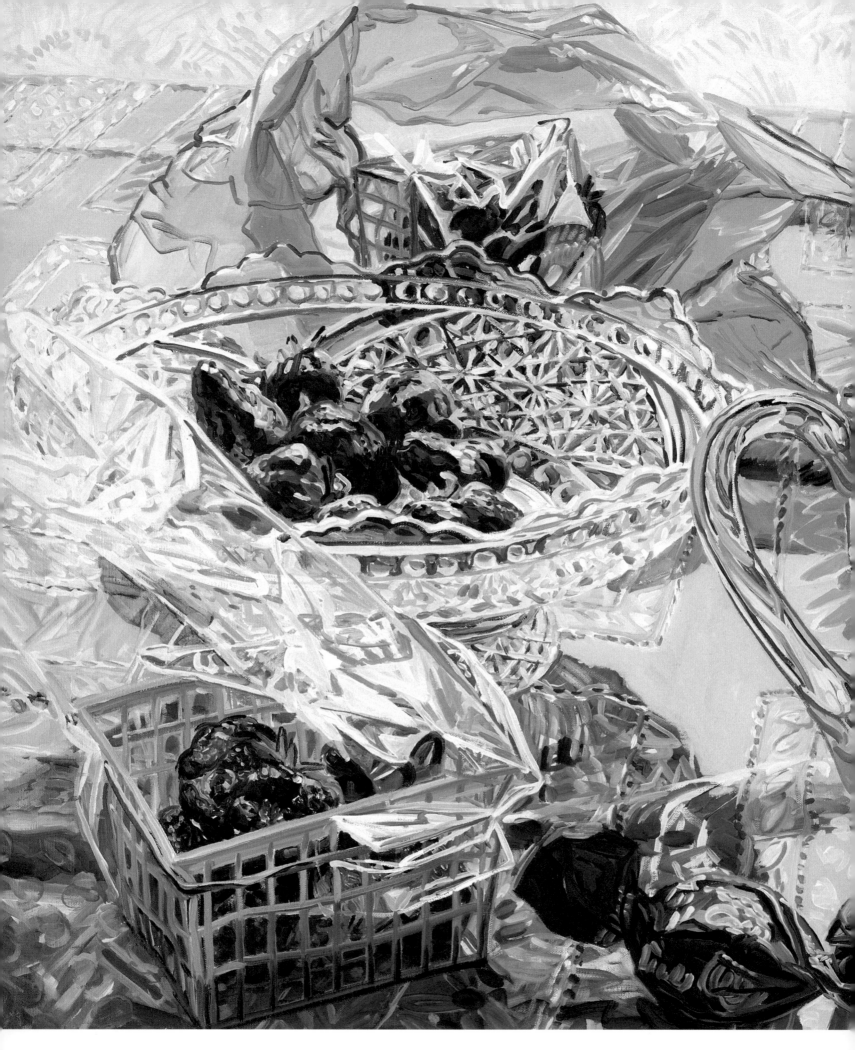

Janet Fish *Blue Cloth/Strawberries* 36" x 60" Oil

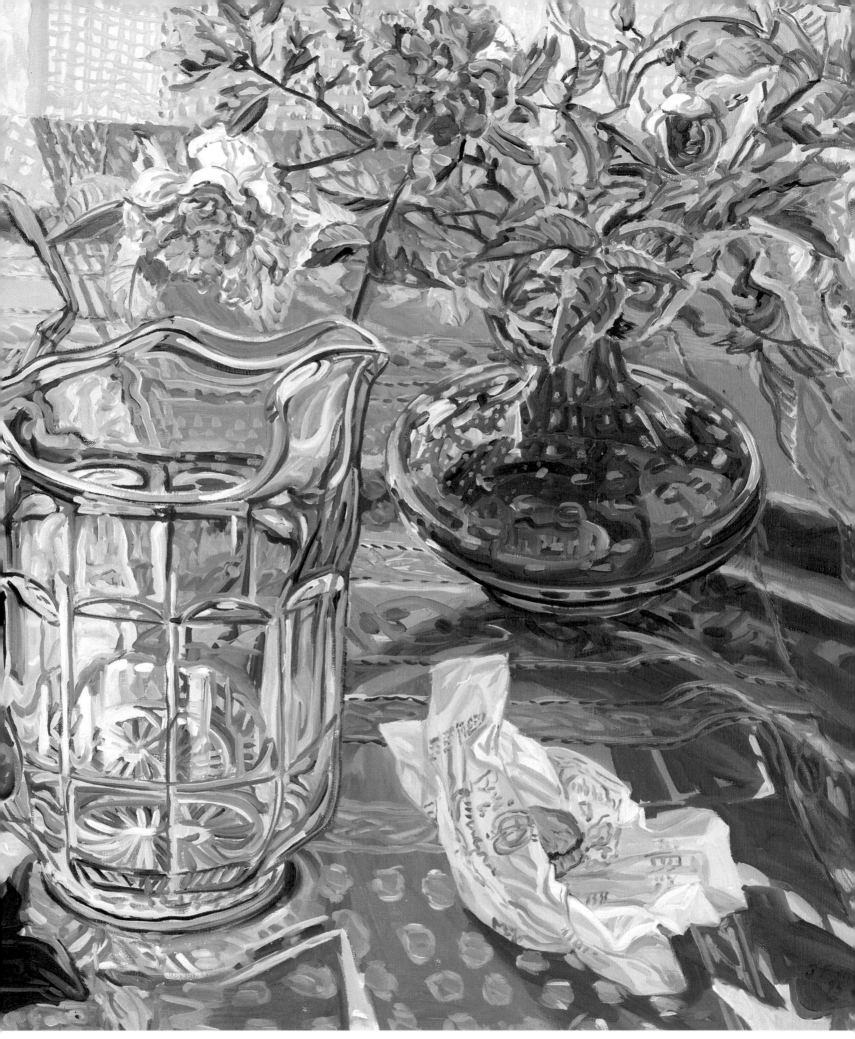

Blue Cloth/Strawberries was done from a still life set up in my Vermont studio. The sun shone directly on the objects which were placed near a window. It was done on a very slick oil primed ground and was, for the most part, painted rapidly, wet into wet in order to keep the paint as fresh and immediate as possible.

INTRODUCTION

I thoroughly enjoyed selecting the watercolors which appear in this book. However, because there are so many accomplished artists painting today, the task was not an easy one. In the end I tried to choose paintings which represent an individual artist's personal approach to his or her work, while at the same time existing in their own right as excellent works of art.

As you leaf through this collection, it is my hope that you will experience as much pleasure and satisfaction as I did. I felt that I could mentally enter the ambiance of some of these pictures and wander around, almost losing myself. Other paintings, such as kemper's **corn dog** and **shot**, are richly amusing. Johnnie Crosby's **Color Me Blue** and Mary Hickey's whimsical **Cat Quilt** are pure delight, while Sook-Kyung Hong's **Three Apples** and Langerman's **California Sunshine** paintings are visually riveting in their impact. (It is worth remembering that, in actuality, the apples and the oranges rendered are almost a foot high — difficult to imagine when viewed within the limitations of a book. Still, you get the idea.) Another painting that is huge is **Magenta Glory** by Linda Stevens Moyer. Try to imagine it in it's full glory of 53" x 65".

Bill James' **The Throwaway** offers a social commentary which can prove unsettling to the viewer. Other paintings, like those of Donna Vogelheim and Linda Banks Ord, encompass paintings within paintings. The energetic brush strokes of Janet Fish and Gwen Tomkow are reminiscent of the technique used by Van Gogh.

Many of you reading this book are artists, some long established and recognized as professionals. Others of you are aspirants to the wonderful world of painting. It is my sincere hope that the paintings presented here will provide an exciting experience, perhaps triggering a surge of inspiration that will get your creative juices flowing!

Chris Unwin

Flowers

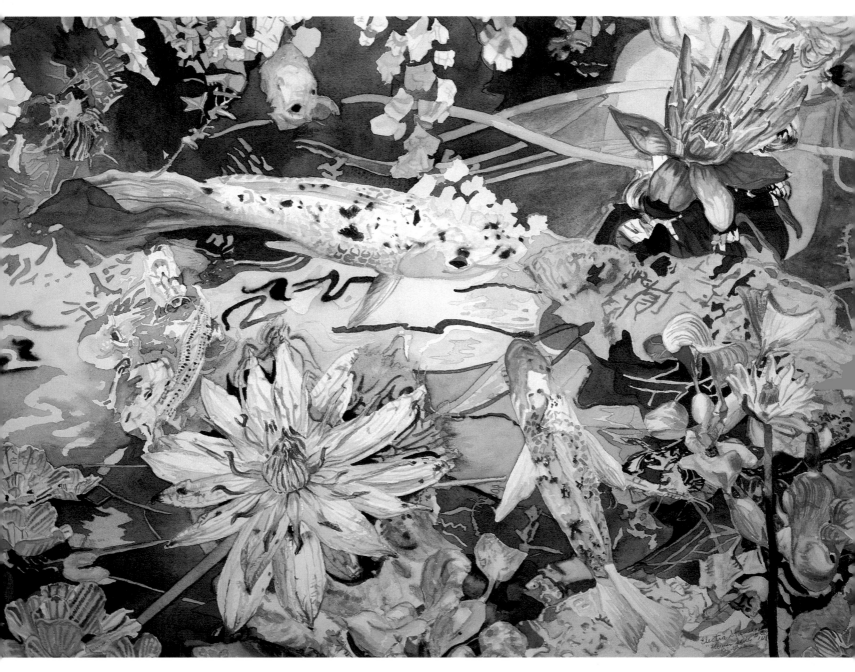

Electra Stamelos, NWS *Koi Garden* 18" x 24" Watercolor

My inspiration for this painting came from visiting the University of California at Long Beach and the Mathaii Botonical Gardens in Ann Arbor, Michigan where these beautiful fish are displayed in exotic settings. The composition was started in pencil by incorporating many of the varied water plants into the drawing. I then skipped around, painting in the fish and the plants. I tried to capture the characteristics of water and how it ripples when fish dart under and around the water plants. The color of the water was spontaneously conceived and the painting sold almost before the paint was dry!

...the Tiki was like an angel!

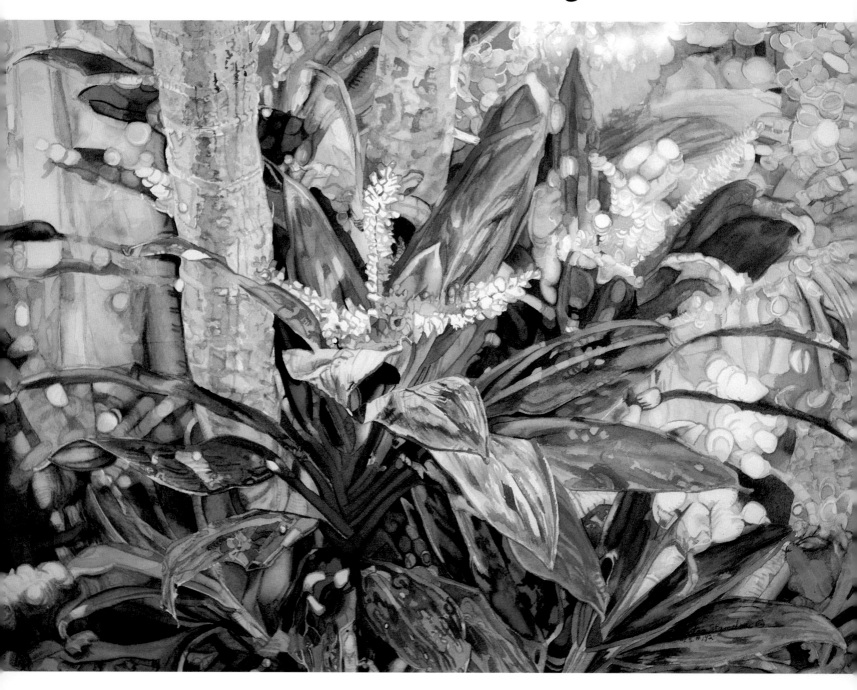

Electra Stamelos, NWS *Tiki Plant* 18" x 24" Watercolor

While on an early morning walk in Ft. Myers, I noticed this blossoming Tiki plant. It was wedged between the bamboo stalks. The light was ethereal and the Tiki looked like an angel! I drew every shape as I saw it before adding color. Later, when the painting was finished, I went back to the scene. But the light was gone and the Tiki plant was all but dead. I wonder ... was that the hand of God showing me his 'beauty' when I was discouraged and blue?

I tried to express the complexity of shape and the richness of color

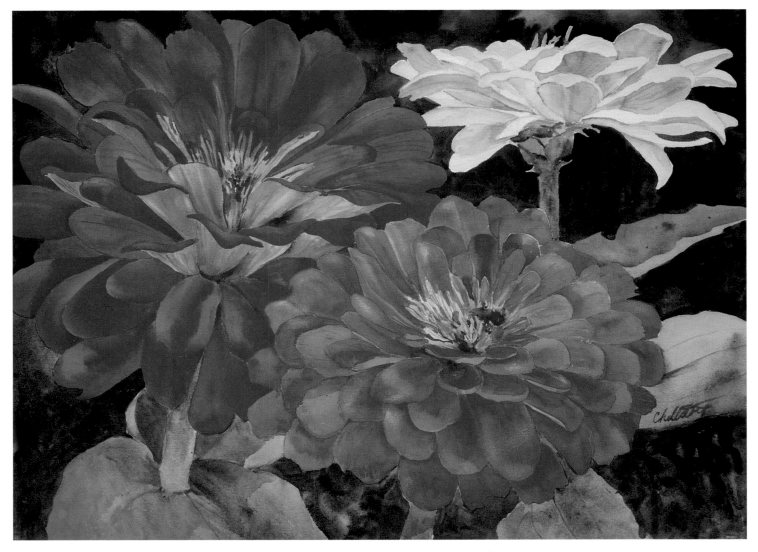

Marjorie Hogan Chellstorp *Zinnia* 22" x 30" Watercolor

I often find myself exploring various painting methods and being creatively involved with a variety of subjects. No matter what subject I choose to paint, I hope my personal involvement will come through and give my work a meaningful content.

In this painting I wanted to express the complexity of shape and the richness of color that is so much a part of this wonderful flower, which conveys both the wildness of a summer field and the domesticity of a garden.

Colorplay was an exhilarating experience — a joyful encounter.

June Y. Bowers, NWS *Colorplay* 22" x 30" Watercolor

I used a transparent technique to explore and reveal the concepts of color relationships and the effects of light upon certain hues. Colorplay was an exhilarating experience — a joyful encounter.

Their colors, shapes, and elusive beauty are a challenge and a joy to explore in watercolor —

Donna Brown *Open Arms* 16" x 29" Watercolor

Flowers beckon to be noticed. Their colors, shapes and elusive beauty are a challenge and a joy to explore in watercolor — a medium perfect for depicting their delicate translucence. Although I prefer to paint flowers when they are in bloom, it seems I can never execute all of the ideas they inspire during our short northern growing season.

I used d'Arches 300 lb cold press paper. I work out my ideas with photos and quick sketches but the final decisions are made while painting and, therefore, I need a forgiving surface. This paper also works very well for the layering technique I use to build up the intensity of colors.

Ruth Baderian *Sunflowers Blue* 37" x 45" Watercolor

16

I love to paint flowers.
They've become an exciting symbol
of my personal and spiritual growth.

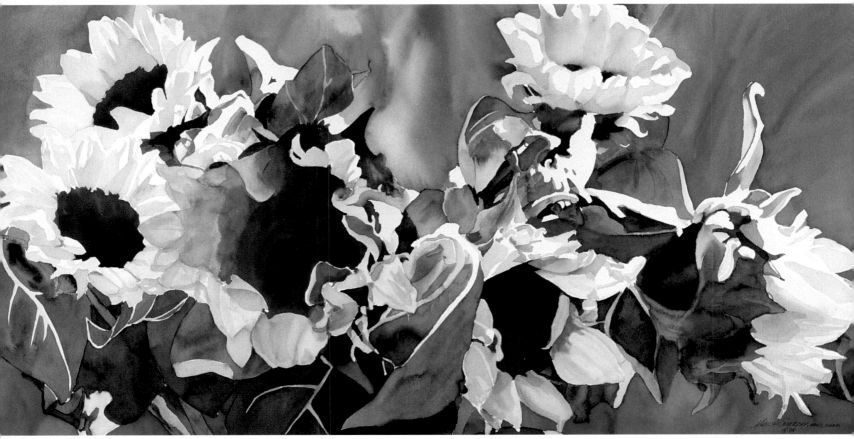

Marilyn Schutzky *Sun Worshiper II* 37" x 45" Watercolor

I love to paint flowers. They've become an exciting symbol of my personal and spiritual growth. I like the wonderful shapes revealed in a close up view where light and shadow play across their surfaces.

This painting was inspired by the strong, seductive light of the Arizona desert country. The desert light rarely enters the house at the same angle for more than a week. At this time of year, you are constantly rounding a corner to discover the sun playing across the surface of the flowers in an entirely different way. It's exciting to discover these light treasures and capture them before they vanish.

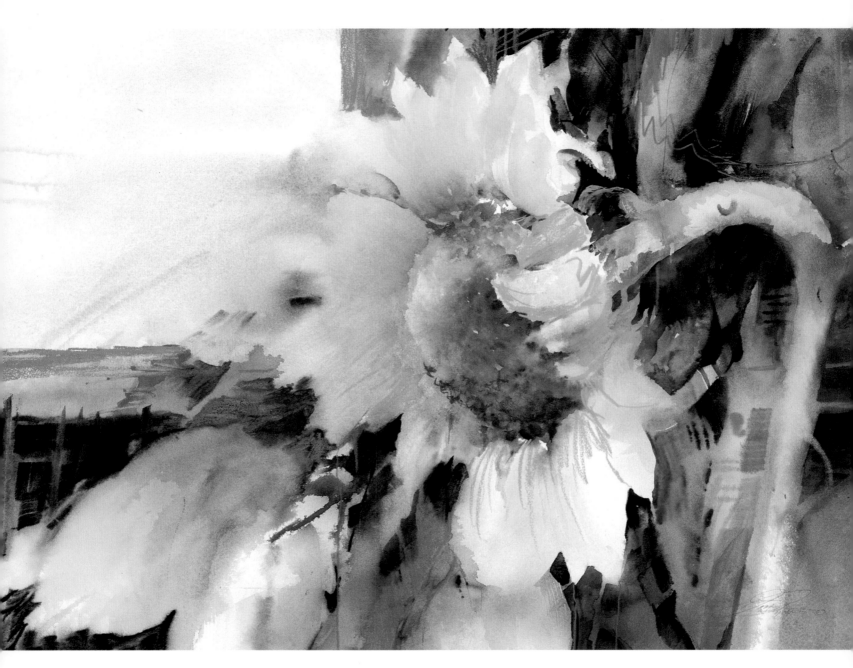

Joan Cawthorn *Summer Solstice* 22" x 30" Watercolor

I delight in exploring the dynamics of composition which result from an infinite number of possible juxtapositions of color.

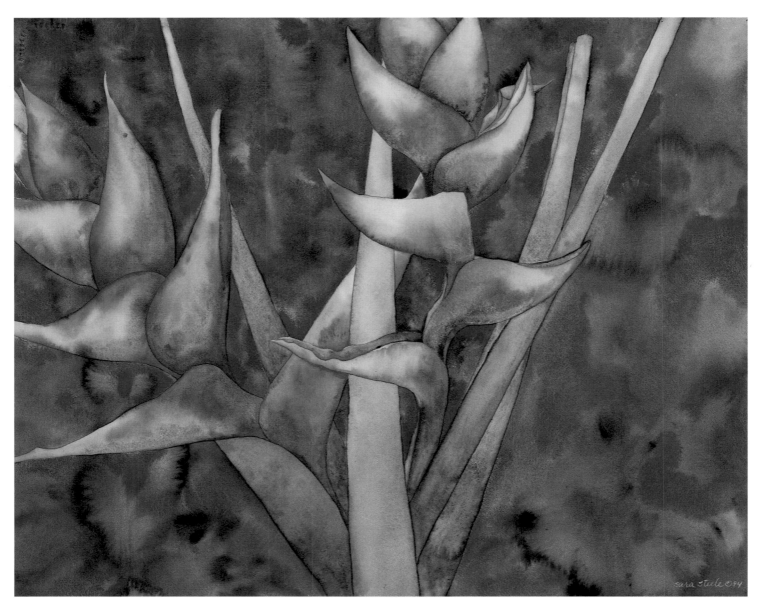

Sara Steele *Heliconia* 17" x 22" Watercolor

Shapes which repeat themselves in the natural world are my primary source of inspiration. I delight in exploring the dynamics of composition which result from the infinite number of juxtapositions of color.

I paint realistic botanicals, expressionistic florals, landscapes, and completely abstract compositions. I usually work with cold pressed paper or handmade cotton rag papers, using only permanent pigments. Most of my brushes are Kolinsky sable, although I use some handmade and Chinese brushes as well.

Because my artist friends liked the painting ...
I decided to have prints made.

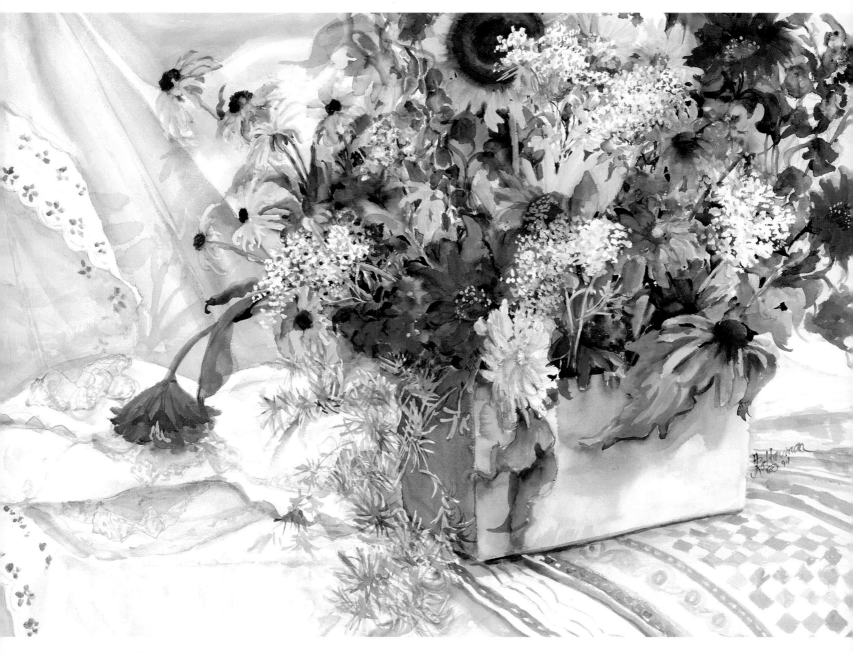

Audrey Sanders Ratterman *Flowers by Design* 32" x 40" Watercolor

The design and arrangement of the colors is what makes this painting work. It was done using 300 lb d'Arches cold press paper, Lefranc & Bourgeois watercolor paint, and Yasutoma Hoboku round brushes. I used Janet Walsh's technique of laying in color followed by the immediate lifting of some of the pigment. Because my artist friends liked the painting so much, I decided to have prints made.

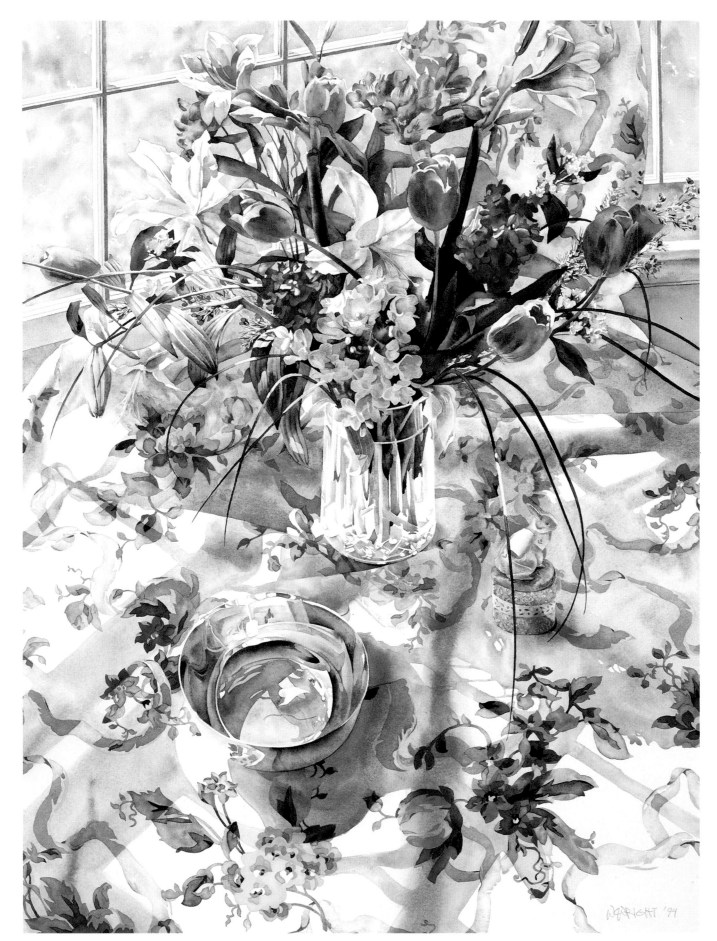

William C. Wright *April Bouquet with Bowl* 21" X 29" Watercolor

The focus of this painting is the flower arrangement and its relationship with the fabric pattern. I was trying to achieve an interesting design with contrasts between light and shadow, and between organic and geometric shapes. There are some color contrasts as well, though they are more subtle. The painting consists of predominantly cool colors with some warm color accents.

The gold leaf either blazes with light or becomes very dark.

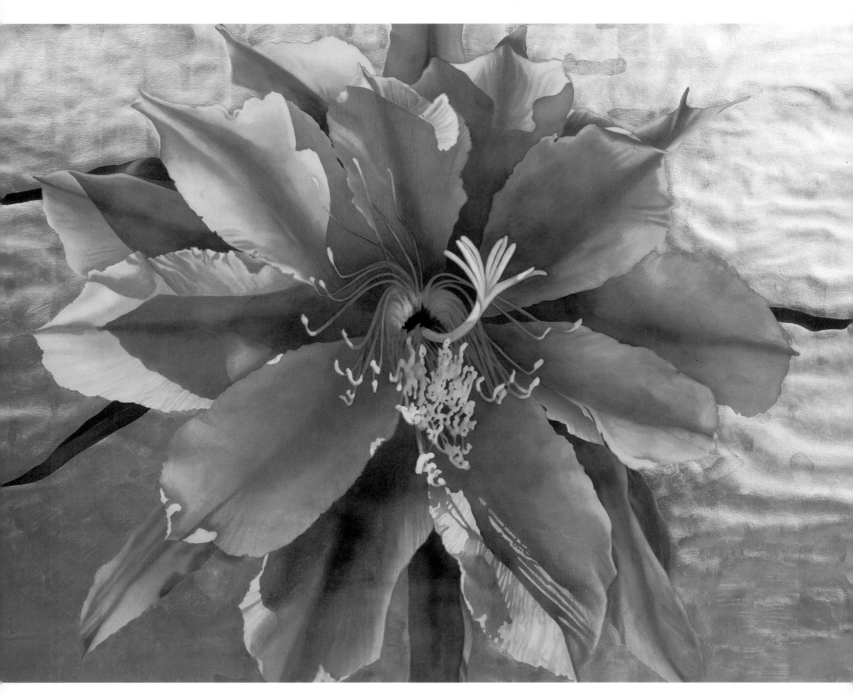

Linda L. Stevens Moyer, NWS *Magenta Glory* 53" X 65" Mixed Media

Magenta Glory was inspired by my earlier painting, ***Consider the Lilies***. It features, on the top portion, a magenta colored epiphylum on a field of 23k gold leaf. As I contemplated it from a distance, I had the overwhelming desire to do another painting with that portion enlarged.

I drew the epiphylum on a large (53" x 65") portion of paper taken from a roll of 140 lb d'Arches rough watercolor paper. I then rendered the color and form of the flower with transparent watercolor and watercolor crayons, completing the painting by putting 23K gold leaf in the negative space around the flower.

This wall-sized painting changes its appearance throughout the day and night depending on the amount of light in the room. The gold leaf either blazes with light or becomes very dark, changing the appearance and prominence of the flower depending on the time of the day.

I tried to mix Eastern and Western feelings and techniques...

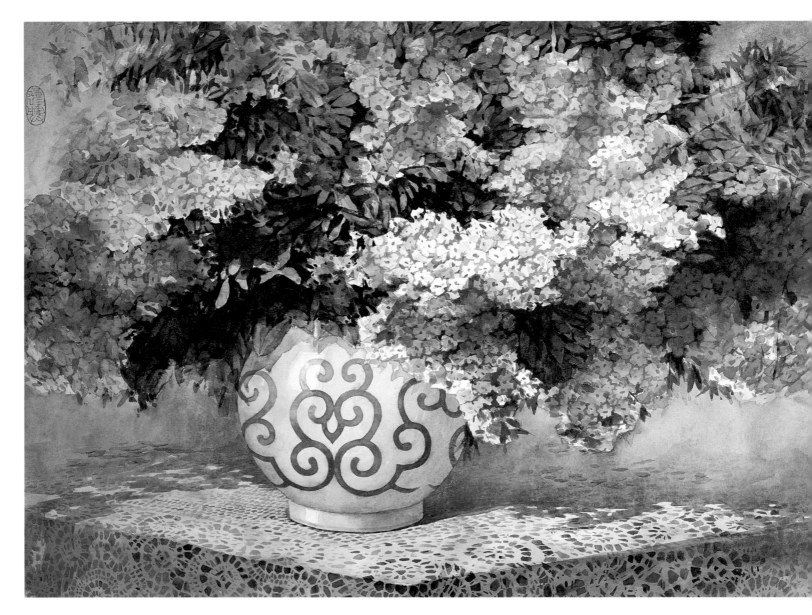

Mei Shu *Lilac & Lace* 22" X 30" Watercolor

When East meets West, the result can be unpredictably beautiful. I tried to mix Eastern and Western feelings and techniques in my painting, ***Lilac and Lace***, in an effort to produce a harmonious rhythm. The petite, delicate flowers demonstrate the beauty of nature; the vase, with its curves and intricate designs, brings out its maker's artistic talent; and the laces, weaving through the picture, provide an overall flow with the fine patterns. When the three come together, a delightful composition is created.

Landscape

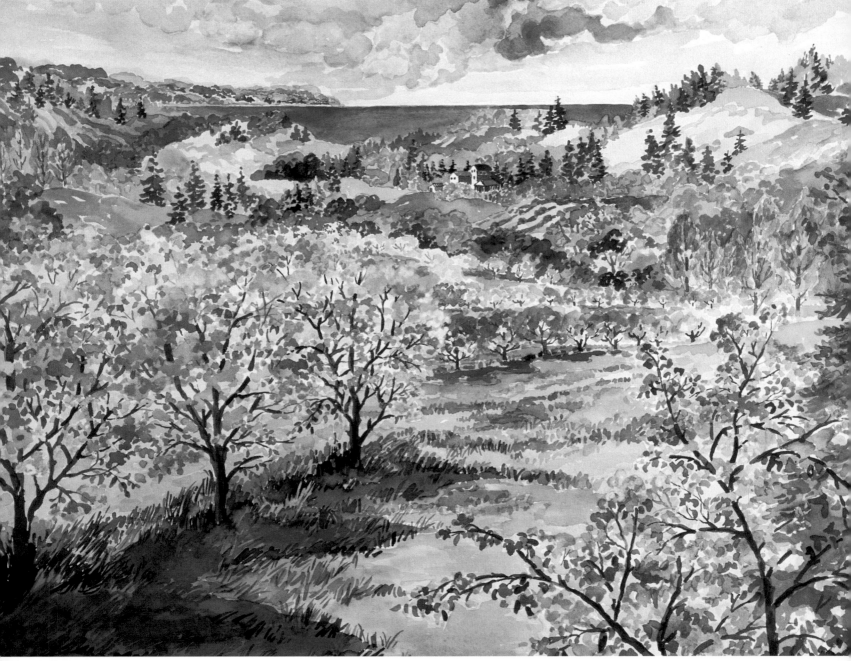

Gwen Tomkow *Spring Glory* 28" x 36" Watercolor

Spring Glory is my impression of an area of Traverse City, Michigan. The carved hills left by the Ice Age present a gorgeous panorama to inspire the watercolor artist.

The fruit tree on the right bows and points to the three angled trees leading up a path of warm and cool colors. Saturated color turns into more pastel tones and the simple shapes of sand dunes. Finally, the brilliant blue of Lake Michigan peeks out and gives just the calming touch needed.

Spruce trees are interspersed in the background to give a feeling of dimension, distance and vastness, guardians of the rugged, ever-changing dunes. Patterns of activity are organized and balanced by the tranquility of earth rhythms. Just like a gourmet dessert, the best comes last. Cloud forms settle around the peninsula at the horizon to add a final sprinkling of magic to *Spring Glory*.

24

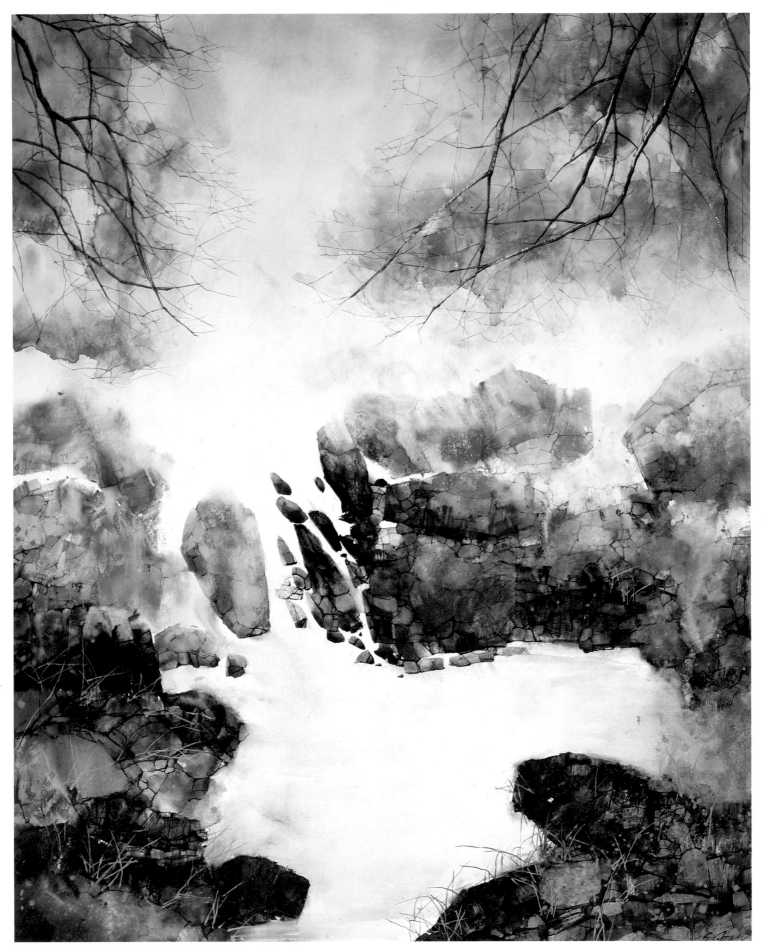

Z. L. Feng, AWS, NWS *Rocky Pond* 23" X 29" Watercolor

Even though I was excited, I was very relaxed when painting *Rocky Pond*. Because of the influence of oriental brush painting, I can feel the power "Chi" go through the painting. When my imagination runs wild, the magnificence of Nature comes alive under my brush strokes. The beauty of Nature shines through the colors and I am able to see its power and force.

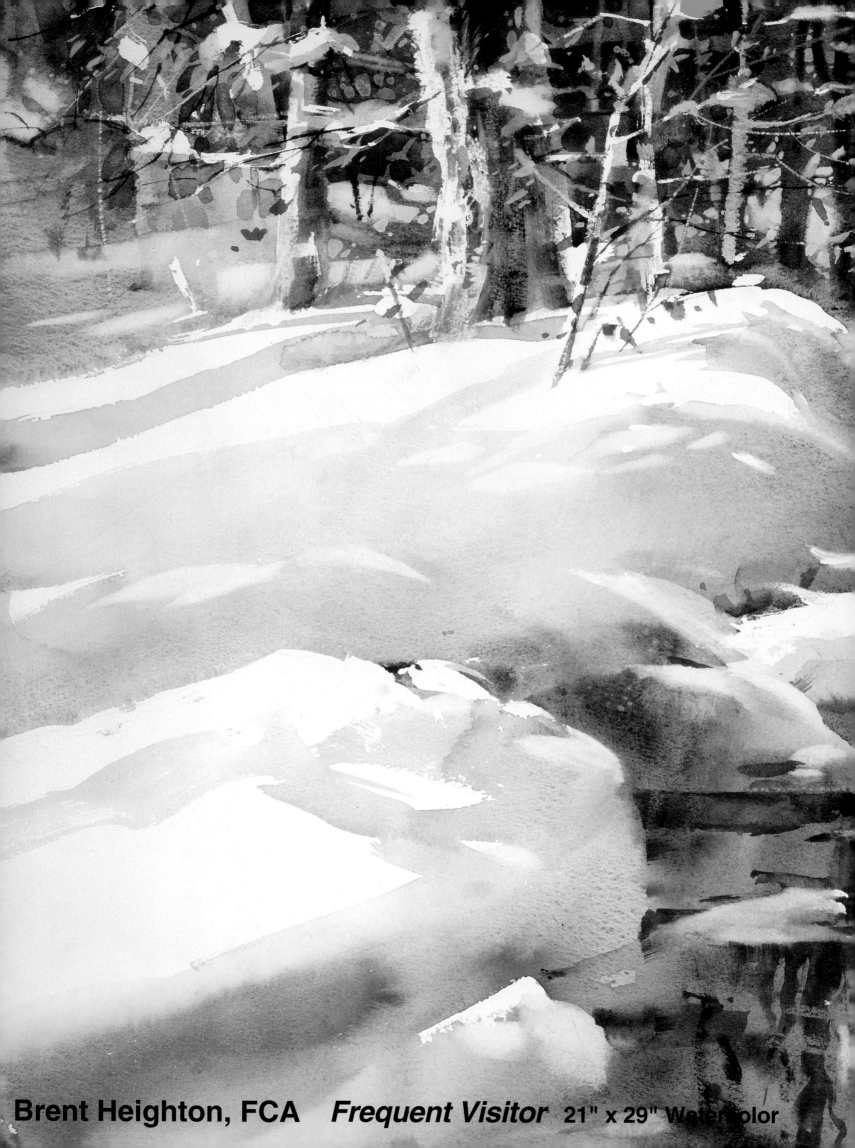

Brent Heighton, FCA *Frequent Visitor* 21" x 29" Watercolor

Brent Heighton
THE FREQUENT VISITOR

I was inspired by Lake Superior's frozen shoreline and the nearby streams, ponds and puddles.

Kathleen Conover-Miller *Winter Shadow* 40" x 60" Watercolor

This diptych painting exhibits a unique technique for achieving rich textural under-patterns. Water and liquefied water-based pigment is put on 140 lb hot pressed paper outdoors when it is about 20 F. It freezes and creates natural ice crystal patterns like those often seen on windows in winter.

I was inspired by Lake Superior's frozen shoreline and the nearby streams, ponds and puddles. I tried to create paintings which would present impressions of layered ice as if on the surface of a winter pond. I explore and interpret themes such as flora and fauna of a season gone by, a captured moment in time, or a continuous motion stilled in my work.

*I tried to emphasize the magnitude of
the ledges by silhouetting two
figures against a late afternoon sky...*

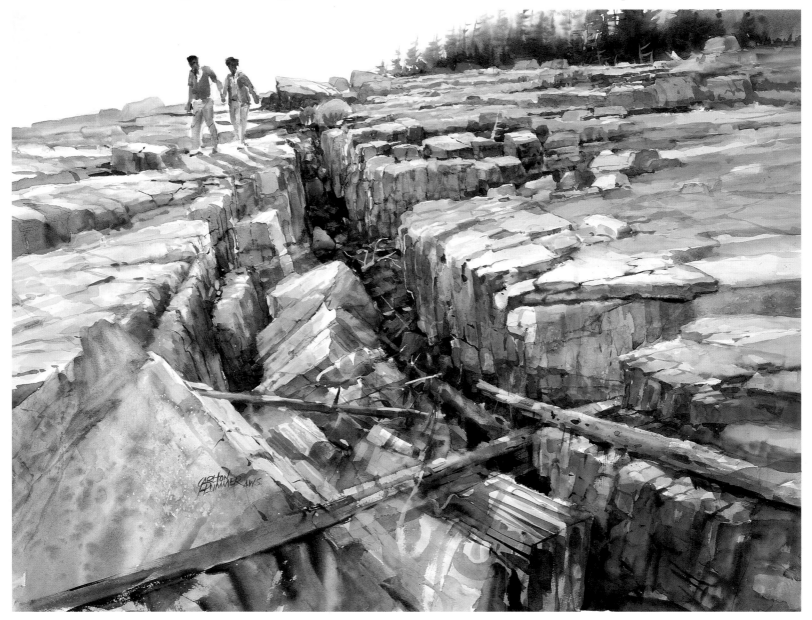

Carlton Plummer, AWS *Acadia Figures* 21" x 29" Watercolor

Acadia Figures was a 1995 award winner in the San Diego International Exhibition of Watercolors. It is one of a series of six paintings based on scenes from the Acadia National Park on the coast of Maine. This magnificent area, where the ledges and evergreen forest meet the sea, has been my source of inspiration for many years.

I tried to emphasize the magnitude of the ledges by silhouetting two figures against a late afternoon sky on a high horizon. These figures give scale and interest to the painting but retain their validity as an extension of the ledges having related colors. The chasm running diagonally through the composition creates direction, interest and contrast to the flat geometric planes of the ledges.

Working wet-into-wet with large shapes allowed me the freedom to make spontaneous choices as the painting developed. Transparent and semi-opaque glazing followed, adding value and color changes.

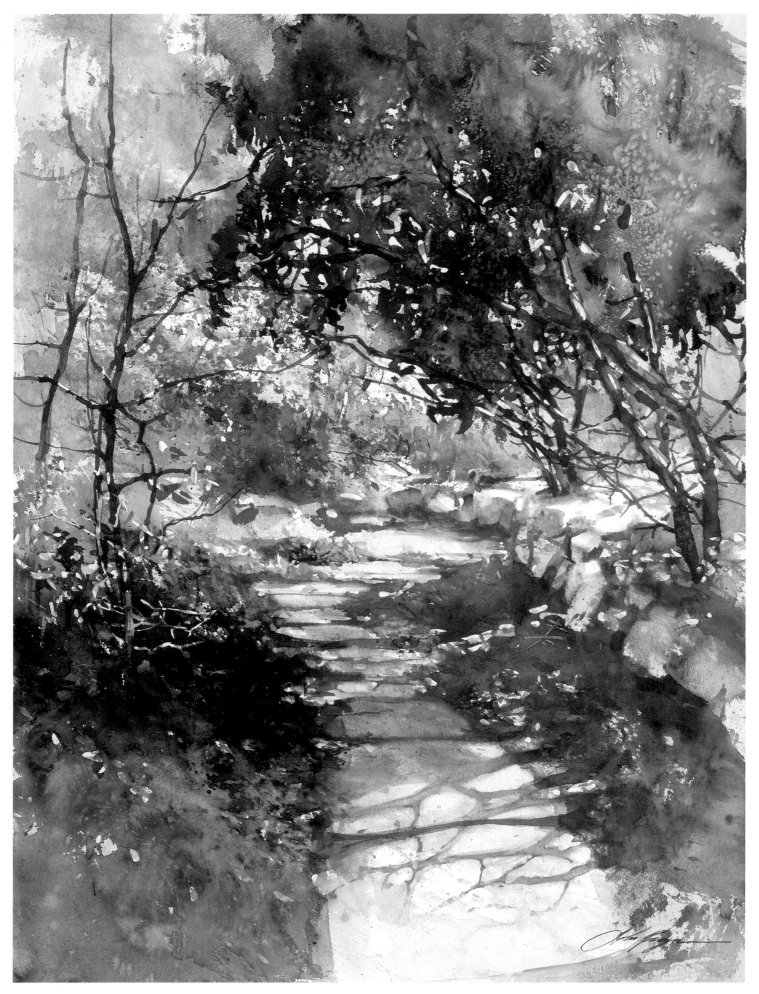

John Krieger *Garden Path* 30" X 38" Watercolor

30

Hooray for watercolor!

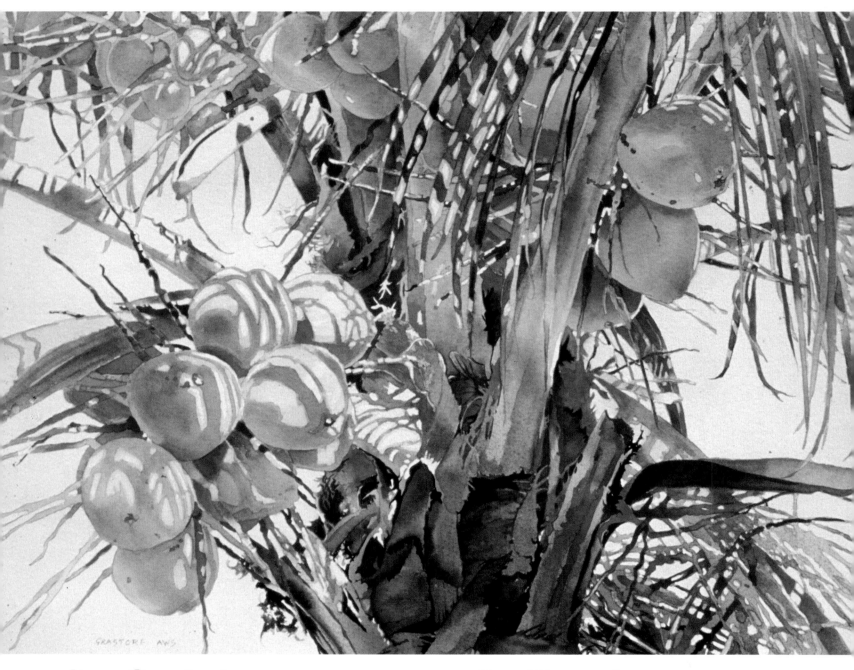

Jean Grastorf, AWS, NWS, MWS *Sun-Ripened* 20" X 28" Watercolor

Painting outdoors in Florida means bright sunshine, heat and deep shadows full of color. Whether the subject is palms, people or parrots the search is on for a strong pattern of light and shade.

Pouring multiple washes of transparent color allows the purity of the white paper to shine through. I use a three-step (mask, pour, paint) approach that requires control yet allows room for the magical mystery of the medium. Hooray for watercolor!

The privacy of the setting allowed me to work undisturbed...

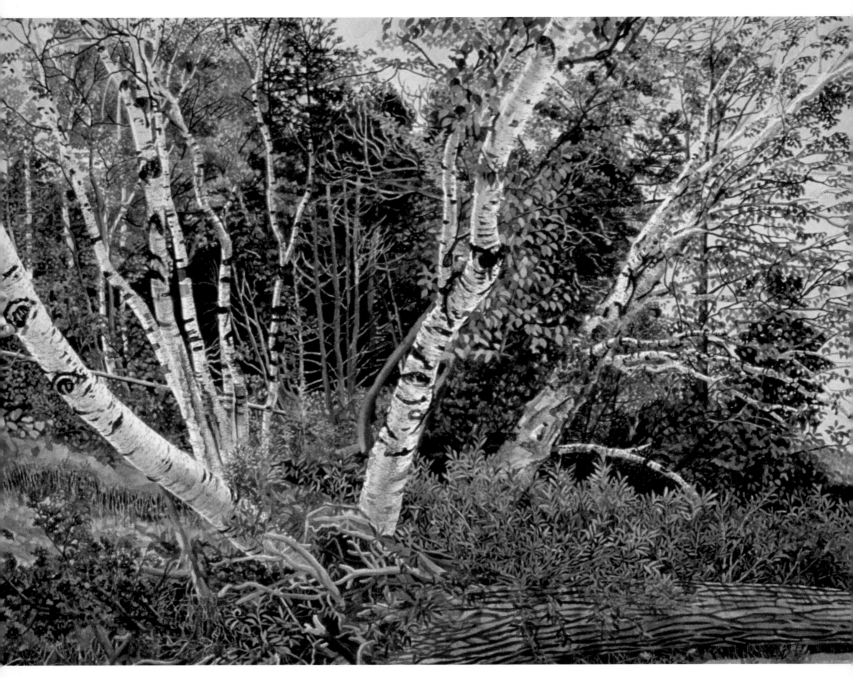

Karen Carter Van Gamper *Birch Grove* 37" x 45" Watercolor

This afternoon subject was done at the family cottage on Lake Huron. The privacy of the setting allows me to work undisturbed while I paint. The trees lean out over the beach at the bottom of a steep bank. I used 140 lb d'Arches paper, cut to 37" x 45". This large sheet was clipped to foam core, with folded tissue between the clip and the paper. I tried to capture the markings, the lighting on the birches, and the contrast of the surrounding foliage.

I enjoy nature and I try to capture the reality of the scene. The watercolor medium allows me to "leave the white of the paper" for the tree trunks and I paint in shadows and markings only. The build up of leaf shapes and dark branches around the trunks creates contrast, making the trees stand out. The detail of the fallen willow tree further strengthens the natural setting.

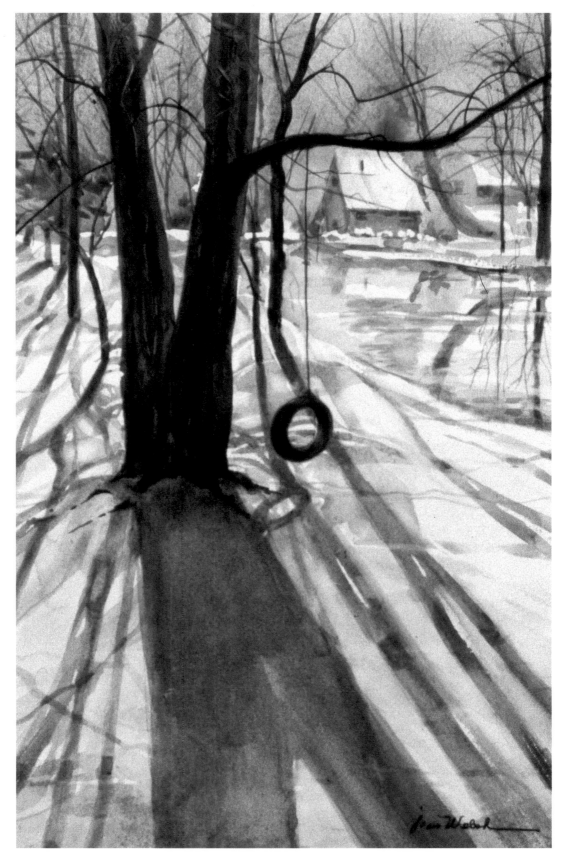

Joan T. Welsh *Patterns - 1* 18" x 24" Watercolor

 The source of an inspiration is as individual as a fingerprint, as subtle as a warm breeze, as unpredictable as Michigan weather. The **Patterns** series is the result of my fascination with the patterns formed by late afternoon sunlight. Twilight, also, is a magical time, wedged as it is between the brilliance of the day and the cloak of darkest night. Dramatic shadows are cast across the land, transforming ordinary objects into exotic dancing shapes and forms. The soft, spontaneous fluidity of watercolor allows me to capture these fleeting patterns in a way no other medium can.

 This painting launched my series. I'm sentimental about it because the tree with the tire swing is in the backyard of my daughter's home.

Fruits & Vegetables

Green Peppers
Chris Unwin

Christine M. Unwin, NWS *Green Peppers* 15" x 17" Watercolor

I was inspired to paint **Green Peppers** while cruising in the Greek Isles. I drew the pepper shapes, floated clear water into one section at a time, then charged in color by loading the brush with paint before dipping the tip of the brush in the water-soaked areas. When the loaded brush touches the water, it flows onto the page. The paint will not run into the dry areas because it follows the path of the clear water. Charging in a second and third color causes the colors to mix on the paper. Since a lot of water is used, many backwashes appear, becoming part of the design. The result is a fresh look. This is a good technique because it avoids overworking the watercolors which sometimes occurs when an artist tries to scrub the colors in. Since we were in Greece, I thought the addition of the Greek key pattern added interest to the piece. The key pattern was painted in a flat wash. The peppers are an interesting subject because of their unusual shapes and their bright complimentary colors. Resisting the urge to get too complicated definitely worked in this painting. It was spontaneous and not over analyzed. Sometimes less really is more.

I tried to capture the beauty of ordinary things...

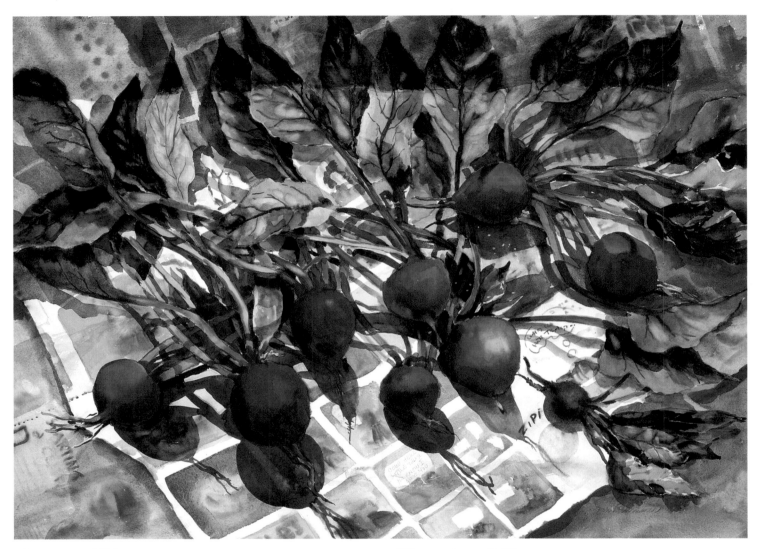

Joan Plummer *Beets All* 22" x 30" Watercolor

I tried to capture the beauty of ordinary things with this painting and planned the composition so that it would fill the space effectively. I settled on two major shapes for simplicity's sake in order to bring more drama to the image.

I started with large abstract areas of color and continued working with deeper hues, glazing and breaking shapes into smaller sections. My goal was to interpret, transform and communicate my feeling toward the subject, rather than to depict the scene literally.

The use of complementary colors seemed a natural choice for this subject. It gave me the opportunity to utilize warm and cool colors and also to push and pull the colors. This caused the picture plane to create an interplay of light and space. It was necessary to push some shapes darker and pull others lighter for a stronger design. This also leads the viewer's eye to the focal point.

Christine M. Unwin, NWS *Grapefruit* 45" x 53" Watercolor

I wanted to explore the simple, beautiful red color of apples. I love vivid color.

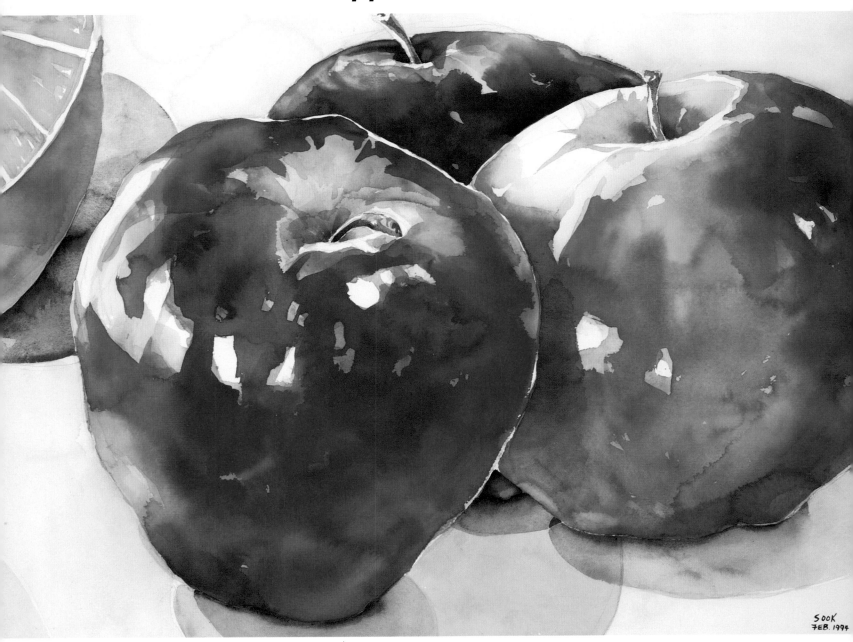

Sook-Kyung Hong *Three Apples* 28" x 36" Watercolor

I chose three apples from among all other fruit because I love vivid color and I wanted to explore the simple, beautiful red color of apples. I used a lot of pigments, and painted quickly. I mix colors on the paper instead of on the palette. I didn't paint many layers on these apples. Because I wanted a fresh look, I had to experiment to find the right colors. I am satisfied with the result.

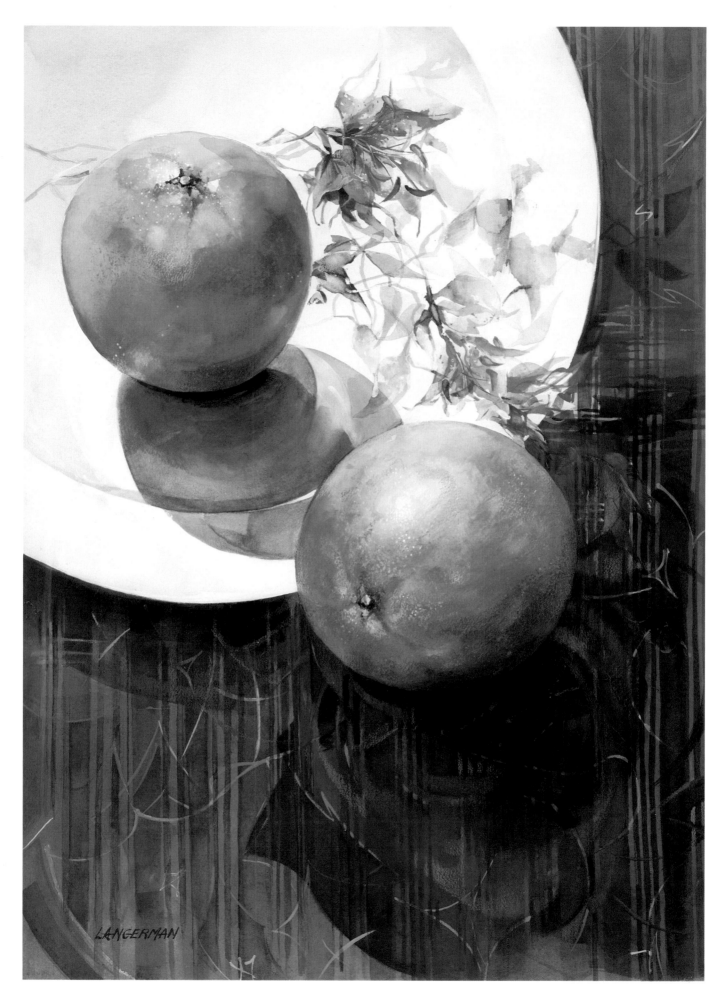

Lillian Langerman *California Sunshine* 22" x 30" Watercolor

Reduced to its essence, a still life can be very exciting to paint. In this painting, the oranges glow, independent of their surroundings. Because I was inspired to make them the dominant focal point of the painting, the flowers and plate became incidental.

Still Life

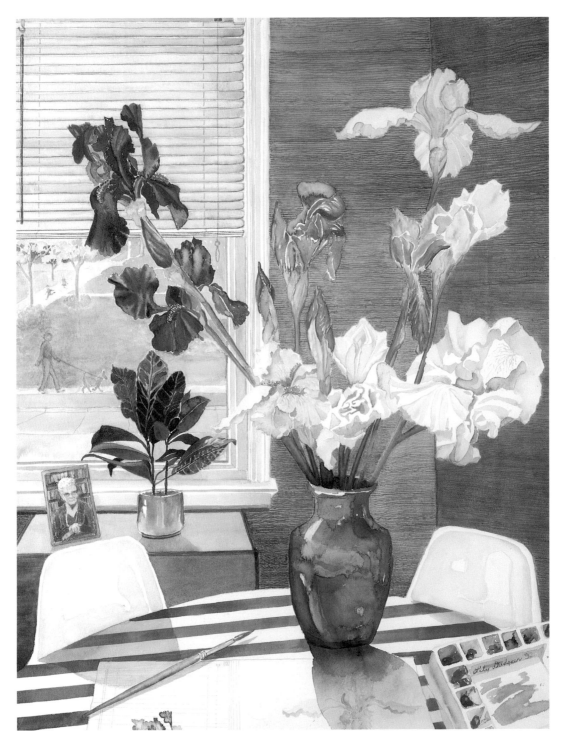

Lily Dudgeon *Remembrance* **22" x 30" Watercolor**

Most paintings are planned, but this one just happened. It started out on my dining room table with iris in a vase, then began taking on a life of its own. While looking out of my window, I saw a neighbor walking his dog and two children running down the sidewalk and incorporated them into the painting. Next, I added a photo of my mother, who had died five years before. Finally, I added a window plant and a striped table cloth along with my palette and d'Arches paper.

Even though it's a still life painting, it summons up a special day in my life and reminds me of my mother whose spirit is always with me.

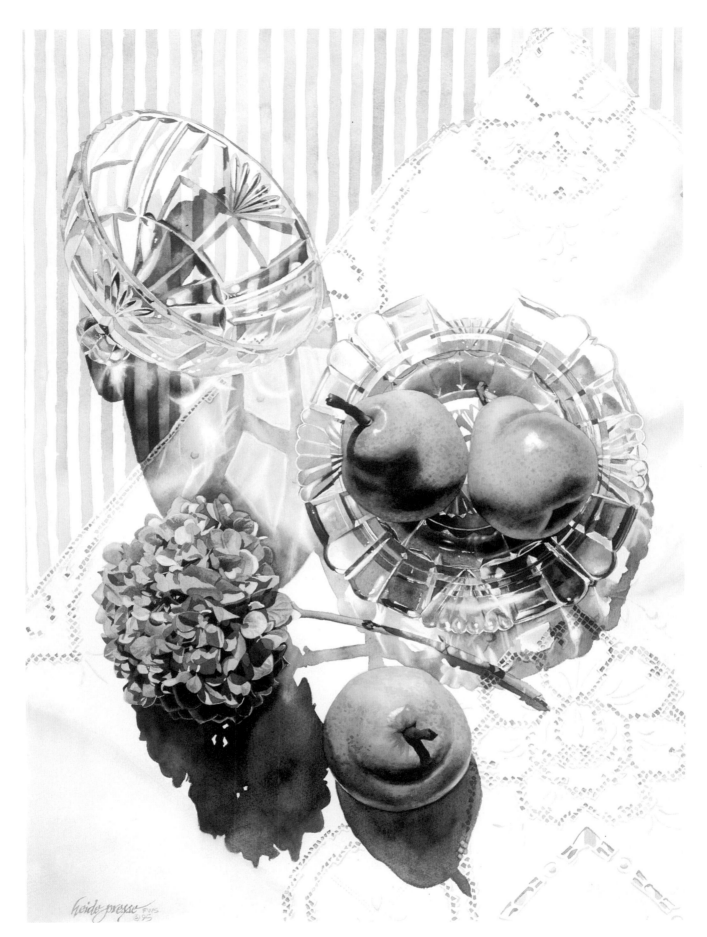

Heide E. Presse *The Last Hydrangea* 19" x 24" Watercolor

Everyday objects take on a personality of their own when in the beauty of sunlight. Shadows create depth. I like to enliven them with a lot of color. My paintings are expressions of the things that mean something to me. I like to preserve bits of life that I feel are worth saving. The challenge here was to depict the many facets in the cut crystal of the antique butter dish. The background stripes were painted loosely to create contrast with the tightly rendered still life.

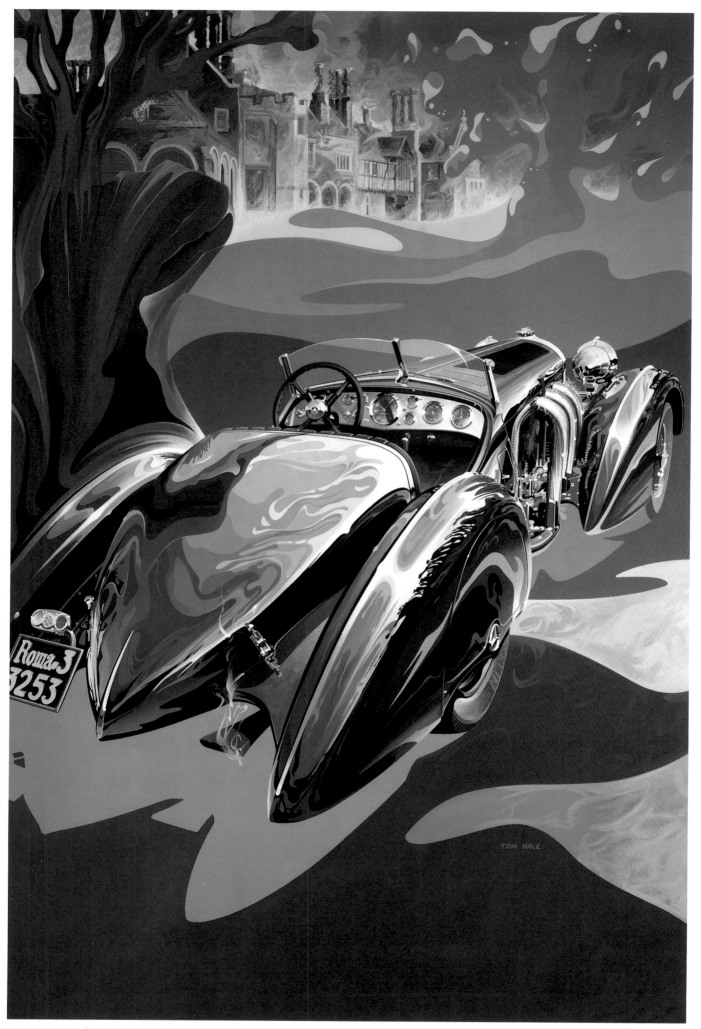

Tom Hale, AWS, NWS *Mercedes SSK* 44" x 72" Acrylic

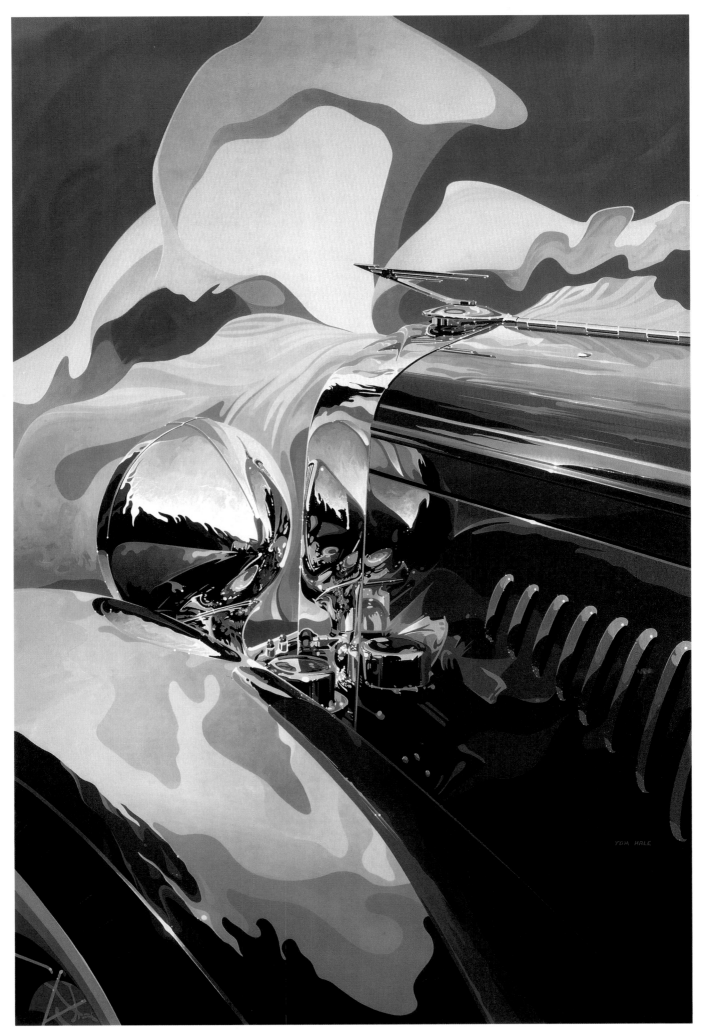

Tom Hale, AWS, NWS *Duesenberg* 44" x 72" Acrylic

This old Cadillac stood out from it's contemporaries...

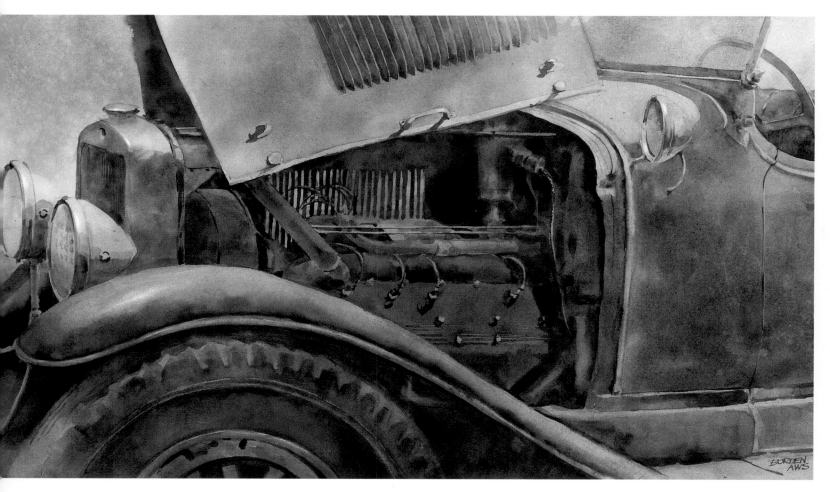

William Borden, AWS *The Cadillac* 14" x 29" Watercolor

This old Cadillac stood out from it's contemporaries at a Greenfield Village antique auto show. The others were all perfectly restored, glistening brightly in the autumn sun. Their mechanical parts, paint, upholstery and plating had been renewed and were better than the day they were built. Nevertheless, this Cadillac received my vote for Best of Show. It had survived years of use and abuse and arrived at the show under it's own power. The other cars had received special attention and consisted mostly of parts which had been re-manufactured or replaced. The Cadillac was a real survivor. I like things that don't give up, fall apart under pressure or change and take off after every new fad. I think an artist has to be like that in order to succeed. Painting is not an easy road. It takes commitment. Sometimes we have to take a beating and suffer discomforts. But the sense of accomplishment makes it all worthwhile when we achieve our goals.

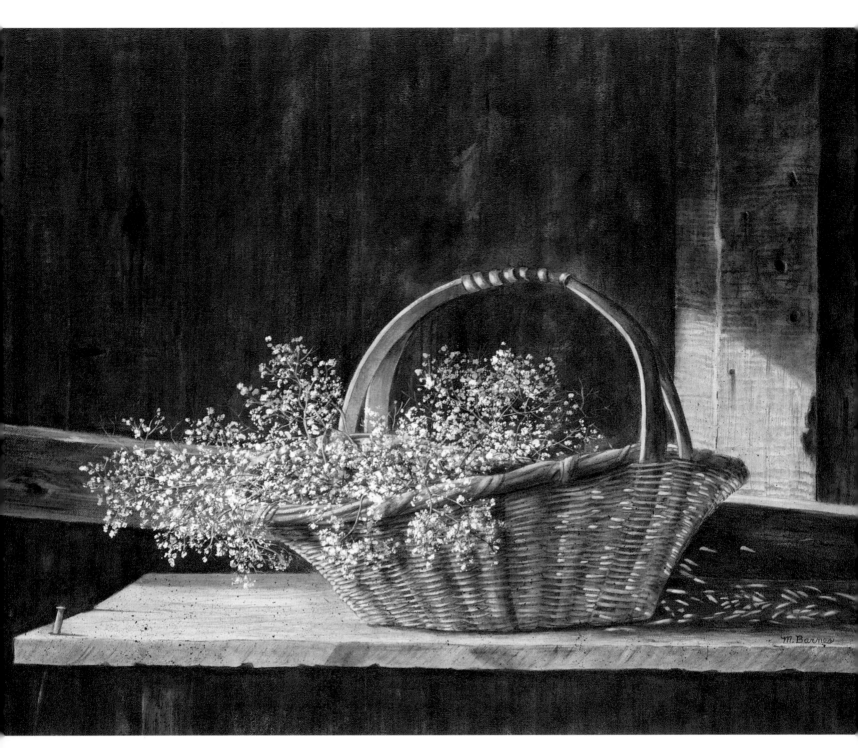

Martha Barnes *Basket of Baby's Breath* 22" x 28" Acrylic

We lived in a Victorian home with a garden shed where I spent many hours setting up still life subjects in various lighting situations. The texture of the hand-hewn beams and the way the light fell on the objects caught my interest. Texture and lights always intrigue me, especially when dealing with subject matter that comes from my personal surroundings. Form, light, and texture are equal in importance to the subject matter, especially in this painting. I was intrigued by the way the light breaks across the basket and also shines through it, creating patterns in its shadow area. The diagonal board creates a strong compositional element which is offset by the vertical beam where the light breaks across it at the same angle and draws one's attention to the basket. In this way the composition becomes an important dynamic element which focuses attention on the subject without overpowering it.

My interest is centered on realism. The works of Andrew Wyeth, Charles Sheeler and Thomas Eakins always have interested me. I also am fascinated by Edward Hopper's ability to capture moods of isolation, intimacy and loneliness in his paintings.

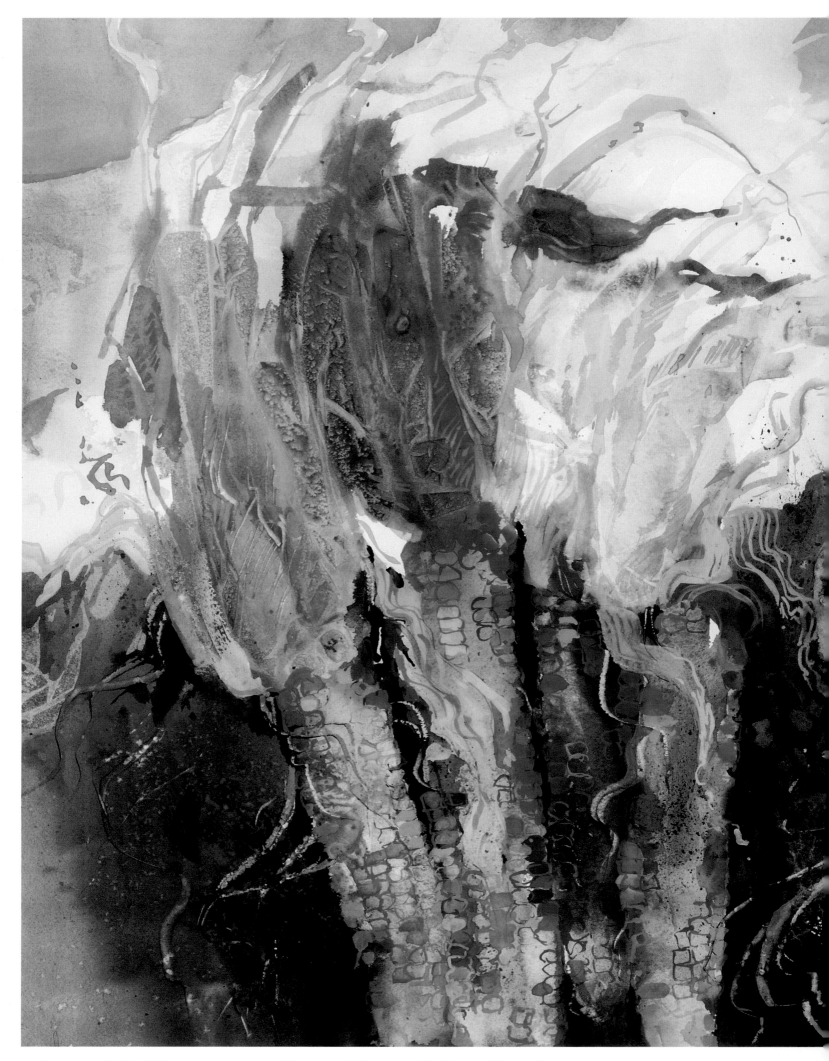

Joan McKasson *Corn From The Earth* 22" x 30" Watercolor

I decided to paint this Indian corn after using it for decorating my dining room table at Thanksgiving. After analyzing its texture and colors, I decided to do the painting without using a still life composition. Because my paintings usually are from Nature, I decided to view the corn in an upright position as it would be growing in a corn field.

With this in mind, I began by brushing shapes of clear water onto the watercolor paper in order to create design interest. I added rich pigment to the wet areas and drew the corn with a water-soluble pencil. By using this approach, I was able to paint with a free spirit and take advantage of any accidents that might happen. Creating a rich natural environment for the corn was uppermost in my mind. Toilet tissue rolled through the moist paint created the light abstract patterns. Use of Saran wrap, salt, splatter technique and scraping away the moist paint with the end of my brush created textures in the wet-in-wet areas surrounding the corn. I added opaque color for contrast, using a mixture of white gouache and watercolor pigments.

I experience the joy of painting when I am emotionally involved. I make my decisions intuitively. Of course, the painting still needs to be analyzed for good design, and some adjustments may be necessary. I always enjoy the surprise I experience at the end of a painting session because the painting is born of my creative spirit, surpassing what I could have planned originally. Corn From the Earth was such a painting.

47

I enjoy defining things that are exciting...

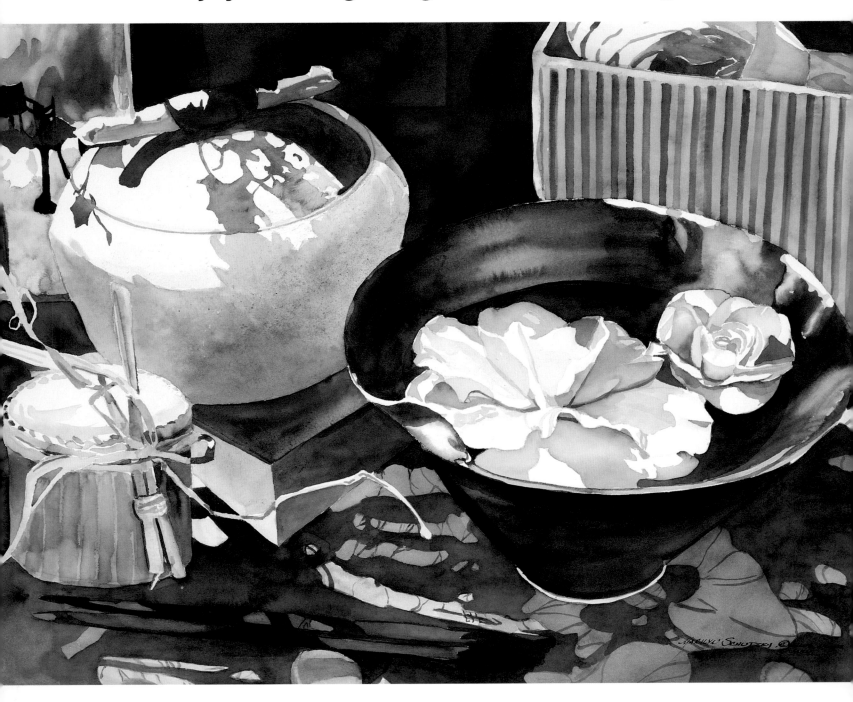

Marilyn Schutzky *Haiku* 22" x 30" Watercolor

 I enjoy defining things that are exciting, like the lines and shapes of the Far Eastern objects, which I use frequently in my still life paintings. I have a love affair with the close-up, a viewpoint ideal for dramatizing the strong play of sunlight and shadow. The close-up also gives me an opportunity to introduce another strong interest — pattern. Haiku embodies the simplicity of Eastern influence.

Dance

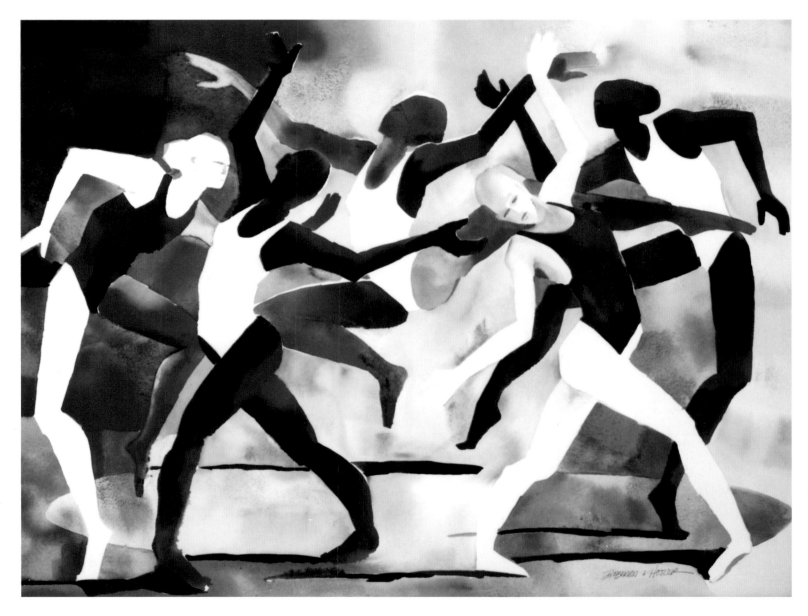

Deborah L. Hoover *Dance Circle* 22" x 30" Watercolor

Although I wanted the viewer to see and hear the music in **Dance Circle**, creating a sense of movement was the primary objective. I placed white against dark, using the angles of the arms, legs and torsos so that my dancers would force the viewer's eye to circle the painting. I painted patches of wet color into wet color and limited the values; the colors and the values became music moving rhythmically around the painting.

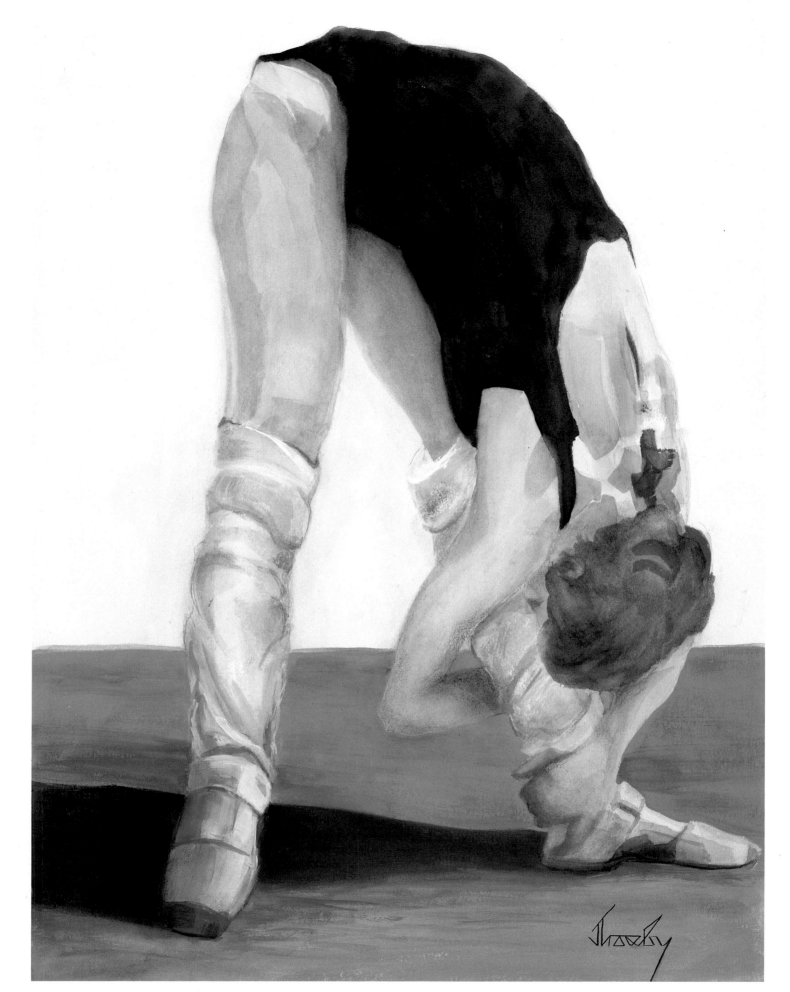

Johnnie Crosby *Ballet Warm Up* 22" X 30" Watercolor

...the early morning sun shines through the windows. It's a breathtaking sight.

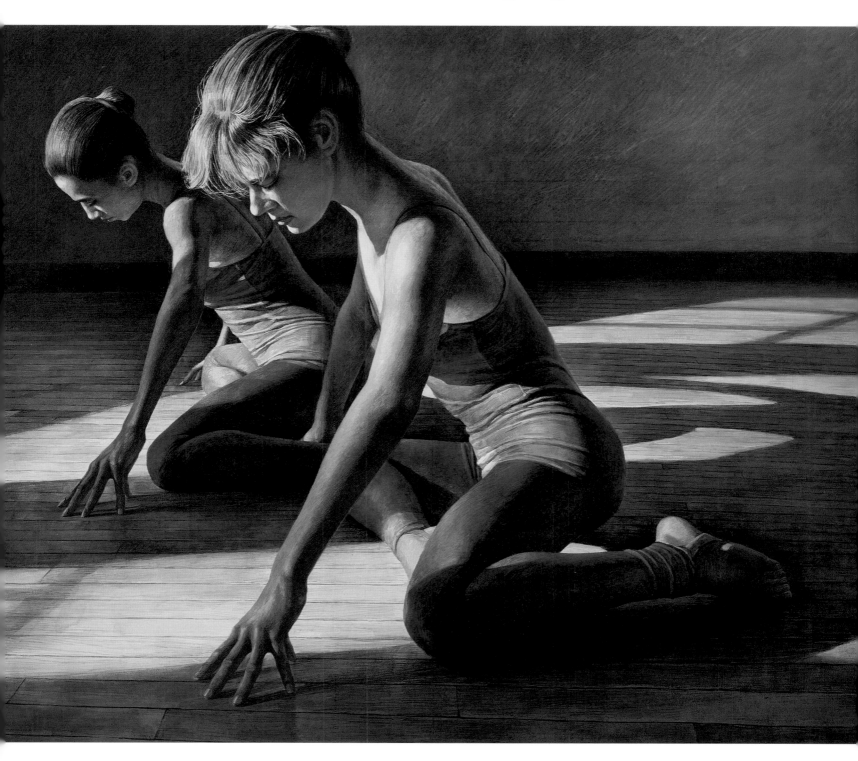

Z. L. Feng, AWS, NWS *Morning Star* 32" X 40" Watercolor

Morning Star emphasizes light, color, contrast, texture and value and expresses my love of beauty and art. The young, beautiful dancers practice under a warm shower of light as the early morning sun shines through the windows. It's a breathtaking sight. This painting was executed by first applying the transparent watercolor base, then gouache with a dry brush.

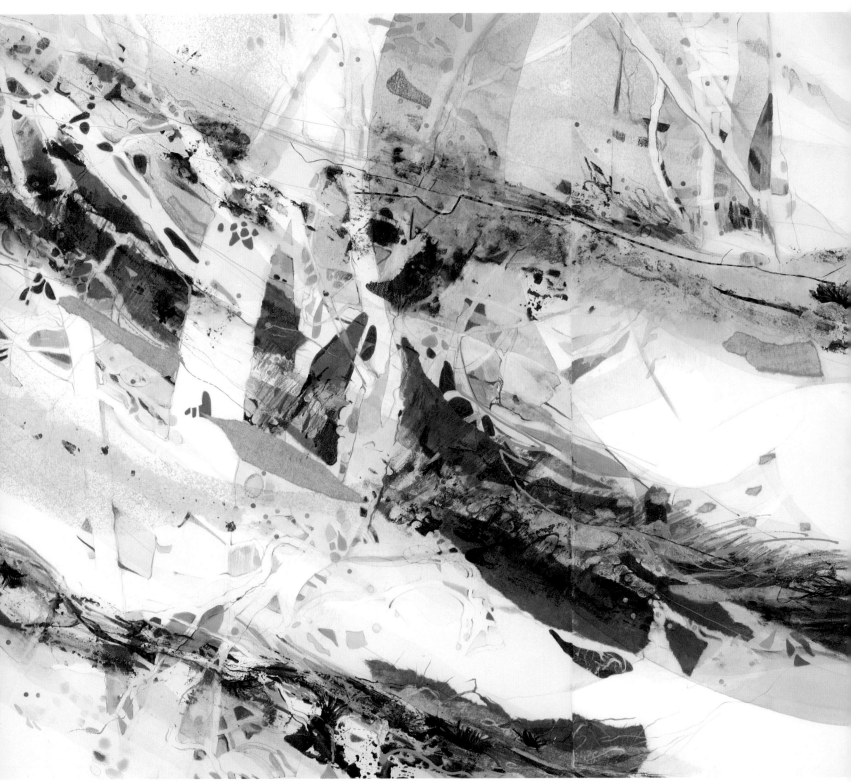

Wanda Gringhuis Anderson *Moonwood* 33" X 70" Watercolor

Three panels of Fabriano 33 lb paper were soaked in water and they were then hand-embossed over hand-cut cardboard shapes for this large triptych painting. Next, I poured and brushed on Winsor Newton paint. Prismacolor Pencil was then used to form the shapes between the branches and roots of the dune trees. Gold Oriental papers, painted wood chips, thread, and string from a bird's nest further embellish the composition.

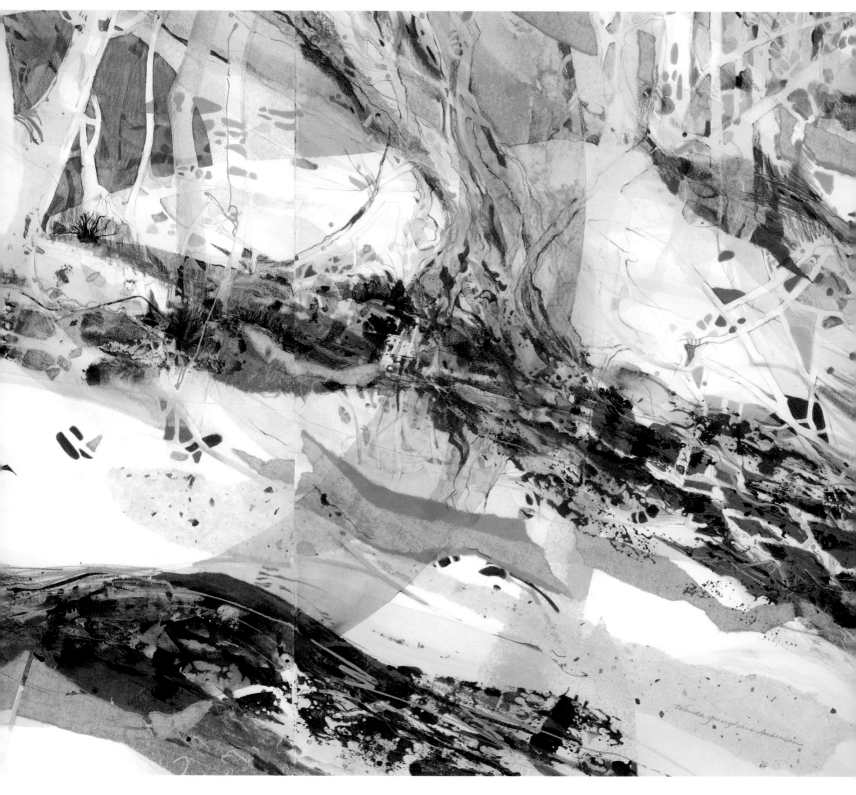

Moonwood symbolizes the undulating feminine woods of the Michigan Lake Hills and the sand dunes along the Lake Michigan shore. The dune behind the trees, and the radiating aura of the moon unite the three pieces of watercolor paper into one composition. The trees appear to shift and move — positives becoming negatives. We have been fighting to save the endangered dunes from the sand mining companies. Some call them "Sacred Sands" — a rare ecosystem still very much in danger which should be preserved for future generations.

This painting has won five awards, including Best of Show. It was accepted in the **Michigan Watercolor Society** competition.

The color reminded me of the Pacific Ocean's gorgeous blues and greens.

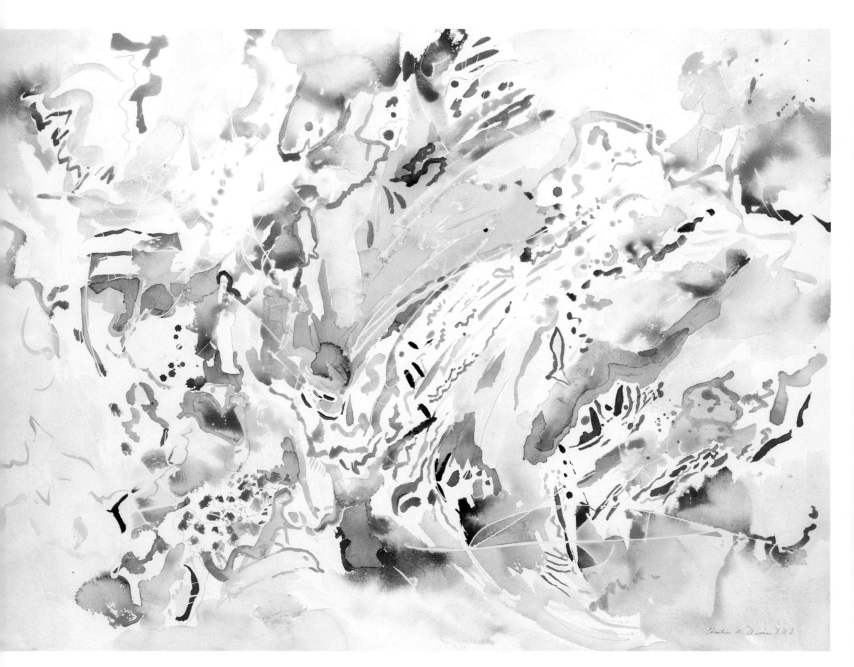

Christine M. Unwin, NWS *Hawaiian Surf* 22" x 30" Watercolor

I love to use calligraphy and I especially enjoy painting with my Chinese wolf hair brush. Calligraphy gives my work a linear quality. I started playing around with marks and color when the large wave shape seemed to emerge in **Hawaiian Surf**. The color reminded me of the Pacific Ocean's gorgeous blues and greens. Once it was clear that the painting represented the surfing waves of Hawaii, I added other colors and shapes that reminded me of the islands, their lyrical magic, never ending breezes and enchanting waves. Human figures are also hidden for interest.

...whimsical sea creatures such as seals, birds and fish seem to emerge.

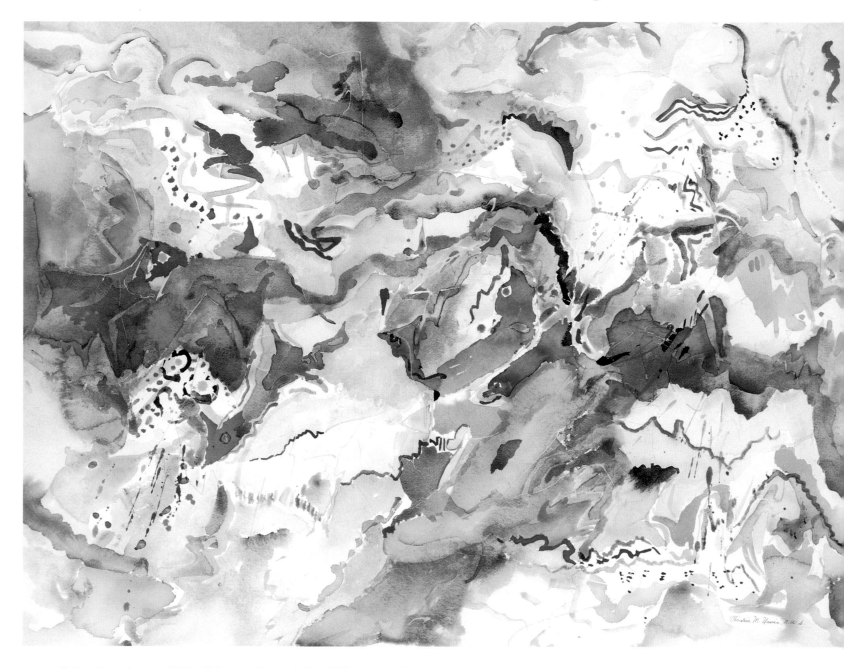

Christine M. Unwin, NWS *Alaskan Waters* 22" x 30" Watercolor

Predominately cool colors were used in *Alaskan Waters* because they represent the cold, icy waters of Alaska. I tried to combine the linear work with the washes. As I work, whimsical sea creatures such as seals, birds and fish seem to emerge. Some are simply implied, leaving room for the viewer's imagination. The Cadmium Scarlet color does not exist in the Alaskan landscape, but I used it anyway for contrast to intensify the blue. I also tried to show the subtle variations of color.

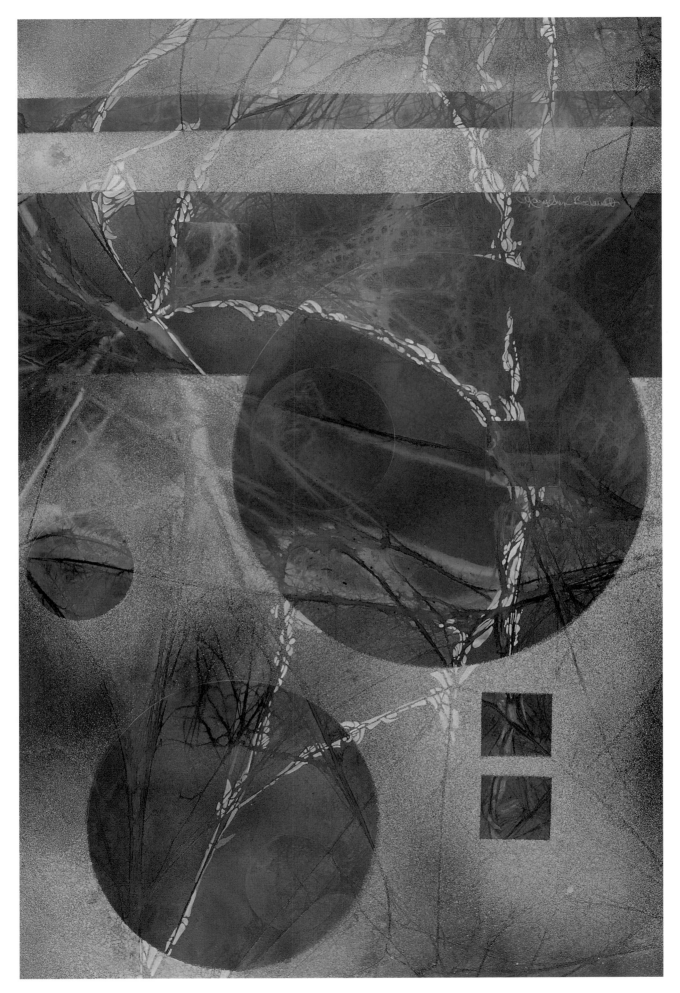

Mary Ann Beckwith, MWS *Celestine Prophecy II* 30" x 44" Watermedia

Igor Beginin *Cycles* 20" x 27" Watermedia

I selected shapes that worked spontaneously, creating a more solid design.

Edward Minchin, AWS *Celestial Travel* 21" x 28" Watermedia

I started this painting spontaneously with large washes of transparent watercolor applied on 140 lb. cold press d'Arches paper. Although I had no specific subject in mind, I was probably influenced by my recent series on space/celestial type paintings. As the painting progressed into darker shapes, I applied acrylic paints and glazes of gesso. I selected shapes that worked spontaneously, creating a more solid design.

I like to see the artist's hand in a work of art...

Danguole Jurgutis *Summer Bouquet* 22" x 30" Watermedia

 I like to see the artist's hand in a work of art. At the same time, I like abstract, unforeseen elements in the painting. ***Summer Bouquet*** was done entirely from my imagination. No flowers, no bouquet as models. The pieces of collage, prepared randomly with fluid color passages and coaxed by a squirt bottle, are the unexpected element in its composition.

 In composing the painting, I chose the most interesting sections from previously painted surfaces as the foundation. The "artist's hand" resolved and completed the imaginary summer bouquet.

I paint what I feel and want others to see.

Jan Dorer

Aquifuge 57" x 62" Acrylic

I shared an exhibit booth with an artist friend at the 1962 Ann Arbor, Michigan Street Fair. I've been painting and exhibiting in shows ever since. Throughout those years, I have experimented with techniques, paints, textures, collages and colors, and have seen the resulting changes emerge in my work. Each of my paintings begins with an idea or mood and evolves slowly. In my abstract-impressionistic style, I do not draw what I see, but rather I paint what I feel and want others to see.

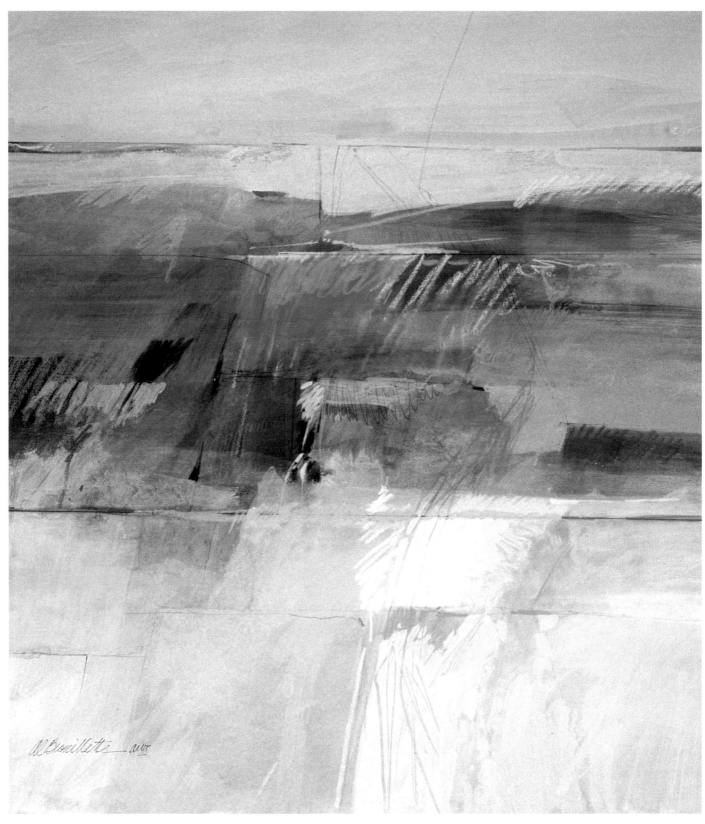

Al Brouillette, AWS *Horizons II* 17" x 19" Acrylic

This painting is one of a series based on my impression and translation of elements I often see in the landscape. The horizontal movement in the distance gradually shifts to verticals and obliques as they advance toward the foreground. The foreground movements serve as countermovements to the background horizontals. To suggest a feeling of space, I used the flattest and coolest colors in the distance with the warm fragments in the middle ground to assure that the center of interest is in the interior of the painting. The larger elements surround and isolate the smaller shapes, also contributing to the establishment of the center of interest as the viewer's eye moves to the minute fragments. I purposely kept the content of the painting somewhat vague so that viewers will have the freedom to interpret the painting on their own.

I wanted to capture this feeling of movement and the immense grandeur of the area...

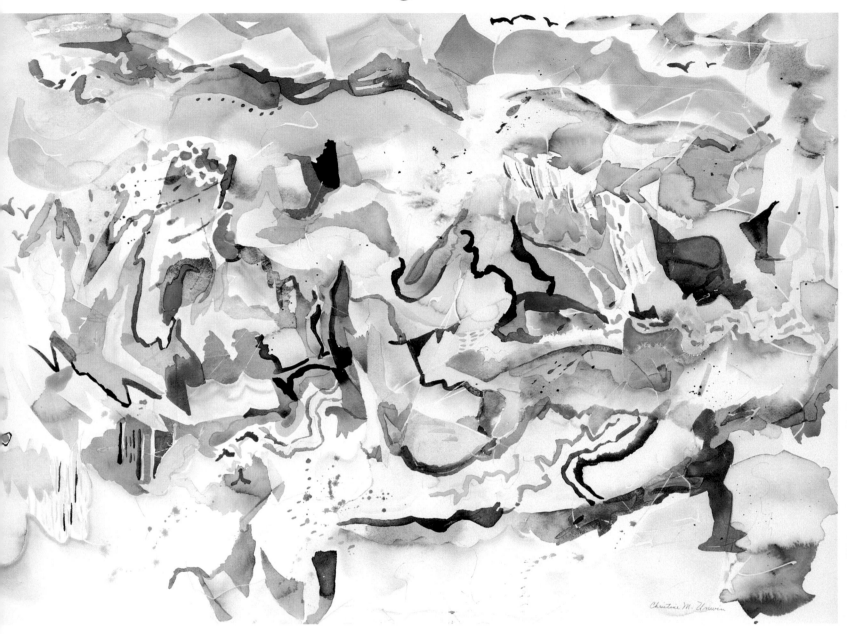

Christine M. Unwin, NWS *California Coast* 22" x 30" Watercolor

I visited Bodega Bay, California during the height of the stormy season. The coast was alive with drama. The winds were ferocious, whales were migrating, birds were nesting and the flowers were hanging on — trying not to blow away. I wanted to capture this feeling of movement and the immense grandeur of the area without limiting myself to painting "what was there". My whimsical painting presents the land, the sea, and the sky as well as the birds, fish, whales, and seals. I try to give the viewer my emotional impressions and reactions. I hope my celebration of life shows in this painting.

I started this painting by swirling rubber cement around on plain white paper. It acts as a resist and cannot be controlled, so it sets the mood for spontaneity. I used a pointed wolf hair Chinese brush for the calligraphy. That brush also has a mind of it's own and, therefore, prevents a "stiff" look. I rarely use a flat aquarelle brush. But in this case I did and I was pleased with the strokes that make up the waves and sky. The scribbles of extremely fine black lines were made with a permanent ink pen to create tension. The pigments used were Winsor Newton. I feel that the calligraphy is like my handwriting and, although it is not perfect, it reveals the "real" me.

The predominantly warm colors remind me of the dry, sandy desert.

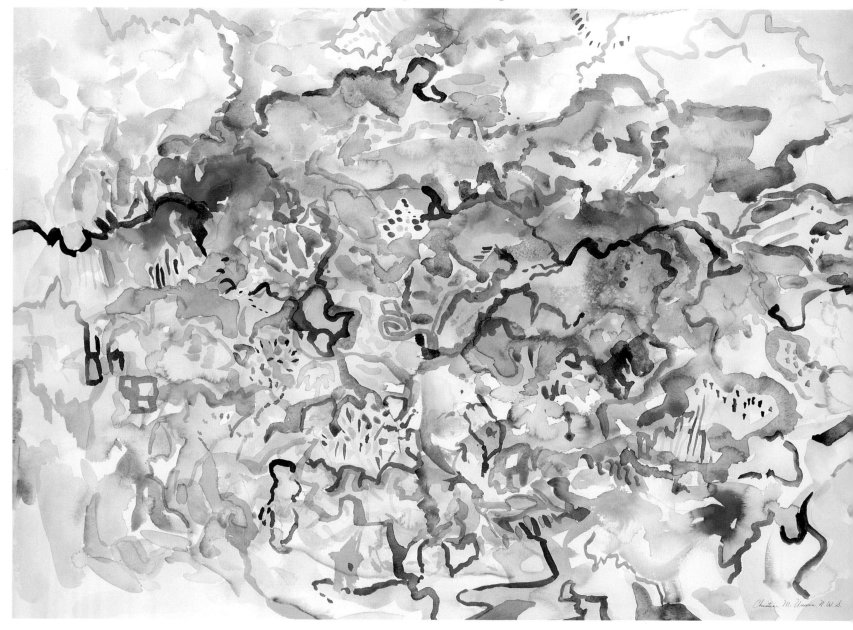

Christine M. Unwin, NWS *Southwest* 22" x 30" Watercolor

This painting represents the Santa Fe landscape. The predominantly warm colors remind me of the dry, sandy desert. Even though this painting is abstract, most viewers read it as a landscape with rolling hills and roads. The color dominance is warm with touches of cool colors for contrast.

...the image is a mirrored version of the original...

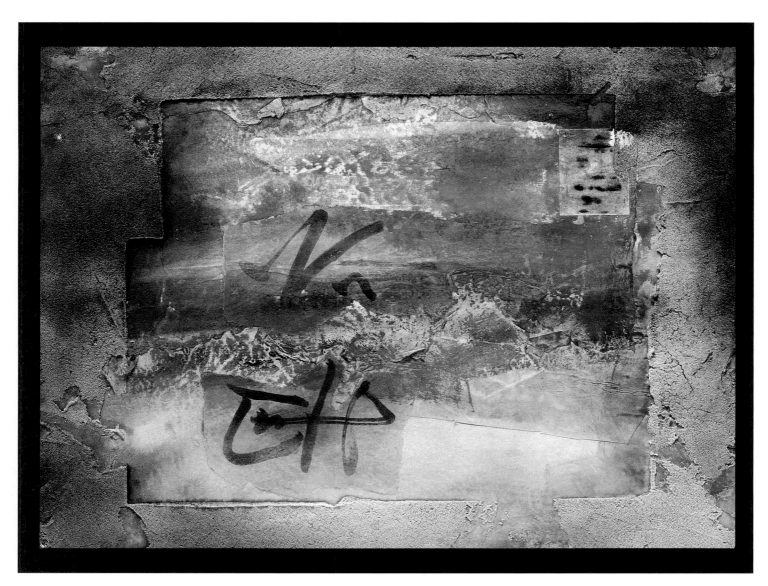

Peggy Zehring *Buddha's Message* 22" x 30" Mixed Media

When I went to China, my Buddhist tai chi teacher came along as translator and guide. He would tell long interesting stories from the Buddhist tradition while he taught me calligraphy. I did this calligraphic work on thin rice paper and flipped them over before laminating. Thus, the image is a mirrored version of the original, which is, I believe, symbolic of the way West sees East.

I normally work on Indian Village Handmade paper which, in large quantity, comes in a wonderful hand-crafted wrapping. For this piece, the wrapping itself became the painting surface, with sand and the acrylic medium creating the highly textured edge.

The cryptic message in the upper right hand corner came from a box of charcoal. I am learning to listen to what is given, trusting its inherent wisdom.

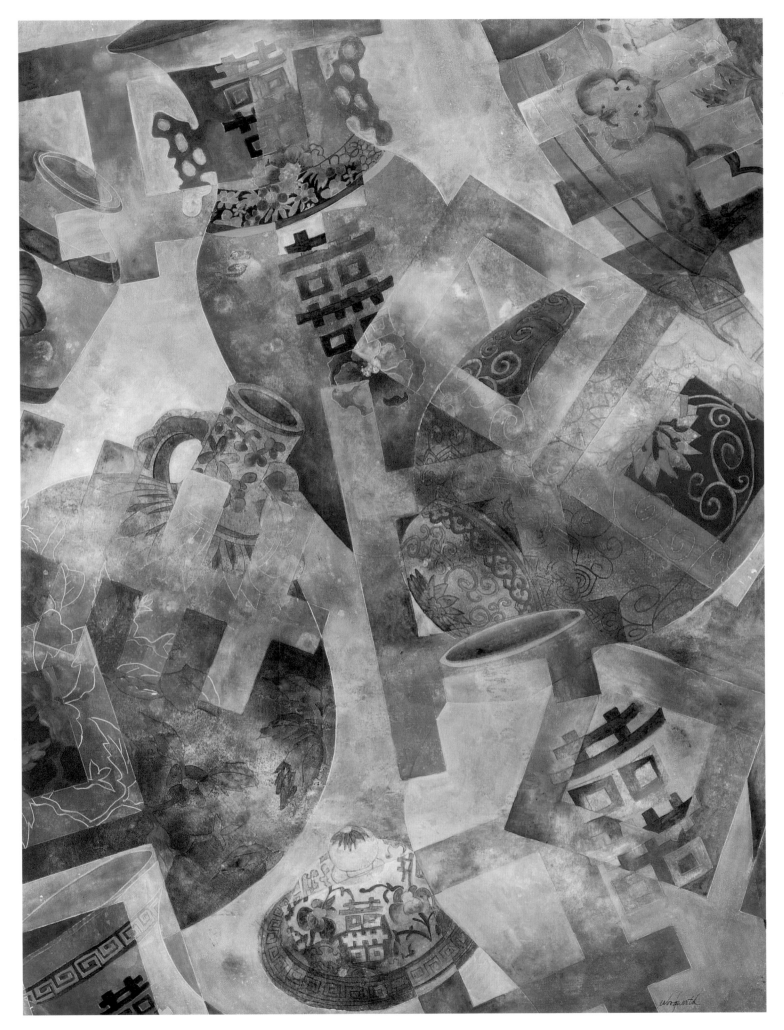

Pat Woodworth *Oriental Vases* 22" x 30" Acrylic

I'm amazed at the clarity of color and natural layered forms which appear in the landscape.

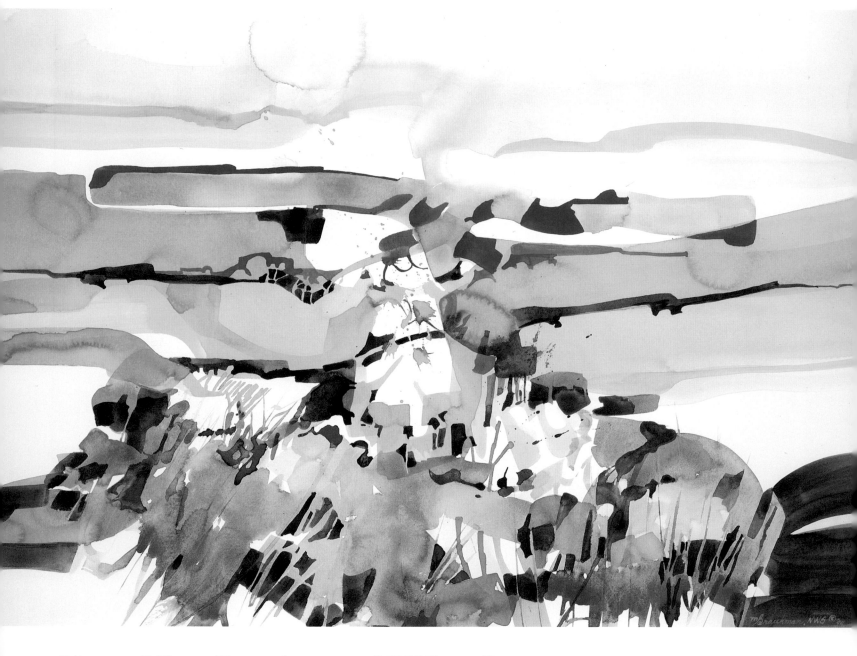

Mary Alice Braukman, NWS *Sunscape* 22" x 30" Watercolor

Sunscape was painted on 300 lb HP Fabriano paper. I work mainly with collage, mixed water media and pastel. Much of my painting subject matter is drawn from my travels. I lived in the West for eleven years and I'm amazed at the clarity of color and natural layered forms which appear in the landscape.

This painting is from a series of five. Each piece shows the layered quality of the landscape, the vivid colors of the sun on the mesas and the layered bluffs in the morning hours. The water spot at the top was an accident but actually worked to set the theme by forming the shape of the sun.

When I work in transparent watercolor without combining other water media or collage, I like to work quickly, using wide brushes. I do not use any masking and seldom sketch on the paper. Nonetheless, I do use my sketch pad. I often tear colored paper, in three to four values, and make my design as a miniature collage without sketching. This gives me my direction. It helps me to simplify. The closer I come to the completion, the slower I work. I will spend days viewing my painting turned in different directions to see the various shapes, the sizes of the shapes, and how they relate to one another.

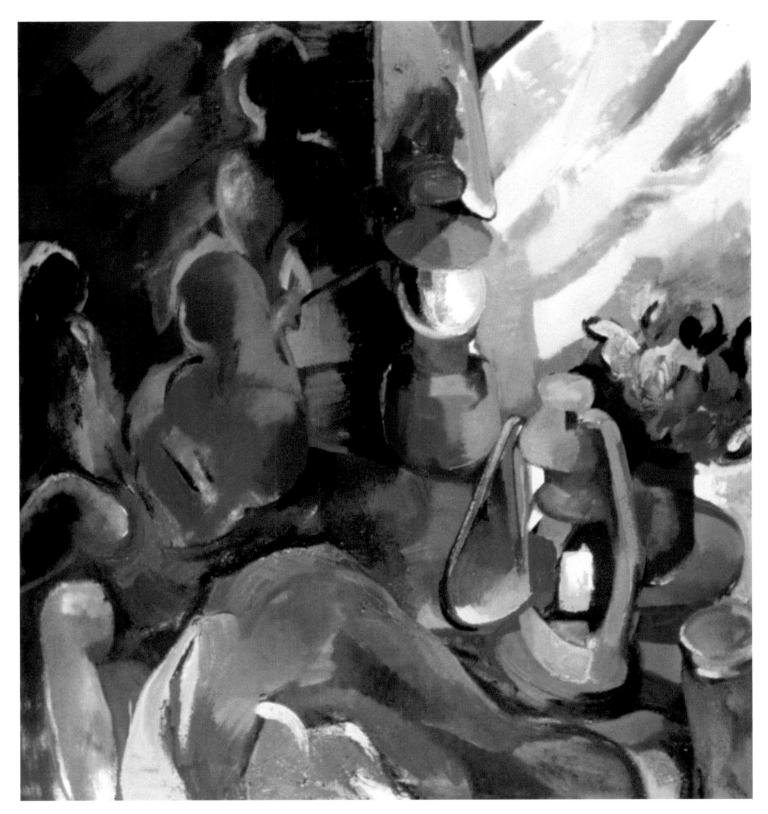

Martha Hayden

The Lantern 40" x 44" Oil

Before starting *The Lantern*, I set up a still life along with a figure painting. My task was to form a new reality by painting the relationships, the rhythms and repetitions of forms and colors that bind the two together. I want a large interior space to draw the viewer in with a logic of its own. I look for the relatedness of all elements, trying not to see anything for itself alone, but as a part of the whole.

The red lantern appears often in my work. I first used it in 1958. I like its formal properties; the redness of the red, the clarity of the pile of cylindrical shapes, the roundness and transparency of the globe and the air trapped in the shape of the handle.

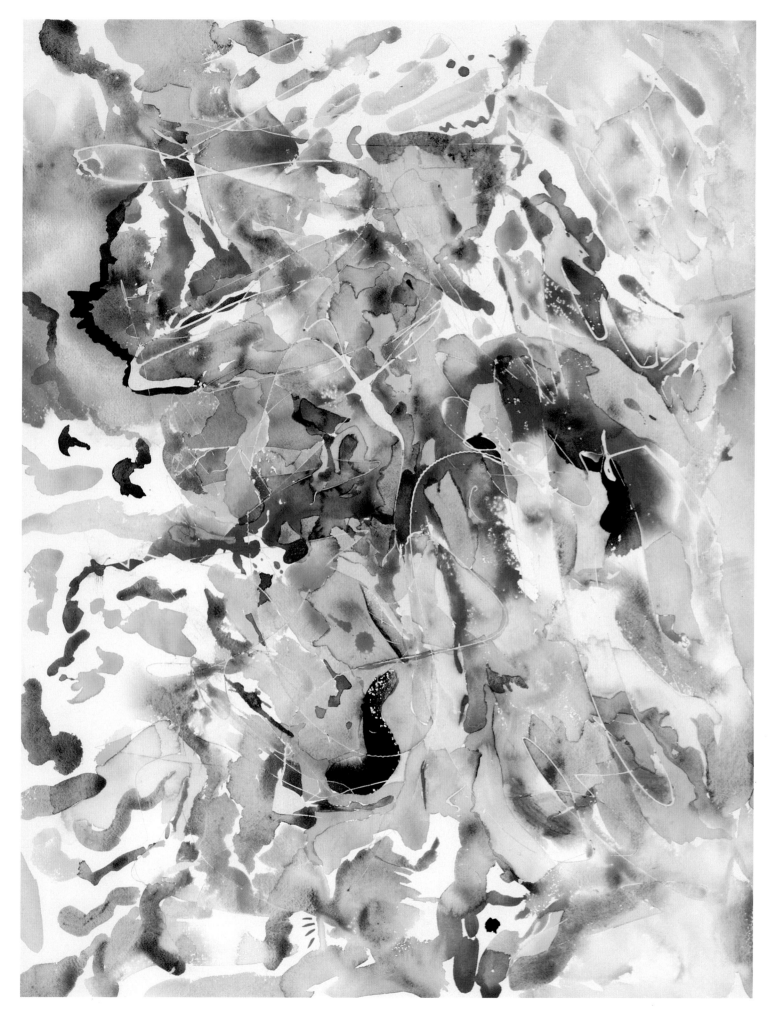

Christine M. Unwin, NWS *Sierra Nevada* 22" x 30" Watercolor

Animals

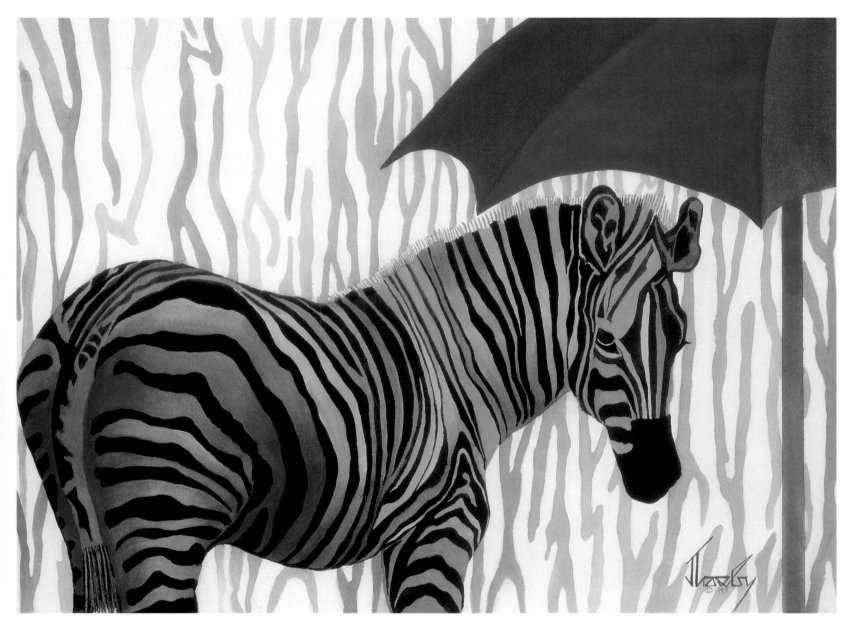

Johnnie Crosby *Color Me Blue* 22" X 30" **Watercolor**

 I never thought of zebras as blue until I chanced to see an ad emphasizing the color blue. I decided this would be a unique way to paint zebras. I added the umbrella to repeat the form of the animal's hind quarters.

 There are different kinds of zebras: Burchells, Grevy's and mountain zebras. All are descended from the wild horse family and no one zebra is striped exactly like another.

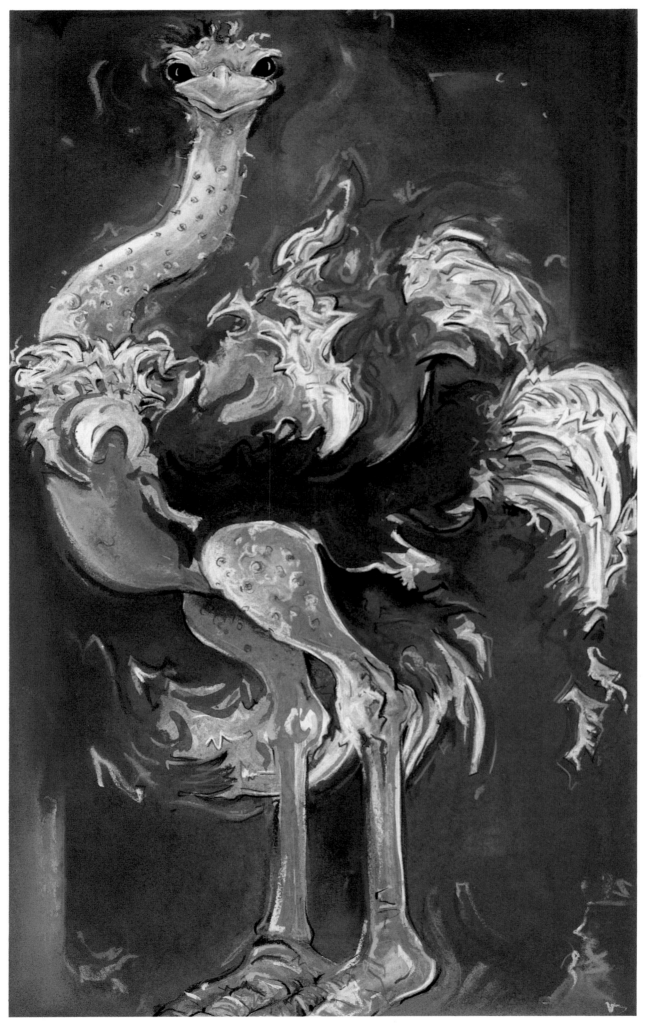

Marsha Heatwole *Ostrich Wave* 12" x 19" Mixed Media

People chuckle when they realize what the subject is all about.

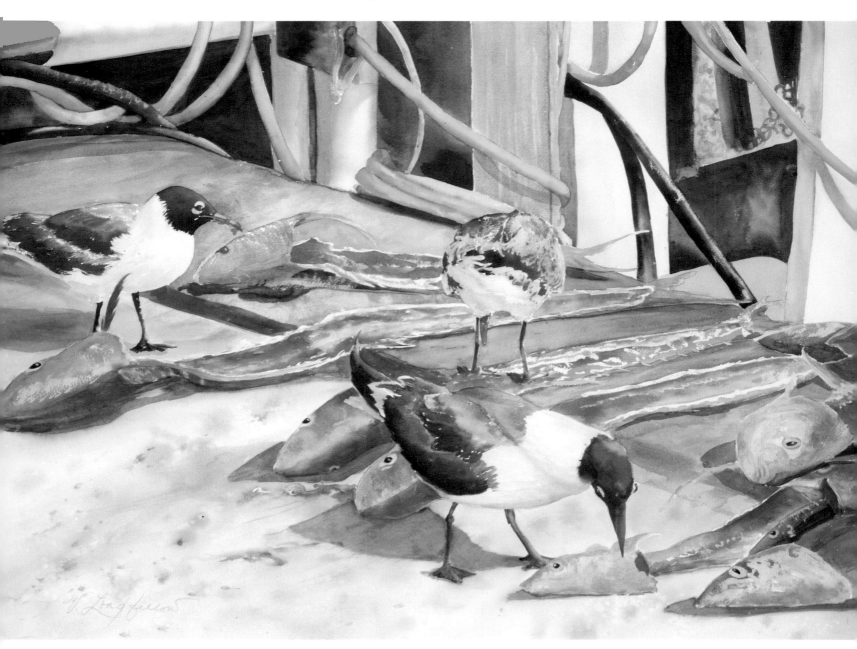

Vivian Longfellow *Free Lunch* 22" X 30" Watercolor

Behind every painting there's a ***Free Lunch*** story. There was so much action on the dock that the excitement inspired me to work on this painting everyday until it was finished. People chuckle when they realize what the subject is all about.

Alice A. Nichols *Camouflage* 36" x 46" Watercolor

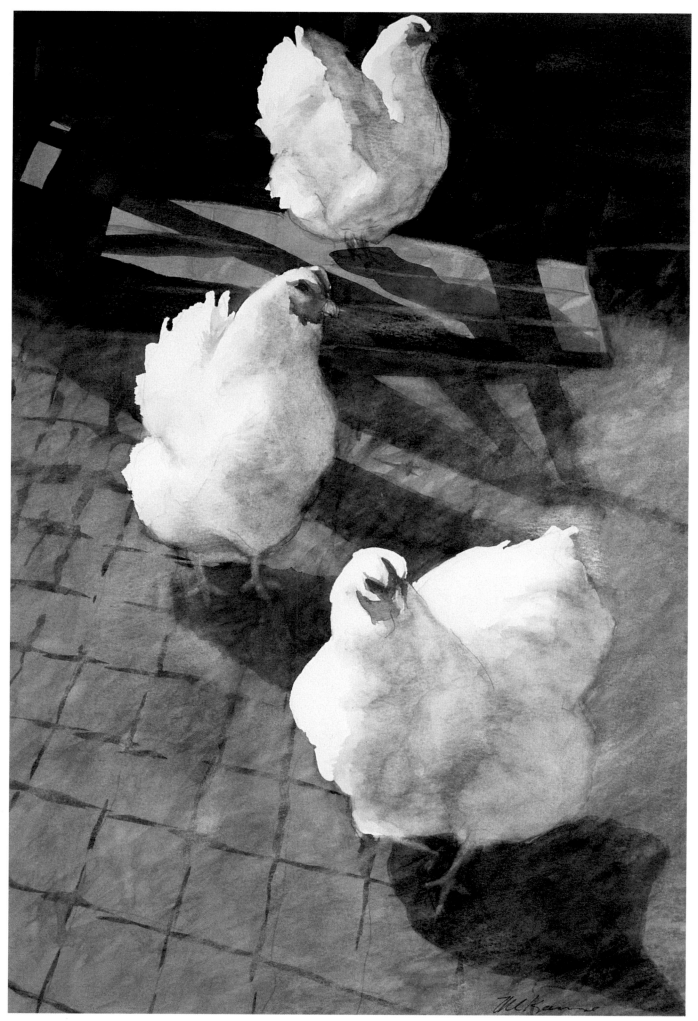

M.C. Kanouse *Three Chickens* 14" x 21" Watercolor

I call my work: creative realism.

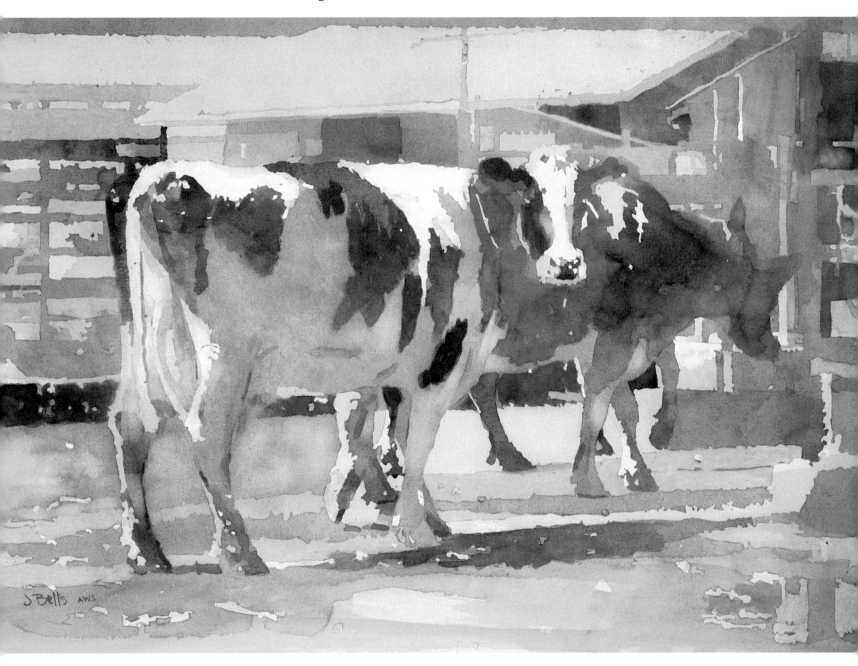

Judi Betts, AWS *Mood Music* 22" x 30" Watercolor

One of the challenges facing artists is simplifying what they *see* into a well organized plan. Barse Miller said to me many years ago, *"Don't paint the whole world"!* In this painting, I chose a small portion of the rural landscape. I liked the strong value patterns of the Holsteins at a busy dairy farm. At first the black and white was like a scrambled jigsaw puzzle. The animals were being moved from one area to another. From a configuration of three animals I decided to paint just one. I achieved the feeling of dust by using many thin layers of transparent colors in glazing. Shapes that I observed between the boards of the fences and in machinery were used to invent new "magical shapes". Puddles of water and irregularities in the ground suggested other ideas. The sun's heat is evident in the warm color dominance; even the grays are quite warm. I gathered images, scents, sounds and rhythms to make this painting. I call my work: "creative realism".

Then I decided to paint cats. I just love cats...

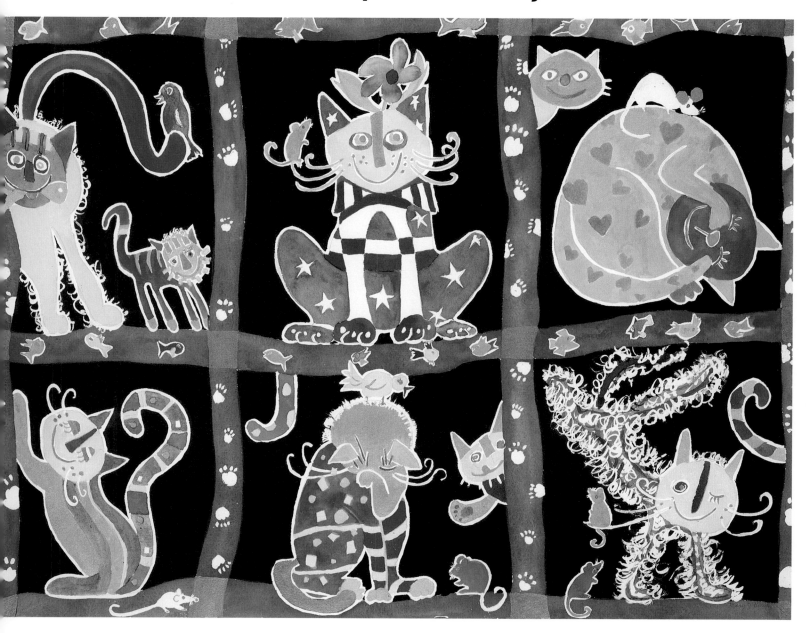

Mary Hickey

Cat Quilt 22" x 30" Watercolor

For a long time, I painted still lifes, portraits, landscapes, etc. You name it and I painted it. Then I decided to paint cats. I just love cats and to my delight, when I began to paint them, I found myself in a new place as an artist. My subjects were no longer "out there", but seemed to be an extension of my life experience. Gradually, through the process of painting, things dear to my heart were synergistically brought together - watercolor, cats, flowers, quilts. I've long had a reverence for and fascination with quilts and the stories and life events that women have celebrated in fabric, while providing practical warmth to the family. *Cat Quilt* is one of a series of four paintings: *Cats O Glorious Cats*, *O Mamma Meow*, and *Cat A-Go-Round*, all vibrant in color and whimsical in nature. In *Cat Quilt* I invite the viewer to enjoy and treasure the wonderful world of cats as told in a quilt.

The adult cheetahs were hunting. Far off on the horizon were the silhouettes of four youngsters watching intently, yet waiting obediently.

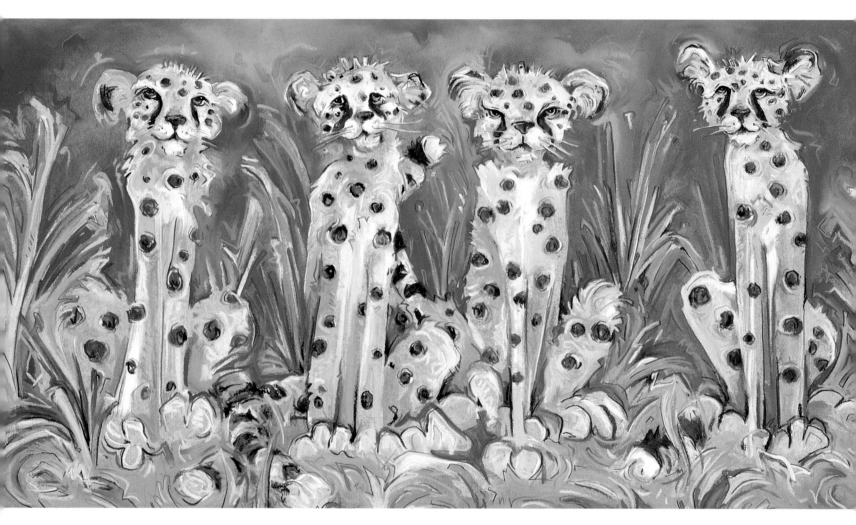

Marsha Heatwole *Duma Watoto* 13" x 23" Mixed Media

I had a tremendous opportunity to experience the beauty and whimsy of African animals while traveling in Tanzania. I have great respect and admiration for both my subjects and for the act of painting. I use the word "paint", but I mean this word to encompass all of my artistic endeavors.

My painting began with sketches made while traveling in Tanzania. The adult cheetahs were hunting. Far off on the horizon were the silhouettes of four youngsters watching intently, yet waiting patiently for the parents return.

I refer to my flower paintings as my garden...

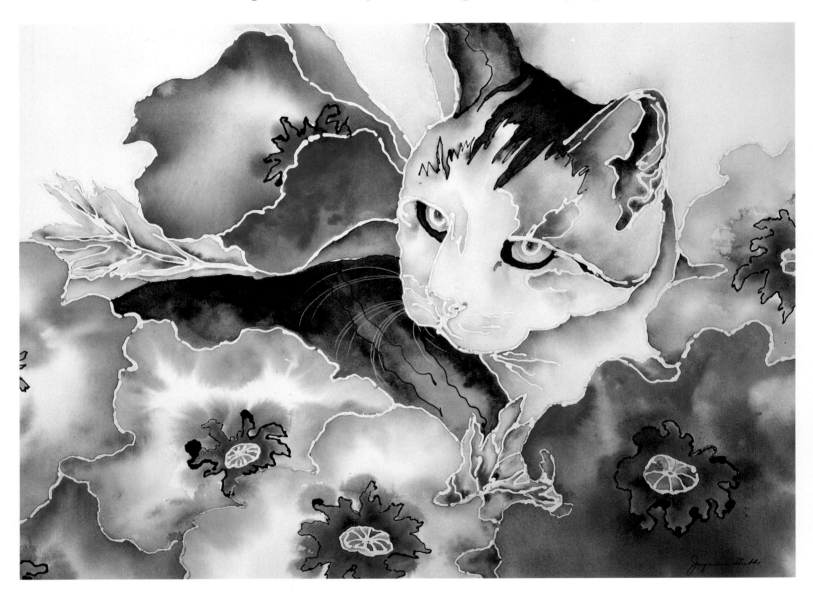

Jacqueline Stubbs *Hide & Seek* 28" X 35" Watercolor

Flowers have always been my favorite subject choice. I refer to my flower paintings as my garden because frequent moves have precluded my having a real garden. Cats have also been a favorite subject and in this piece I've combined the two.

The technique is batik watercolor, which I recently learned from Susan Vitali. Using a batik tool, I draw the subject with paraffin wax directly on blank watercolor paper. After the paraffin has cooled, the paper is thoroughly wetted before I begin to paint. This is a new medium for me. I began with oils and then studied Sumi in Japan. For over 20 years I have been working with handmade, hand-dyed paper, doing a type of collage which I also studied in Japan.

This painting shows her wariness at being surprised sleeping on the table which she knew was off limits.

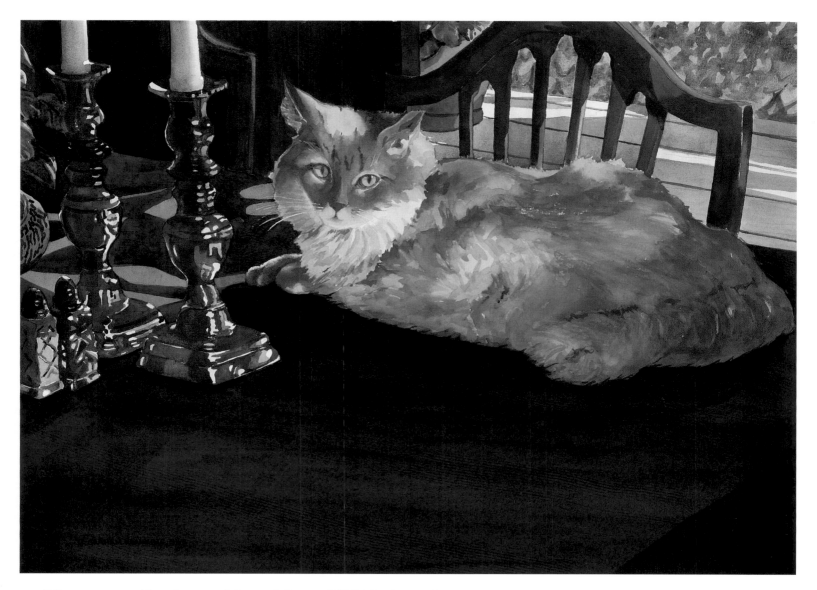

Margaret Graham Kranking, NWS, MWS *Table Setting* 22" x 30" Watercolor

In the course of my career, I have gone from a plein air purist to a combination on-site and studio painter. I missed too many spectacular light effects because the light, the weather or the subject changed. It was then I learned to add a camera to my outdoor equipment in order to preserve the scene.

Painting on-site brings a sense of reality and immediacy to my work — not just the work I do at the scene but the work that follows later in my studio from the on-site paintings, sketches, and photos.

My cat, Brandy, was a favorite subject but always an elusive one. The minute I prepared to "capture" her she would fade away. This painting shows her wariness at being surprised sleeping on the table which she knew was off limits. Instead of a scolding, I grabbed my camera and immortalized the subject. I was thus able to capture that moment of surprise and guilt that shines through *Table Setting*!

Contemplation

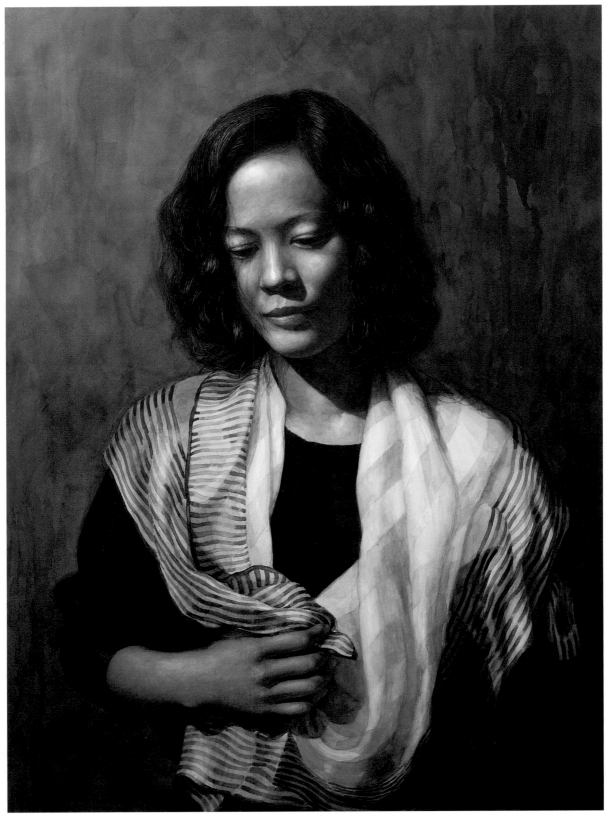

Yumiko Ichikawa *Contemplation* 22" x 30" Watercolor

I try to express mood in my portrait paintings. This girl is quietly looking into herself. She's forgetting the outer world and getting in contact with her own spirituality. I layer transparent watercolor to build up three dimensional forms and often use Japanese brushes for delicate details such as the hair.

80

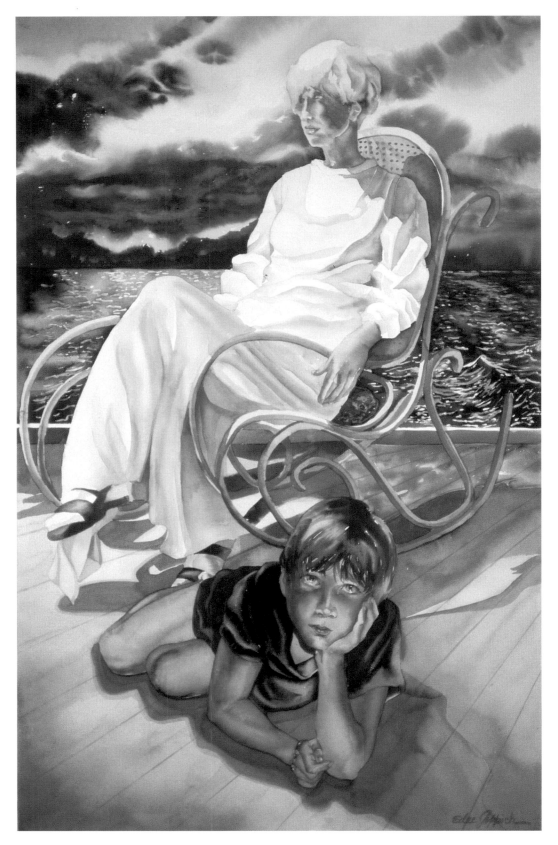

Edee Joppich *Summer's Child* 26" x 40" Watercolor

 Summer's Child was inspired by a short story called "Wild Boy of Northport", written by Kathy, my summer model and friend for many years. The story is about a mother and her young son whose small town summer life-style differs radically from the way they live in Los Angeles the rest of the year. As the painting evolved, I began to sense in their faces bittersweet reflections of summers past and their solitary dreams of an enigmatic future.

 I seated Kathy in a rocker on my gallery deck. Lorenzo posed in my attic studio. The turbulent post-storm sky was over Lake Leelanau. This composite of images lends a sense of isolation and mystery to the painting.

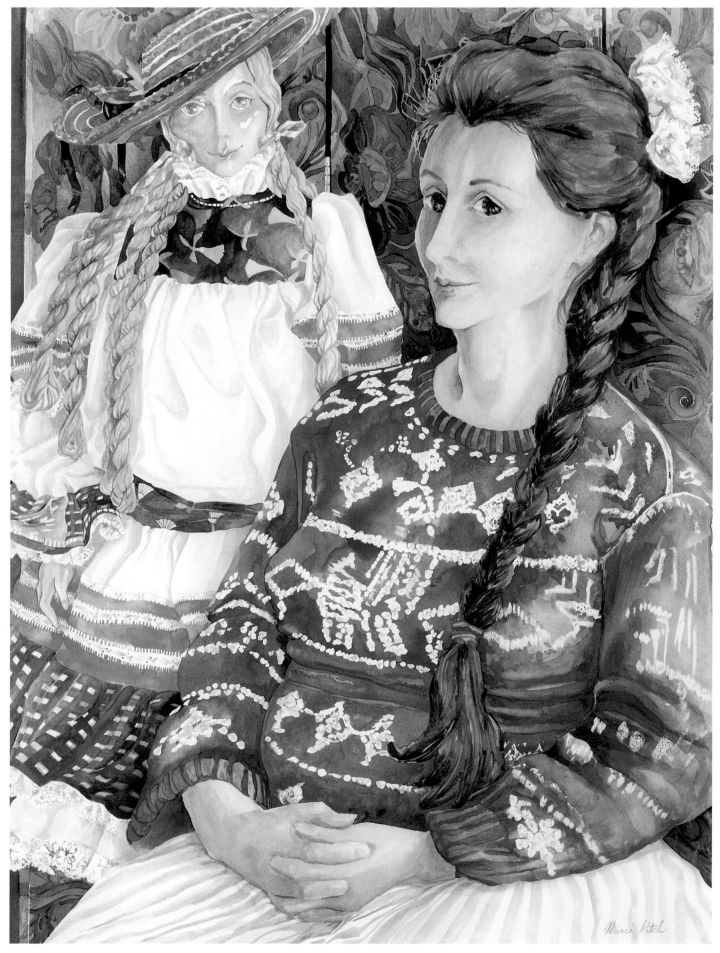

Marci Kitch

Kindred Spirits 22" x 30" Watercolor

Marci painted the model from life. The idea for the background came later when she was struck by the likeness between a doll she had purchased in Europe and her model. More important than the facial and hair similarities is the enigmatic, "Mona Lisa" like expression they share.

82 Editor's Note: Marci died shortly after exhibiting these paintings in the Farmington Artists Club Annual Show. Her friend, Edee Joppich, wrote the descriptions.

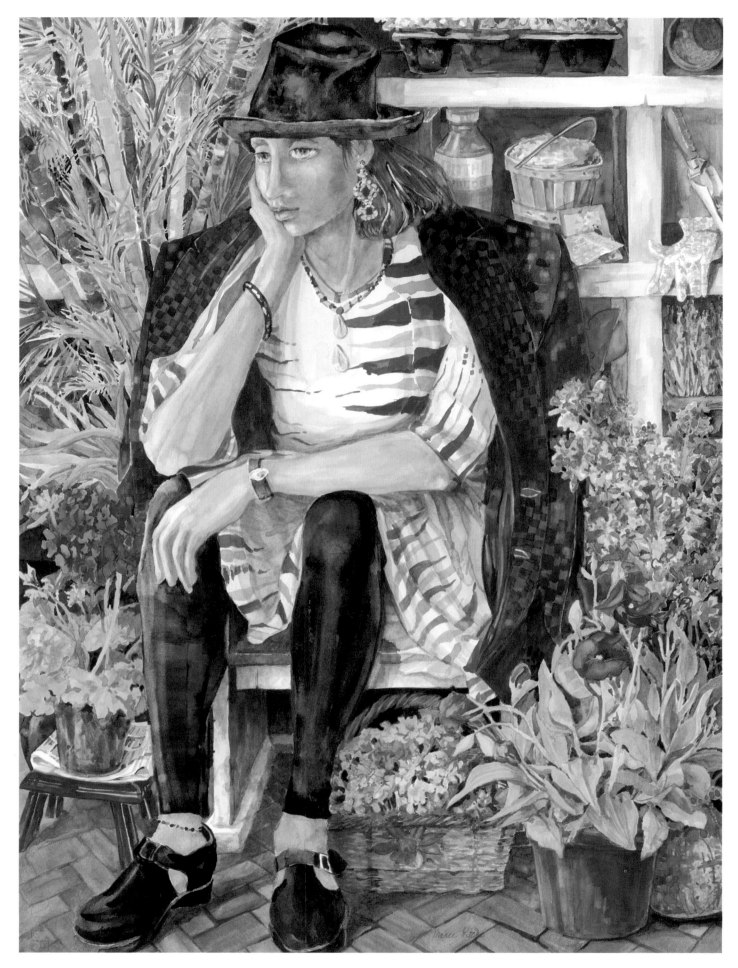

Marci Kitch

Garden Dreamer 22" x 30" Watercolor

The model is tired. We sense her resignation and in her eyes glimpse the sadness of her daydreams. Marci placed this weary heroine among her own glorious plants before the garden shelves, a contrast of gloom in a joyful and spring-like setting. This paradox results in an intriguing painting.

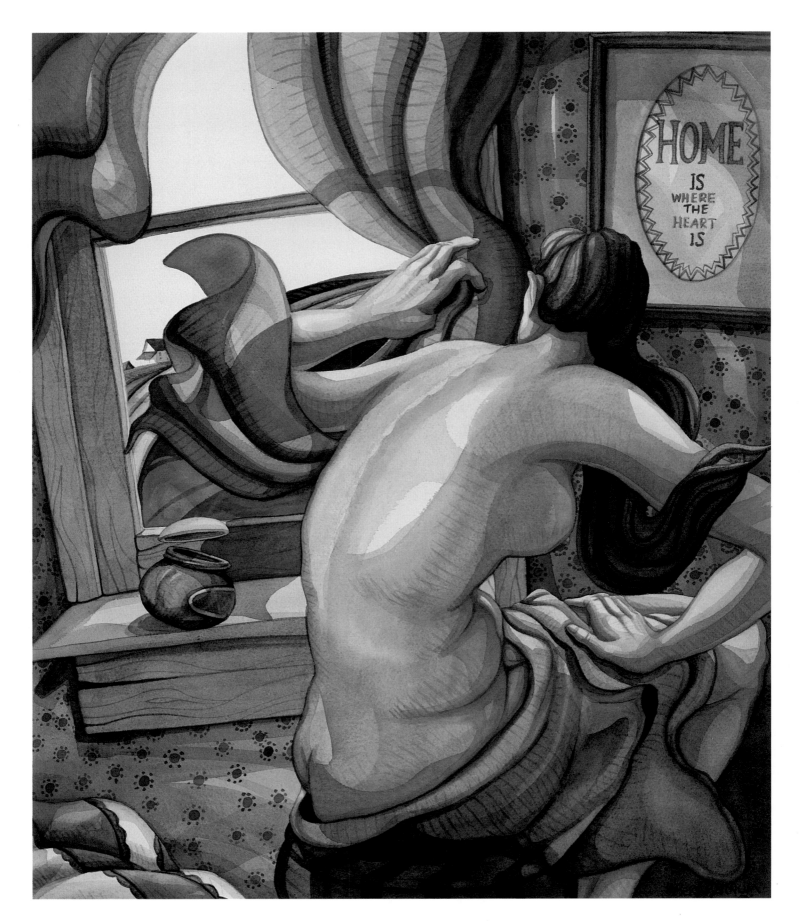

Robert L. Barnum, NWS *Home Is Where The Heart Is* 23" x 30" Watercolor

The majority of my art is literal, or "visual story telling". ***Home is where the Heart is*** was inspired by a situation I frequently witness as a college professor: The struggle young students face when confronting the reality they will soon move away from the comfort and security of their childhood home. My personal involvement with very human situations like this have been and will continue to be the catalyst for my work.

In the context of the vast landscape, the figure seems insignificant and yet he is the focal point of all the grandeur.

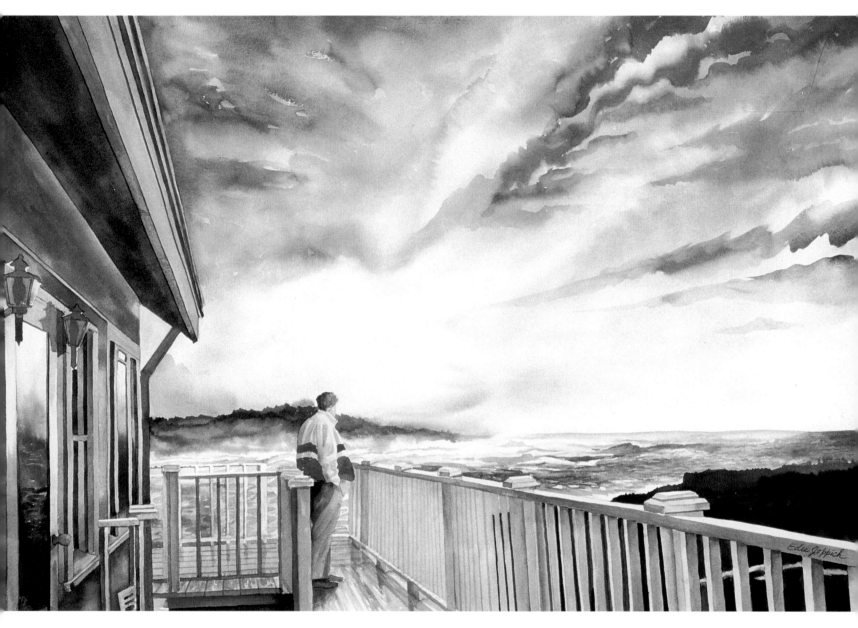

Edee Joppich *To Go Beyond* 26" x 40" Watercolor

To Go Beyond is a spiritual painting. It could be a poem accompanied by a Gregorian chant. In the context of the vast landscape, the figure seems insignificant and yet he is the focal point of all the grandeur.

After a drenching rain in Mendocino, California, my husband Ed was standing on a rain slicked deck, looking out at the monochromatic vista of sky and water. He was lost in thought. Observing him, I began the painting mentally and shot a roll of film to use for reference. Later in my studio, when I referred to the photographs the sky appeared as "washed out" as was my memory of it. I said a fervent prayer for help. And then I looked up from my work and was amazed to see, through my studio window, the perfect sky — which I painted in a matter of minutes.

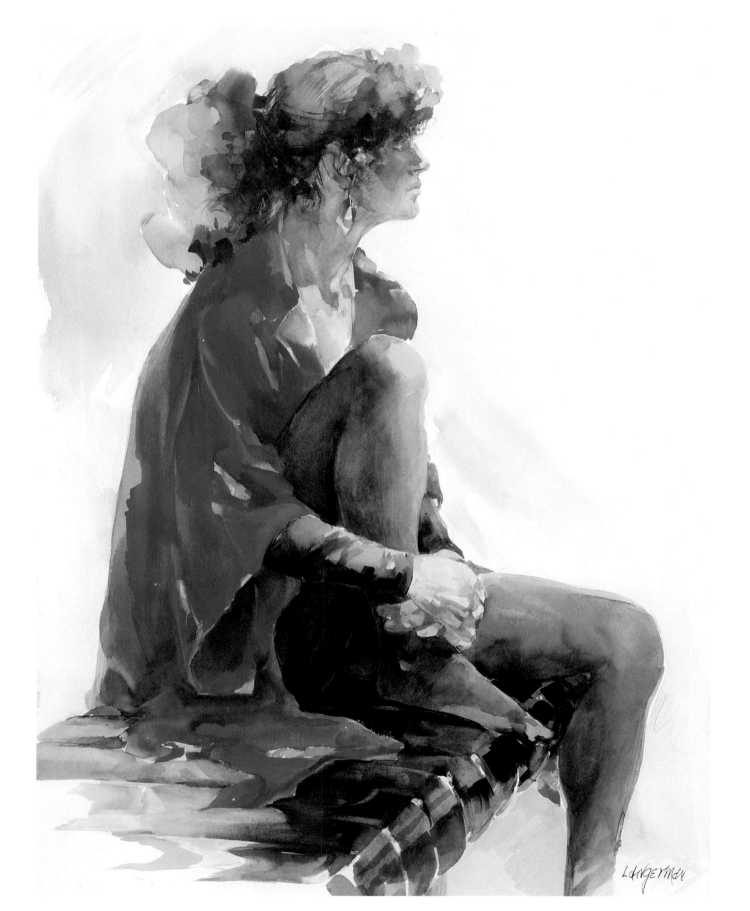

Lillian Langerman *Study in Red Silk* 22" x 30" Watercolor

The human figure always intrigues me. My model, Jean, had relaxed after a number of short poses. Then, as she resumed her posing, her body and costume became as one to my eye. She presented an inspiring combination of red and black as well as a wonderful opportunity to play with the lost and found shadows that blend into the richness of the colors. The *Study in Red Silk* almost painted itself.

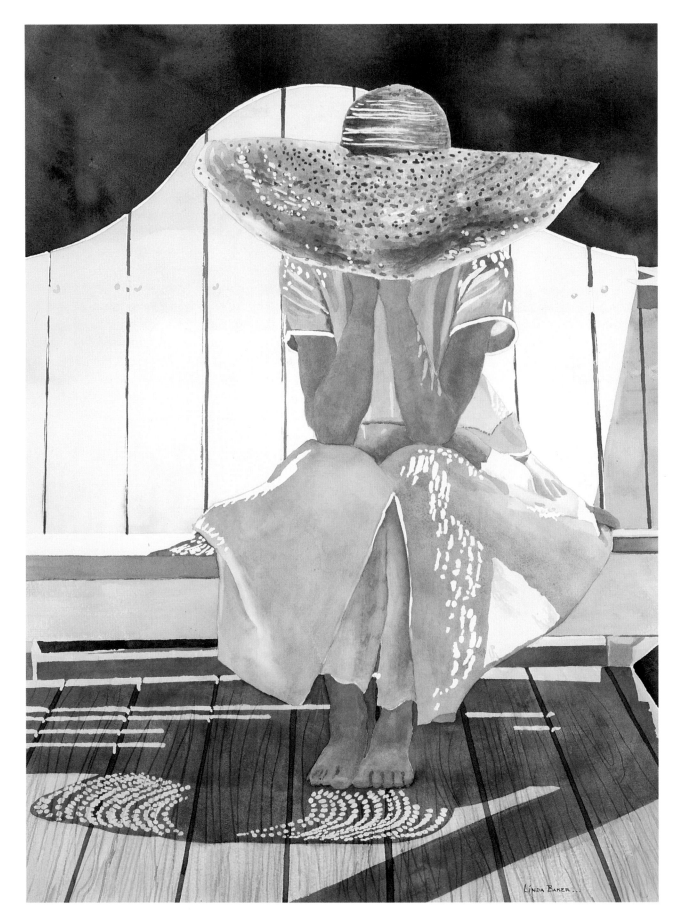

Linda Baker *Michelle Series: Contemplation* 22" x 30" Watercolor

Some of my best work comes from the familiar, a concept which applies in my "Michelle" paintings. My daughter Michelle is relaxing on our deck. Because her face is not visible, we don't know what she's feeling. Some people, depending on their interpretation, suggest she is sad, crying, thinking, meditating, peaceful, or composing herself. I enjoy dramatic lighting and composition with bold contrast. The straw hat offers exceptional secondary interest as opposed to the stark clean lines of the subject.

Children

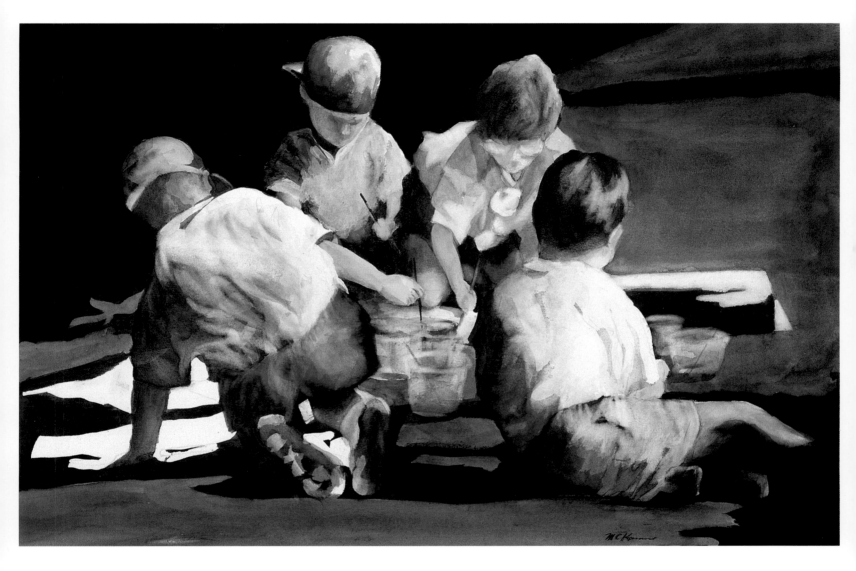

M.C. Kanouse *Painting Class* 26" x 34" Watercolor

 This painting was inspired by observing the energy and interest expressed by these children who were learning about color with simple objects — newspaper, cheap brushes and poster paint. The deep shadows and bright colors of a sunny summer day provide the contrast that bring the painting to life.

I'm attracted to people who are in the process of creating art...

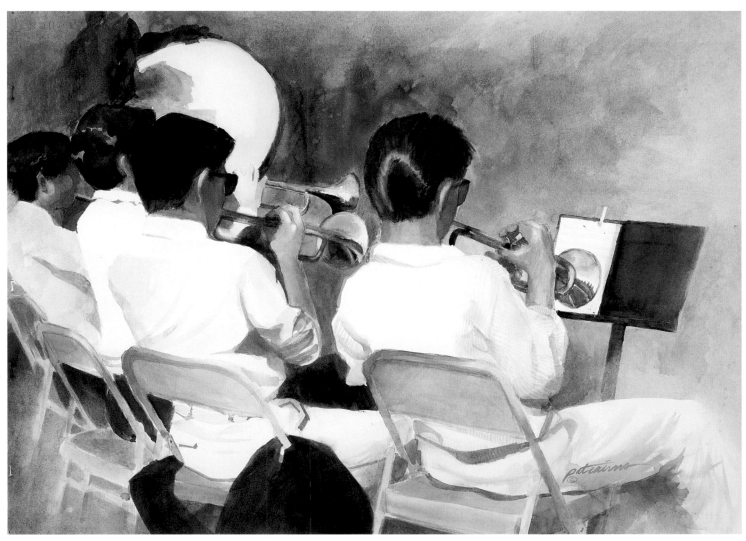

Pat Cairns *Jazz Alfresco* 22" x 30" Watercolor

Artists paint what moves and challenges them. Because I was a high school art teacher for many years, young people frequently challenged me. I'm attracted to people who are in the process of creating art, sidewalk artists, etc. This painting is one of a series involving young musicians. My inspiration was the student band, playing outdoors on a hot June Commencement Day. I tried to create a strong abstract diagonal design by focusing in on my subject, by simplifying the features, by limiting the color and by combining and repeating shapes.

My daughter, Kristin, is reading the Sunday morning paper...

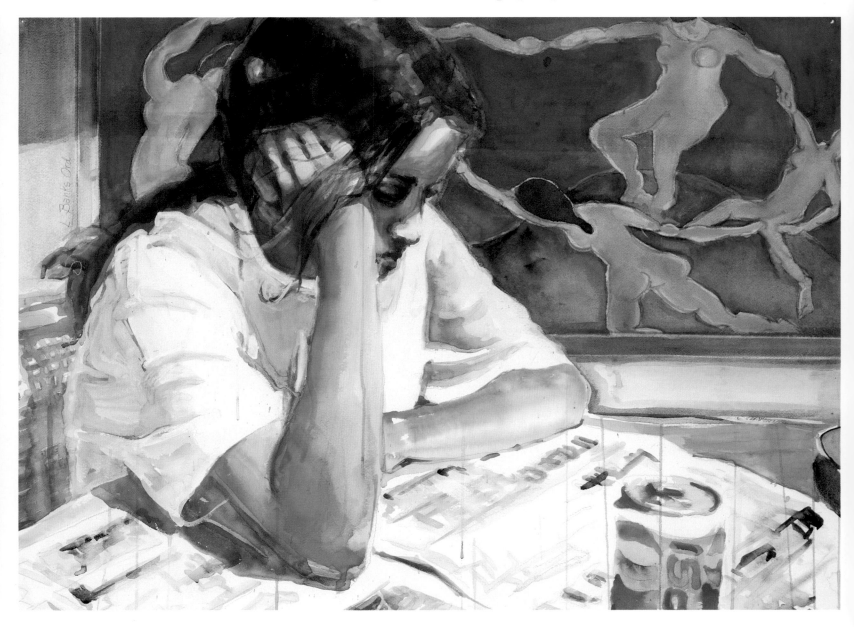

Linda Banks Ord *Young Woman Series #9* 22" x 30" Watercolor

My daughter, Kristin, is reading the Sunday morning paper at our kitchen table.

This painting is done primarily in warm earthy tones. Because I like to have drips and runs in my work, I paint standing at an easel and let the paint run about on its own. I have to react quickly, though, to control its wayward tendencies.

Composition is critical. If a painting doesn't work well as a whole, it doesn't work at all. I try to move each color throughout the entire painting in slightly varying ways and to make the entire surface function as an integrated whole. Originally this painting had some problems with composition which went beyond color. The wall area behind my daughter was simply a wall area with a wooden chair railing; it had been painted with value and color changes which helped to some extent. Still, the wall didn't carry its weight in the rest of the painting. I used my computer to play around with a photograph of the finished painting, changing the wall behind and experimenting with different compositional solutions. Eventually I moved a framed print from another part of the house onto the kitchen wall. This was the first time I had used my computer in connection with my art, but I find I really enjoy using it to deal with design issues. It allows me to deal with "painting" issues spontaneously when I stand at my easel.

Courtney is becoming a very fine artist in her own right and loves to paint animals.

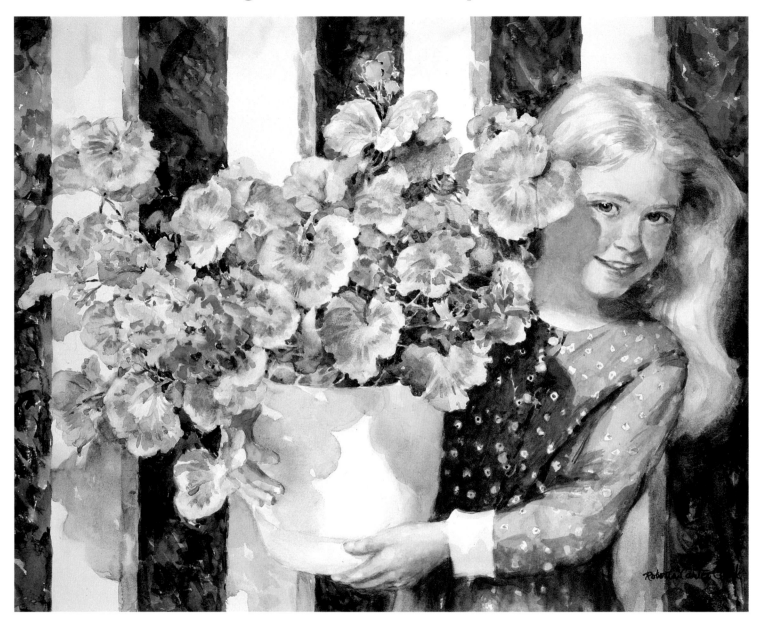

Roberta Carter Clark, AWS *Courtney with Geraniums* 22" x 30" Watercolor

We shot four rolls of film of Courtney, my neighbor's granddaughter. The more photos we took the more sparkly she became. Toward the end of our time together I handed her this huge geranium and said, "Can you hold this?" and she said, "Sure!" This watercolor is the result of her eager participation in our joint venture. Courtney is becoming a very fine artist in her own right and loves to paint animals.

I painted the entire figure and the plant first. When I was finished, I decided to paint something a little more unconventional in the background instead of just leaving the white paper or putting in a color tone. I hit upon the idea of the very dark and white stripes, and, oddly enough, it came out looking rather like a picket fence. This painting is entirely transparent watercolor on 300 lb d'Arches cold press paper. I drew the image lightly in pencil, then began with the flesh tones. I used yellow ochre, scarlet lake and a bit of cerulean blue in places where I want the flesh color to be cool. The cerulean must be added only to the flesh mixture *on the paper.* If you mix these three colors on your palette, the rest will be a dull gray. The mix won't work at all if you work with your paper flat. The paper must be on a slant or even nearly upright so that the colors will run together and mix on their own without your fussing with your brush. The most fun in executing this painting was the glowing reflected light on the white pot. This light is very exaggerated, but it was so beautiful I just didn't have the heart to tone it down!

Buildings

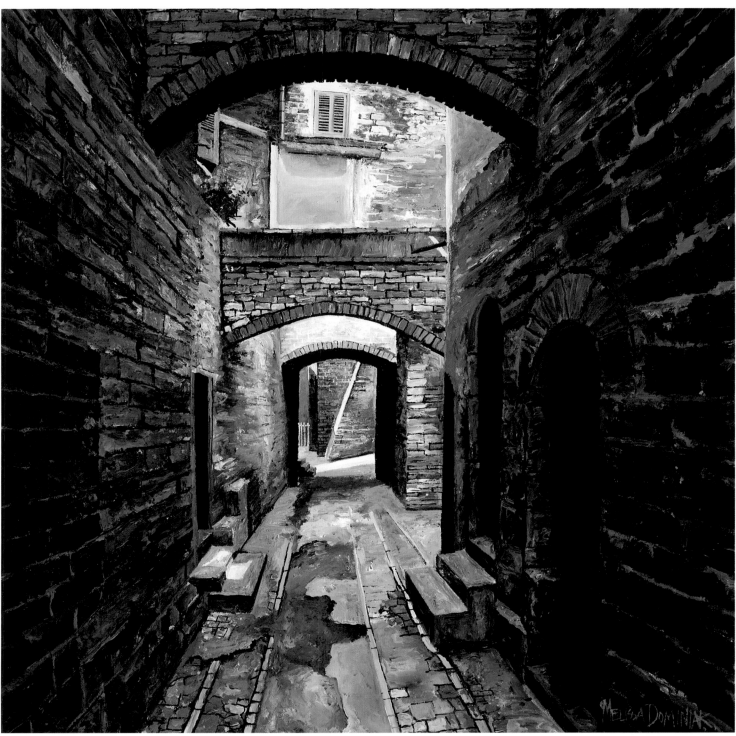

Melissa Dominiak *Spello Lane* 26" x 26" Acrylic

I feel my painting is a success if I can draw viewers into it and inspire them to use their imaginations. I choose European settings for my work. The history inherent in the buildings, in combination with the brickwork, archways, doorways, alleyways and staircases, help to evoke a mood of mystery. Through depth and perspective, I layer different elements to create a sense of place — not necessarily a definition of place. For example, I might frame the canvas with an arched gateway as the first layer. The second layer may be a walled alleyway framed by darkened doorways continuing on to a hint of a corner to be turned or a staircase to be ascended.

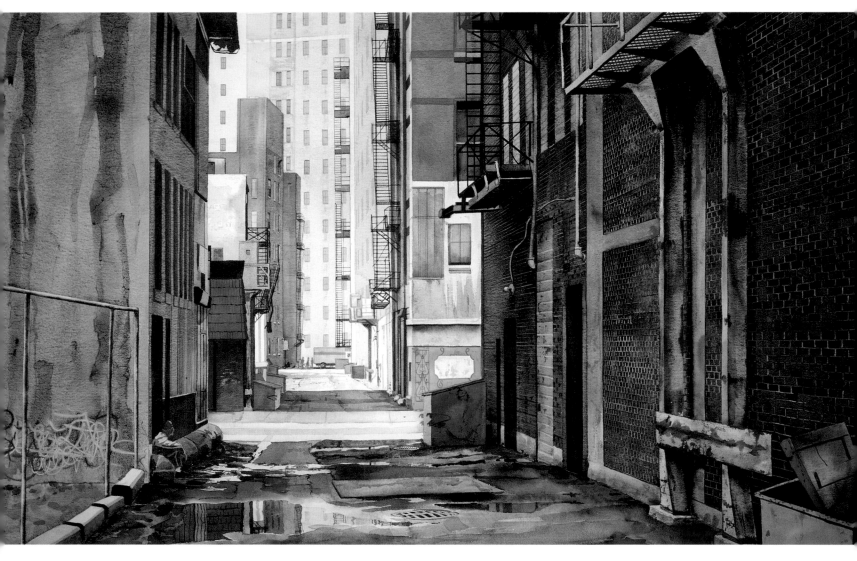

Scott Hartley

Detroit Alley 40" x 60" Watercolor

My goal is to convey a sense of mystery and drama in my paintings. I do this through the leverage of fine composition. When I prowl a city with my camera, I am drawn to those areas that are most colorful and complex. I've learned the most interesting abstract designs and the most intriguing lighting will be found behind buildings in the alleys and the delivery areas. Later in my studio, I manipulate the large interlocking light and dark shapes until they are in harmony within the rectangle and are also expressively in harmony. Then I put in the details to enhance the whole painting.

In *Detroit Alley*, I sought a balance of large and small shapes, a strong feeling of depth as well as a profusion of textures and colors. The mood for me was subtle and complex, a mood of detachment and decay, of time suspended while at the same time a celebration of light and geometric complexity.

My goal is ... to capture the bedazzling light!

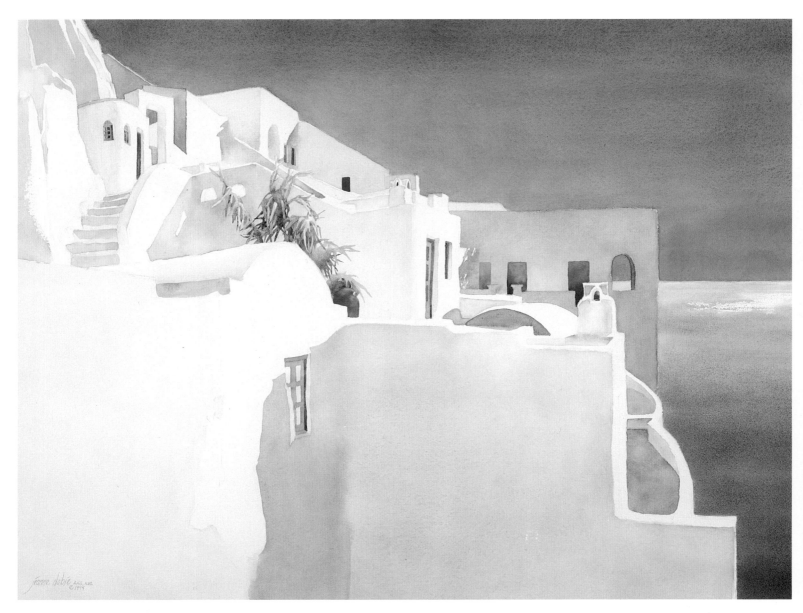

Jeanne Dobie, AWS, NWS *Aegean Shadows* 20" x 30" Watercolor

Aegean Shadows reflects the luminous, glowing color, especially in shadows, that characterizes a Dobie painting. Since the eye sees more color than a camera can capture, I paint directly on location in order to include the subtle color nuances and the atmospheric effects that are usually lost when an artist paints from a photograph. I use a "pure pigment palette" for mixing my "personalized color combinations" which are described further in my book: *Making Color Sing*.

To capture the luminous colors of light permeating the village, I chose a glazing method — layers of pigments applied transparently — which like glass, allows the light to pass through the pigments to the paper and reflect back to the viewer. My goal was not merely to paint a skillful painting of the hilltop village, but to capture the bedazzling light!

I felt this enchanting image was a symbolic expression that typified the warm and proud, yet humble, people of Mykonos.

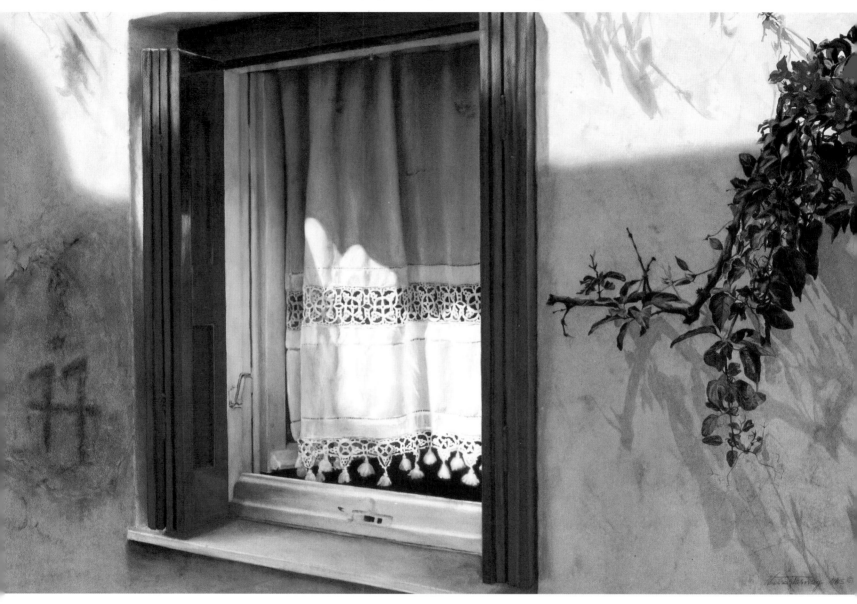

Nedra Tornay, NWS *#77 Mykonos* 25" x 36" Watercolor

I was intrigued by the Mykonos, Greece house numbers, hand painted directly on the walls of some of the island homes. I thought they were charming and uniquely informal. Then I came upon this inviting window! There was no screen and the shutter-like framed panels of glass were pulled back in an open position, leaving only the linen curtain, with loosely woven lace fringe at the bottom, to provide privacy. I felt this enchanting image was a symbolic expression that typified the warm and proud, yet humble, people of Mykonos.

I took several photographs of the window. When I returned from my trip, I used the photos as a reference to paint *#77 Mykonos* in the comfort of my studio. I added the vine in order to utilize its shadow as an element of design, keeping the direction of light consistent with the rest of the image. I placed the two numbers in the lower left for a more balanced composition.

Using transparent watercolor, I layered washes, allowing the paper to dry between the washes as well as to control value and intensity of color and achieve the luminosity of this painting.

95

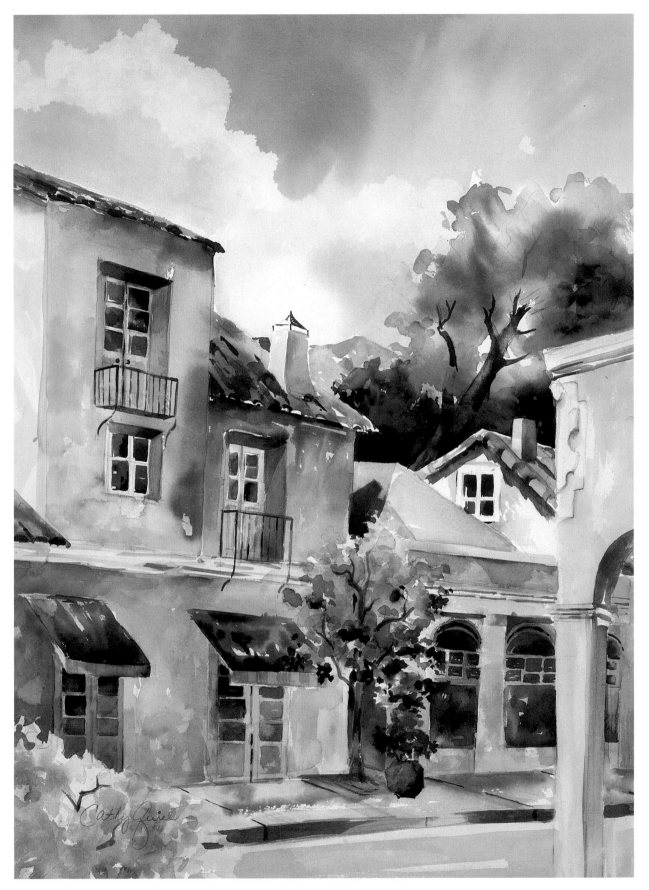

Cathy Quiel *Chromatic Bounce* 22" x 30" Watercolor

Chromatic Bounce was painted in Santa Barbara, California, a marvelously sunny city of white Spanish style architecture. Reflected colors and polychromatic shadows abound. I had a wonderful time applying an array of powerful staining colors on the shadowed side of the buildings. I prefer a staining palette for its vibrant colors and because I cannot create muddy colors with it. A staining palette's advantages outweigh its unforgiving lifting aspects.

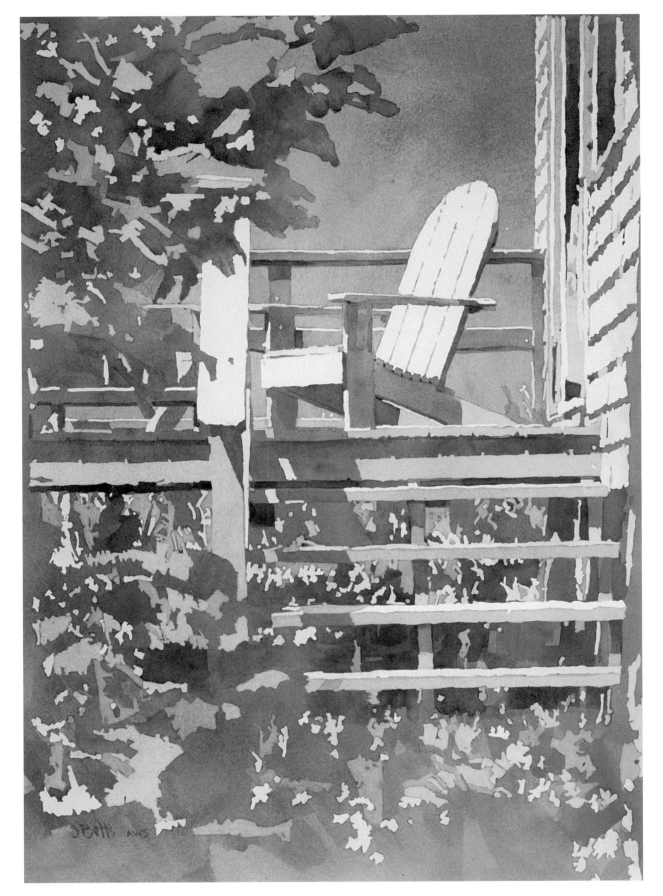

Judi Betts, AWS *High Chair* 22" x 30" Watercolor

On a quiet summer afternoon in Maine, I noted the contrast of light and shade on a cottage porch. The configuration made by the angularity of the architectural shapes was intriguing. Although I could *feel* the heat of the sun, it seemed to me that the scene suggested the idea for a painting with a cool dominance. The foliage had an abundance of green, but I chose to make it a tonal painting — without concern for local color. The upper right quadrant has the most contrast in light and mid-tone values and the largest warm dark and cool dark areas. The cool upper left foliage shapes serve as arrows to point to the chair.

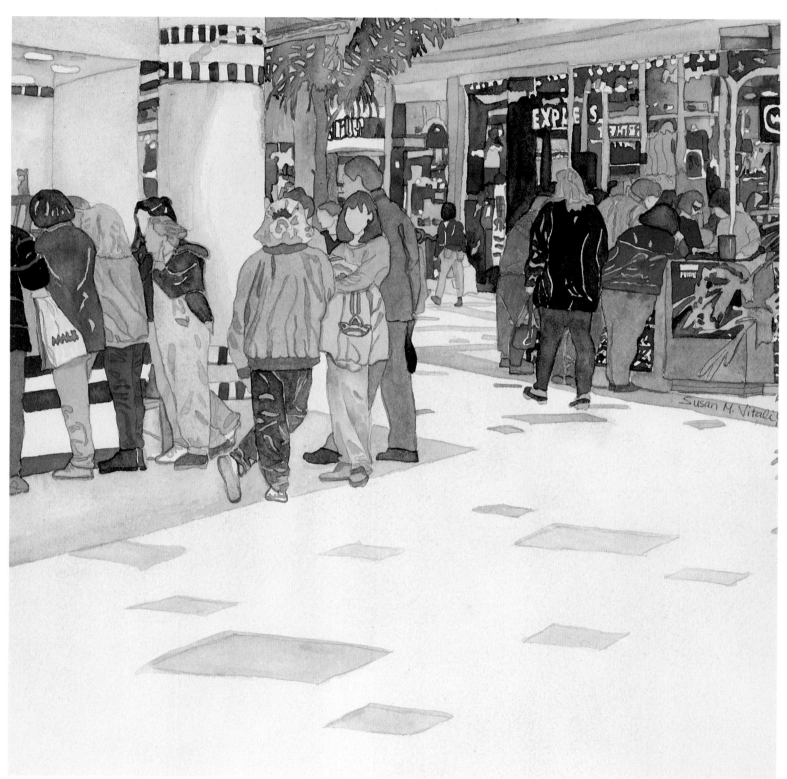

Susan Vitali *At The Watch Kiosk* **10" x 10" Watercolor**

 I'm pursuing a new direction by trying to capture and express energy in my art. People radiate energy. Their relationships with one another and with their own environments cause the energy to change. The things people do and the environment they create for themselves describes who they are.

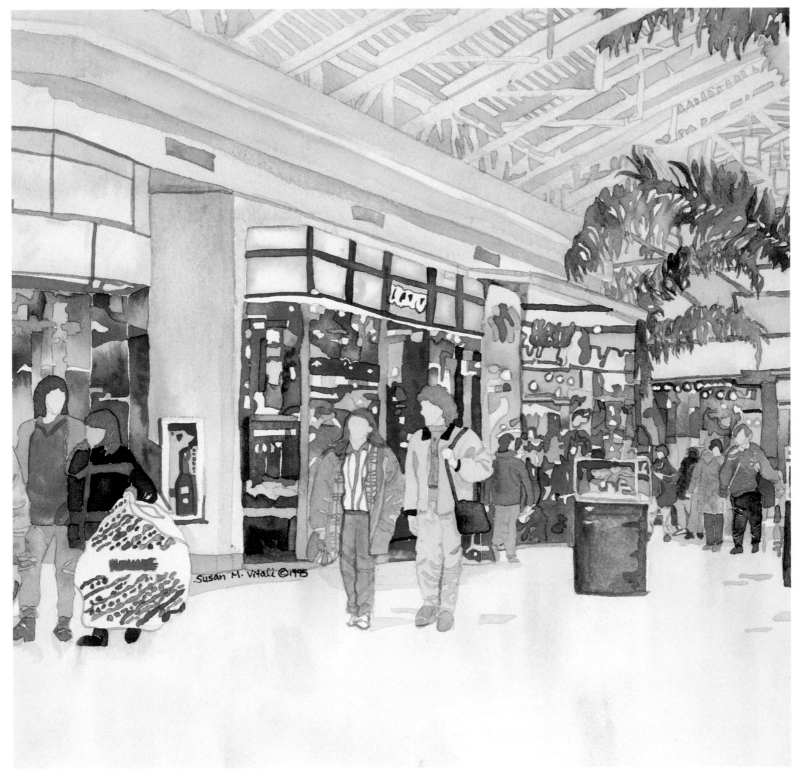

Susan Vitali *Window Shopping* 10" x 10" Watercolor

In my shopping series, I tried to capture scenes showing how people relate to one another in their environment. The importance of a common area like a community shopping mall where people can meet, converse, and share ideas and feelings vs. the way people sometimes isolate themselves by walking with there eyes straight ahead and by not engaging in conversation with other shoppers is an interesting juxtaposition.

Ann Adams Robertson Massie, AWS, NWS

River Festival on Jefferson Street 21" x 29" Watercolor

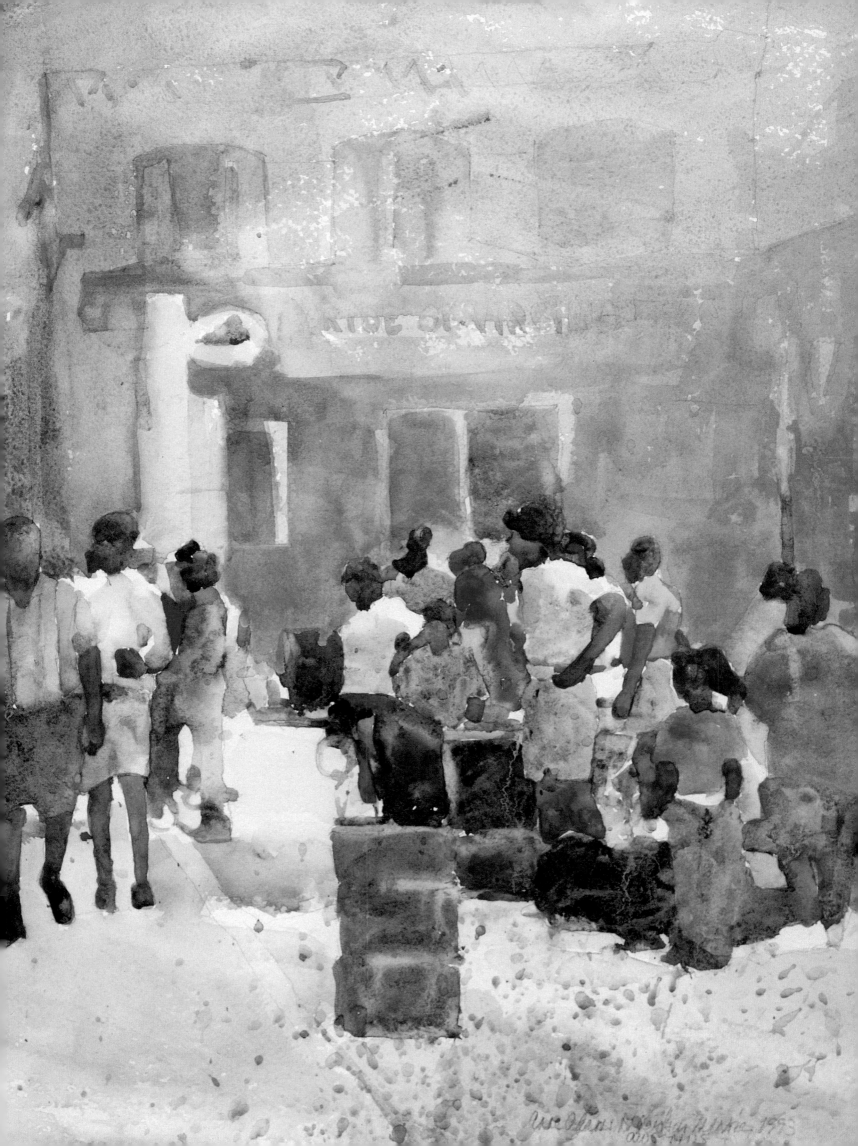

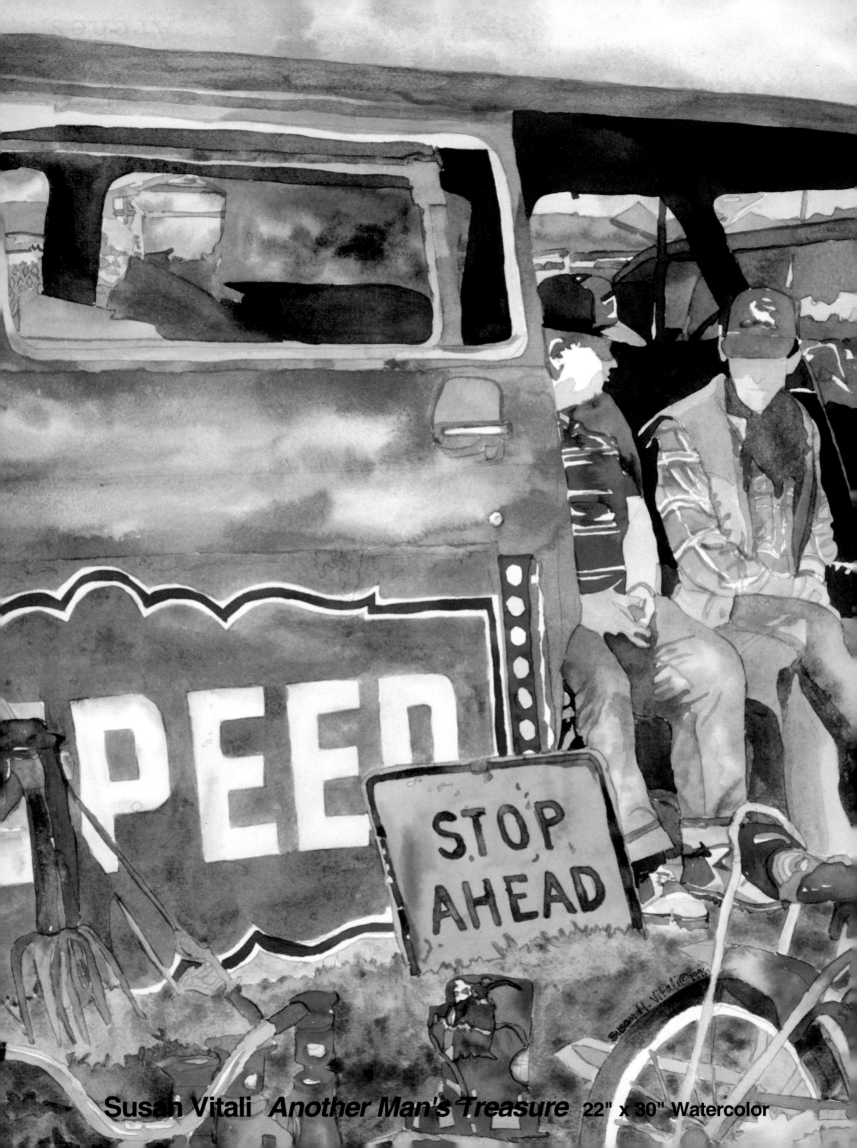

Susan Vitali *Another Man's Treasure* 22" x 30" Watercolor

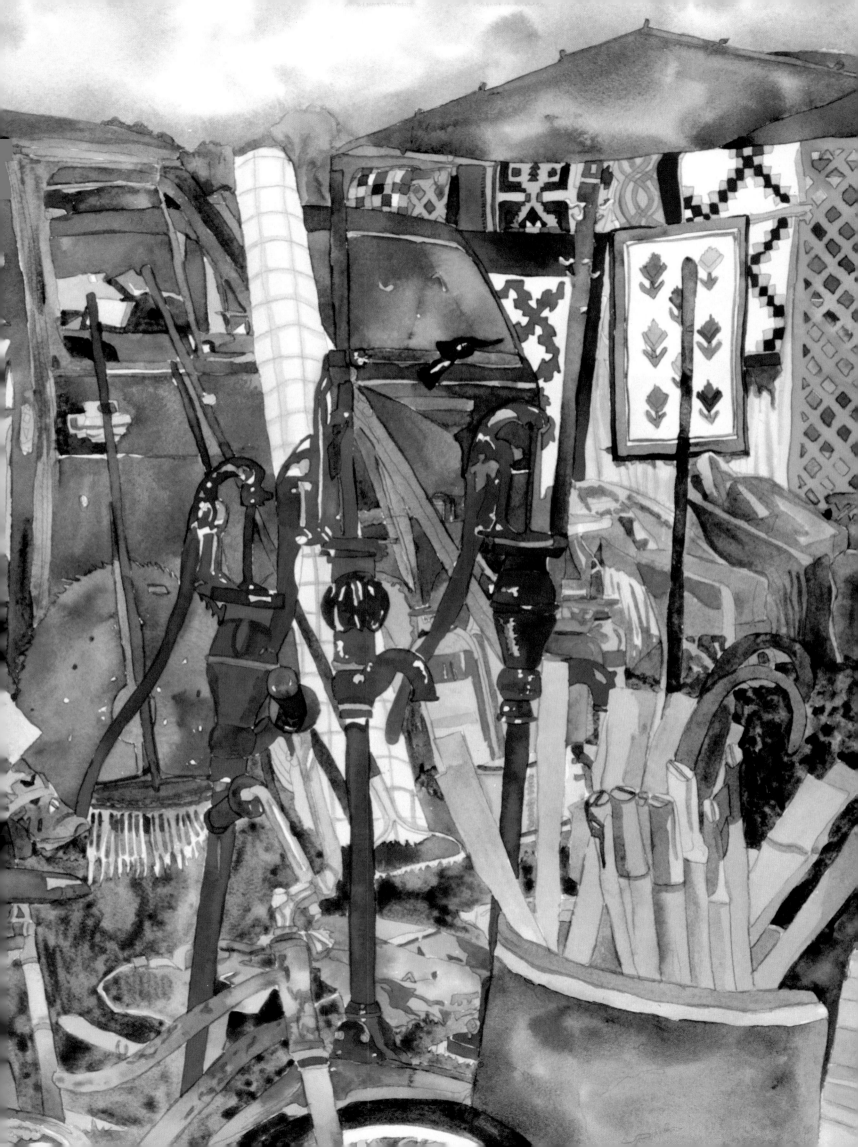

Chicago is a visually powerful city — beautiful and gutsy at the same time.

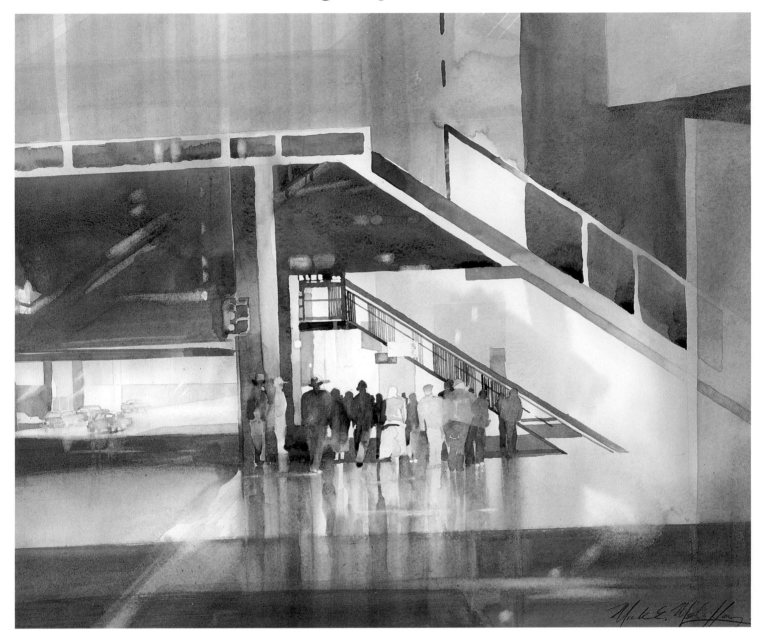

Mark E. Mehaffey, AWS, NWS, MWS *Rainy Day Chicago* 22" x 30" Watercolor

Chicago is a visually powerful city. Buildings, elevated trains, traffic and crowds combine as a feast of form for any artist. Chicago is a city of grit — beautiful and gutsy at the same time. I tried to express these ideas in *Rainy Day Chicago*. A light rain brings out the grittiness of the city. Add to that the wonderful reflections available after a rainfall and you have the makings of a painting. For this work I chose Daniel Smith's indigo, cobalt violet deep, and lunar black watercolor paint. The last two are especially sedimentary colors and give the textural quality I was looking for. The use of this limited palette resulted in a certain color harmony which magnifies the "rainy day" effect. In addition, the few bright spots of pure pigment used, such as the coats of paint within the crowd, and the lights on the traffic signal, are made visually all the more intense because they are surrounded by neutrals. I gessoed the 300 lb d'Arches cold press watercolor paper with one coat of acrylic gesso. One coat of gesso allows the removal (with rag or brush) of pigment almost back to the white of the original surface. I prepared the surface in this manner to allow me to lift the various reflections produced by wet surfaces. In addition, this surface allows for corrections at any time during the painting process. The actual painting process was fairly straight forward. I laid in the largest, lightest washes first, then proceeded to the smaller darker shapes and saved the darkest darks and the brightest high lights for last.

How can you fully describe Paris!
It has a feeling all its own — so much to absorb.

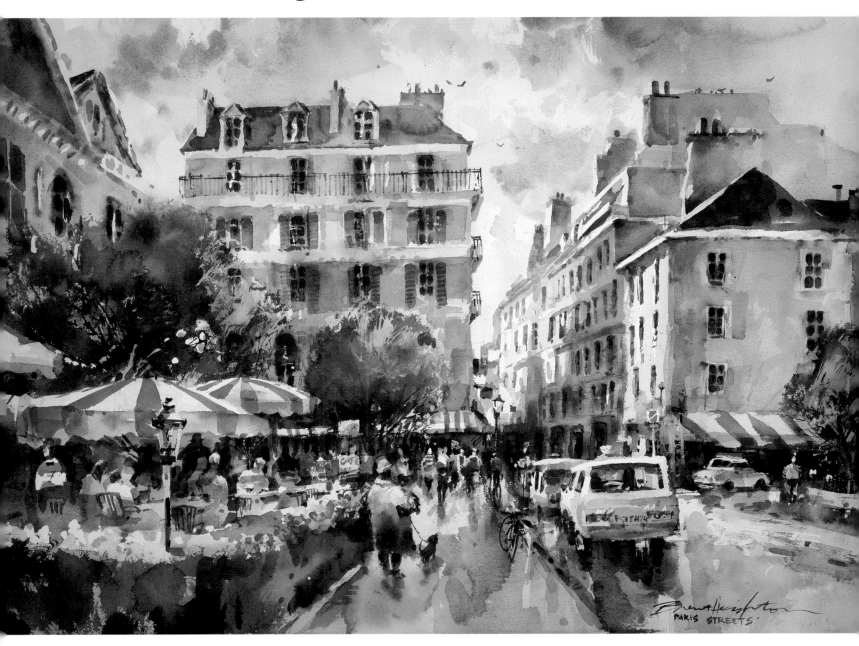

Brent Heighton, FCA *Paris Streets* 21" X 29" Watercolor

How can you fully describe Paris! It has a feeling all its own — so much to absorb. The hustle and bustle, the aroma and taste of fresh baked bread, the architecture are so stimulating. The recipe for success in Paris: take a cup of café au lait — sip slowly — rest your feet and enjoy the sun at any outdoor cafe. Coffee's expensive, but the experience is priceless.

Different Messages

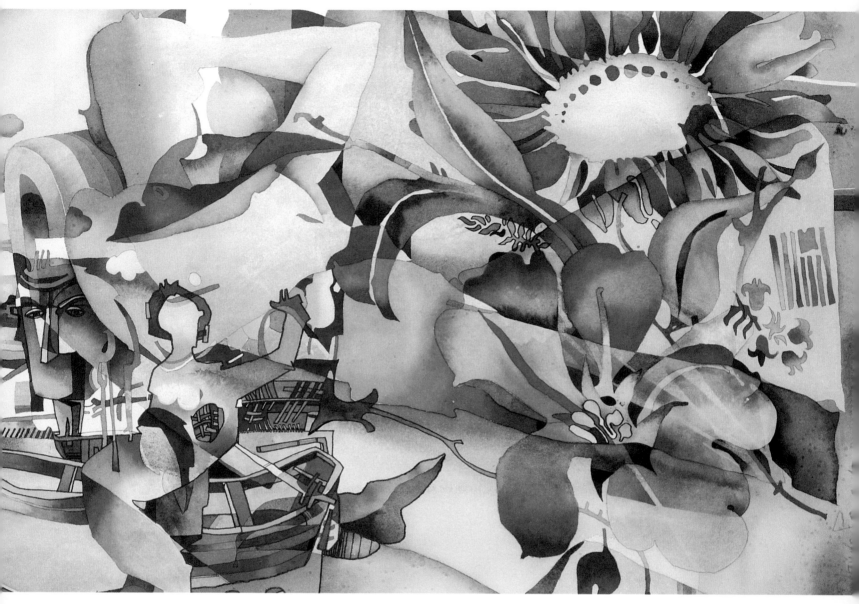

Claude Ponsot, NWS *Summer Long Island 21" x 30" Watercolor*

I am influenced by the freedom expressed in French Romanesque Art. I worked with Fernand Leger, who has influenced my work. As a result, the figure is the focal motif for the structure of my compositions. The flowers mean: "keep the planet green as long as possible". I treat the subject matter with a soft touch of Surrealism and I try to achieve a serenity in my work while also creating a form that will interest the viewer.

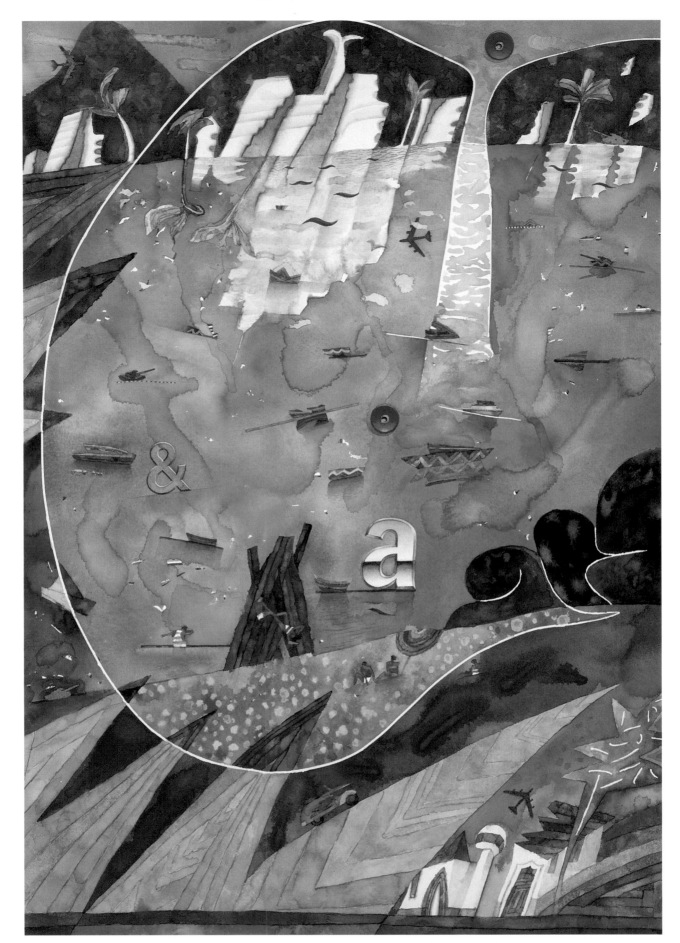

Miles G. Batt, Sr., AWS, NWS *"a" Bay (Acapulco)* **21" x 29" Watercolor**

It was February. The Mexican sun was warm and wonderful. What to paint? Déjà vu! I've been confronted with this problem before. My perceptions and emotions suggested a solution. I chose as my subject a deep blue-green lagoon. The water reflected an infinitely pure sky and a tangerine yellow sun. The tinted palm trees subtly aglow on the blazing golden sand; the sparkling white buildings of two cultures, Spanish and Indian, and the ever present water traffic combined to create a playful attitude that disarms the viewer immediately. Boats, airplanes, suns and letter shapes freely invented from these saved white shapes presented a configuration of symbols which convey a pictorial idea.

107

and paints in my backpack, i traversed a portion of india's vastness. traveling about such a densely populated and visually rich land requires a certain nimbleness, but my movement was slow. it occurred to me that if i'd just stand in one place, eventually all of india just might pass by. so, having the good fortune of meeting a family of temple dancers and being invited to stay with them in their village, i did just that. this stay preceded carnival in goa, which brings an interesting array of acrobats, freaks, and street performers to the area. the numerous circuses passing through the city, as well as the elaborate customs and makeup of the dancers gave me wonderful photographic opportunities. being surrounded by such theater influenced, and continues to influence the imagery in my work. I painted *shot* a year after seeing my first outdoor festival. Feeling an affinity with these people of the indian circus, these bands of street performers, I drew parallels with my own life. these gypsies and misfits band together and become a troupe, as do the artists who tour these shows. *shot* is a self portrait of sorts, in which I project a sense of being scrutinized by a vast number of people.

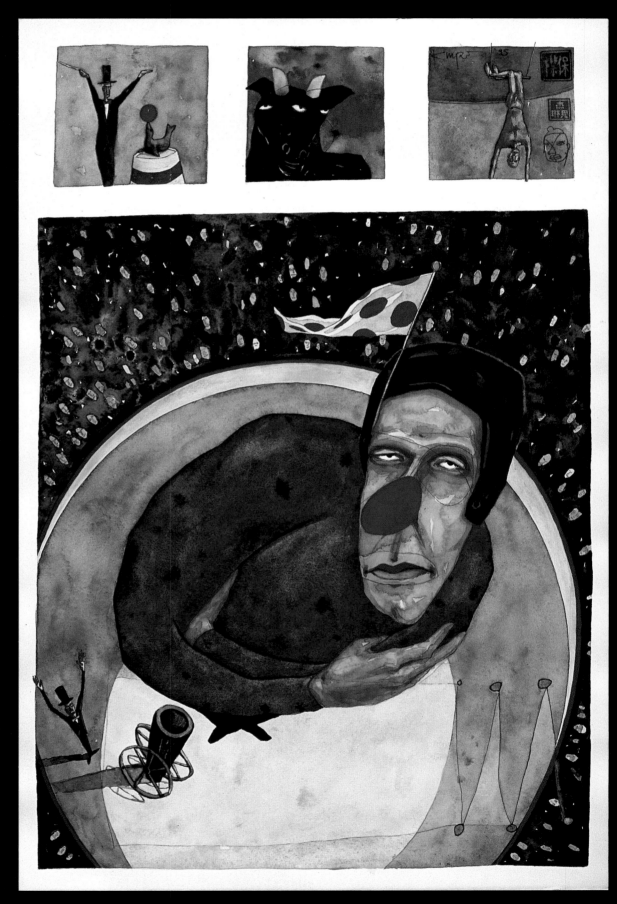

kemper *shot* *24" x 33" watercolor*

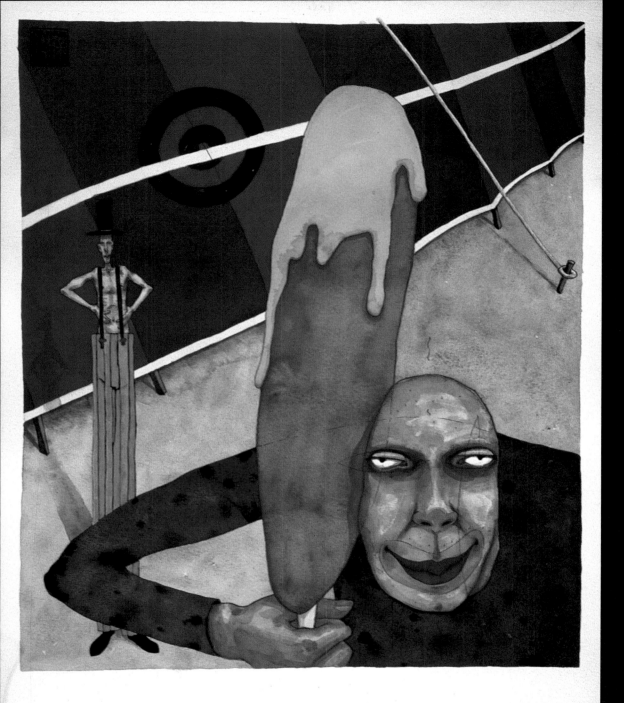

corn dog was completed at my mother's studio in oklahoma city for an exhibition with an erotic theme. originally, the performer holding the food was to be siamese twins.

both of these paintings combined transparent watercolor and gouache on 140 lb 100% rag paper. i use a variety of different papers for varied effects. corn dog is on cold press. shot is on hot press.

kemper corn dog 24" x 33" watercolor

In the cool stillness of a blue velvet night, choices and decisions are to be made.

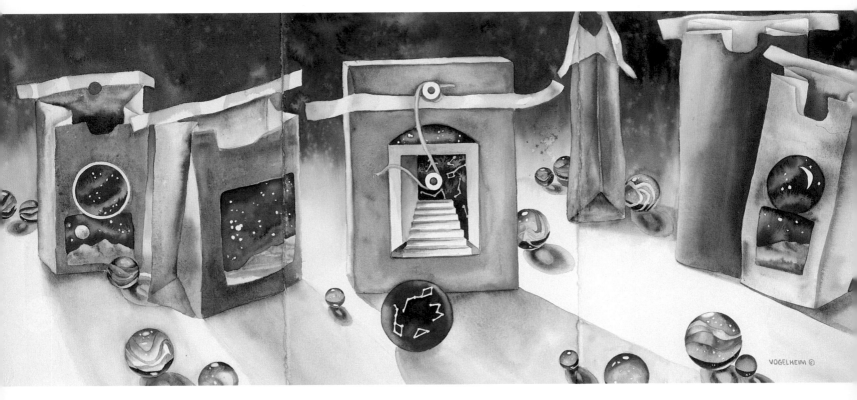

Donna Vogelheim, NWS *This Way In* 15" x 34" Watercolor

In the cool stillness of a blue velvet night, choices and decisions are to be made. Are the animated marbles going to remain in the indefinite space on the outside of the bag-like structures, or will they pass through the definite openings into different domains?

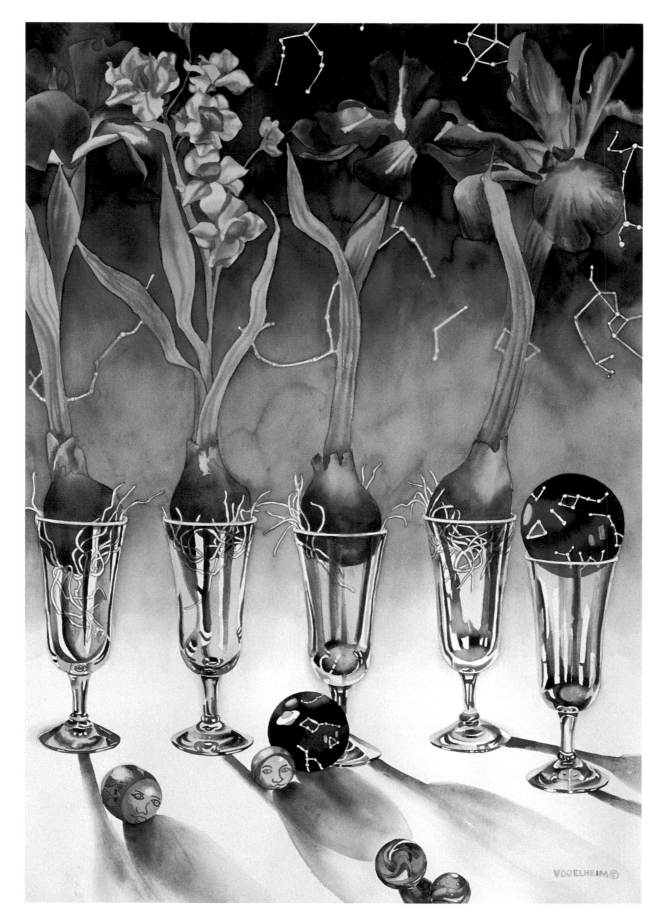

Donna M. Vogelheim, NWS *Nocturnal Blooms* 22" x 30" Watercolor

After several paintings using the same images, I felt my work was becoming stale. I began to include "play" with the objects and set them in unusual circumstances. In this painting, the flowers are stationary sentinels while the marbles take on an anima. They travel in the stillness of night through boundless space, observing their surroundings.

Ellen Wilt *Watershed* 46" x 49" Watercolor

The body of water symbolizes the human condition,
allowing me to illustrate;
limits
potential
stability
peril
access
isolation
The next series, "bridges".

I perched the bird on the chair for fun and surprise.

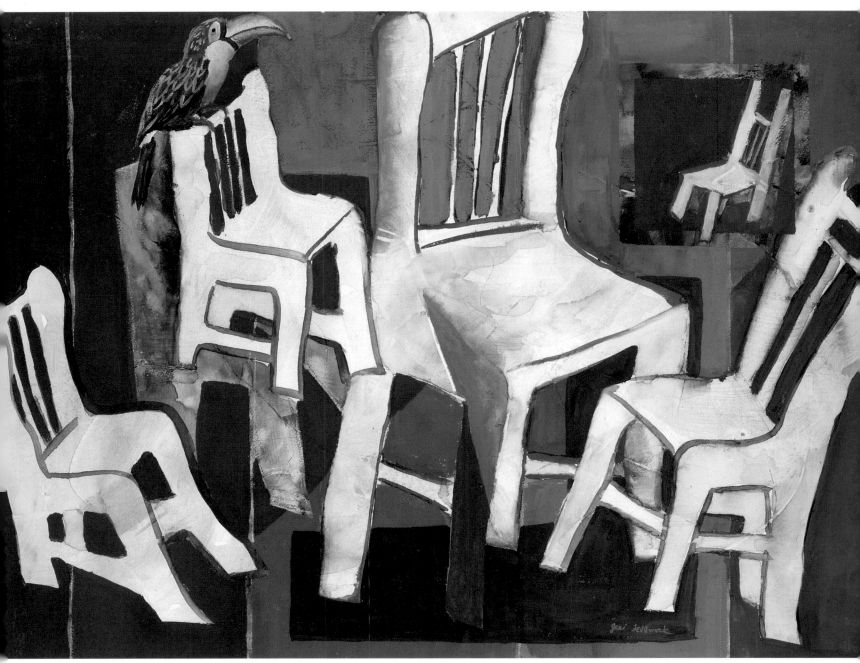

Jeri Fellwock *Multiple Chairs* 22" x 30" Watercolor

I was inspired to paint **Multiple Chairs** one day as I passed by my miniature doll house. I noticed the little chairs and thought it would be interesting to take one chair as a subject and do multiple images, exaggerating their shapes.

The surface is gesso primed watercolor paper. I began by abstracting the shapes of the chairs. Four chairs were painted in first with the fifth chair added within a square to help balance the composition. The original washes were allowed to show through parts of the painting, creating a design element. I broke up the background with different shapes using dark opaque washes. These shapes reinforce the design effect in the painting. The dark values of the background against the white chairs add a dramatic effect. I perched the bird on the chair for fun and surprise.

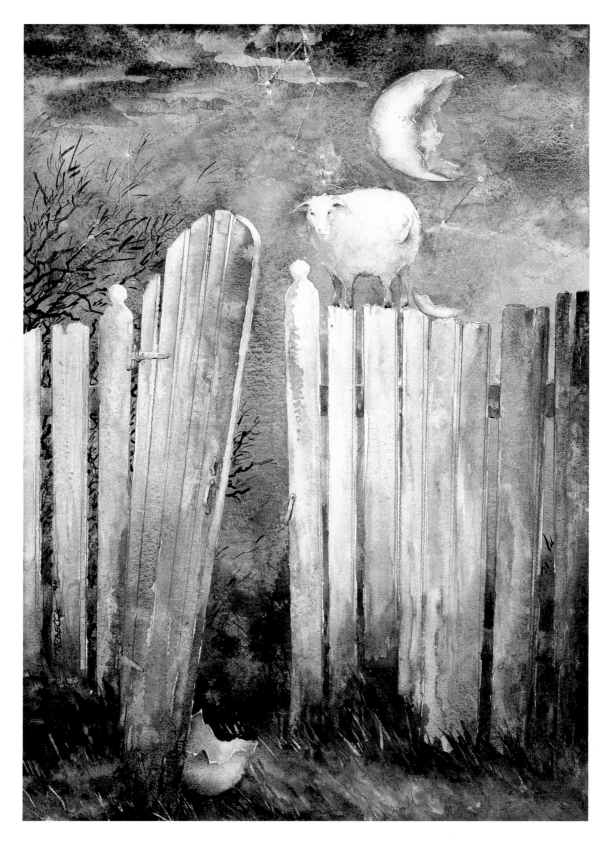

Rebecca Houck *The Autumn of my Spring Chicken Years* 15" x 22" **Watercolor**

 The Autumn of my Spring Chicken Years was an introspective response to a personal milestone—my 50th birthday. Its symbolism is special to me and yet hopefully clear enough that the viewer can relate in his own way. The sheep, which has become a personal motif in several recent works, finally has hatched from the moon-egg and is uncertain which direction to take. The barrier or obstacle, in this case the fence, has become an important element also. The spring chicken could pass through the open gate, but she chooses to do it the hard way and go over the top. She looks back wistfully, but I think what she would really like to do is fly away into that uncharted constellation in the sky.

 This watercolor was done on gesso-covered watercolor paper, a technique with its own unique difficulties and delights.

Donne F. Bitner *Field of Dreams* 30" x 40" Acrylic

 I was a child of the suburbs so that visits to my uncle's farm were always the highlight of the summer. There was a dairy farm down the road. I never tired of watching the cows.

 When I started experimenting with acrylics, I did a series with cows as the subject matter. In *Field of Dreams*, I sprinkled salt into gesso and used a multiple image format to give a new twist to my favorite image.

Bill James, AWS, NWS *The Throwaway* 22" x 28" Gouache

This is the first painting I ever did where the title came first. I was doing a series of watercolor and pastel paintings concerning homeless people. I had just completed a very successful pastel, so the subject was still on my mind. That night, I heard someone on a television show use the term "Throwaway" when referring to a child who was literally kicked out of his parents' house. At the time I had heard, as we all have, the term "runaway" but never "throwaway" referring to a person. This intrigued me and I decided to paint someone who would illustrate the title.

Because emotion plays a large part in my work, I decided to depict sadness by the expression on the boy's face. I also used a somber color palette and had a sleeping bag over his head and body to bring out the feeling of loneliness even more. The painting proved to be quite successful. The first national show I entered the painting in was the Georgia Watercolor Society Annual, where it won "Best in Show".

*It's been fascinating to hear what
people think he is waiting for.*

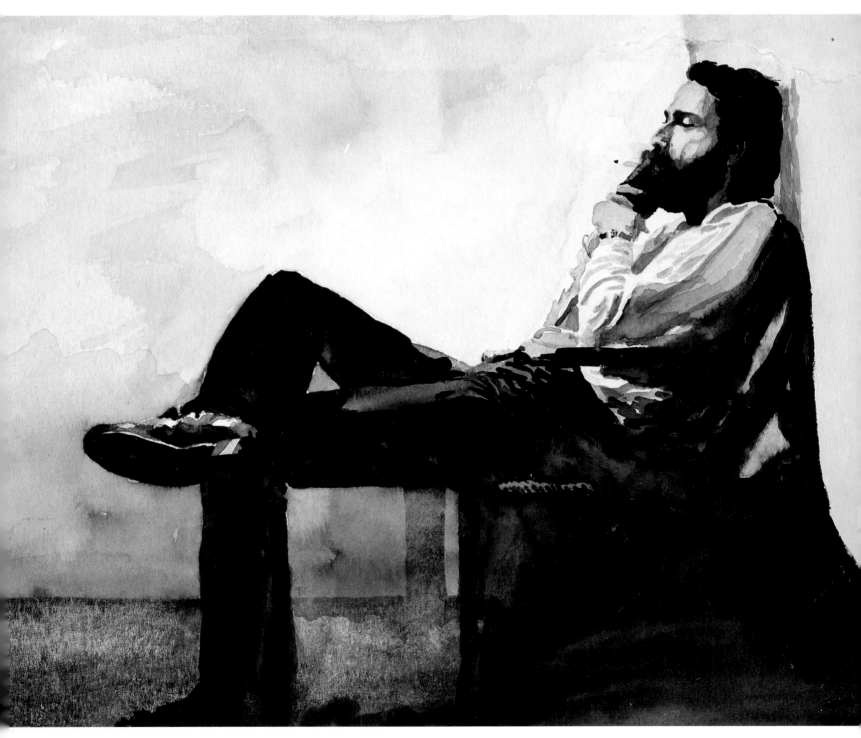

Penny Hill *Waiting* 10" x 12" Watercolor

Waiting is a portrait of a dear friend who is a painter, author and musician. He is waiting for inspiration — his muse — the final sound check. It's been fascinating to hear what people think he is waiting for.

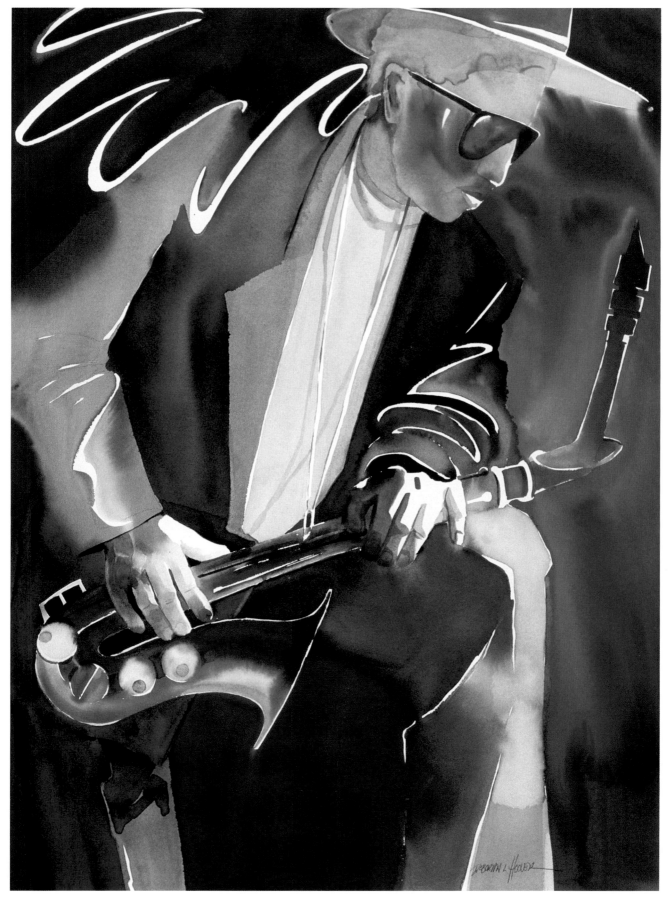

Deborah L. Hoover *Blues Break* 22" x 30" Watercolor

Paul Klee's directive: "make the invisible visible" challenged me to develop a unique concept for every painting. Concept determines choice of colors, lines and shapes. The concept of **Blues Break** was very simple — a jazz musician taking a break, contemplating his music. Having established the concept, I then drew a graphite value study and tried to design an exciting value pattern with interesting shapes to enhance the concept. A rhythmical white line became my musician's future music. I used the value study like a map, following it closely.

While soaking my d'Arches 140 lb cold press paper, I chose colors that appeared jazzy to me. I dried the surface of my paper and, using moist paint, ran large areas of wash together. Seventy-five percent of the painting was produced in one session.

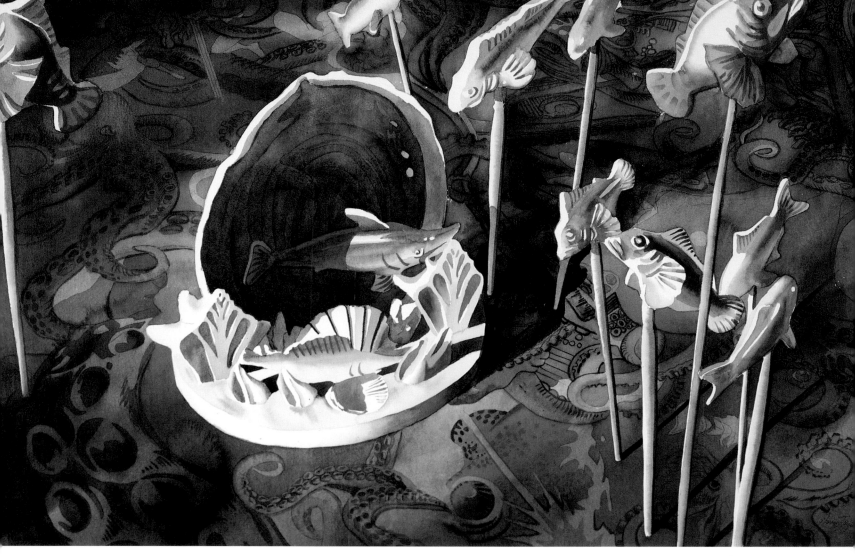

Warren Taylor, AWS, NWS *Estuary* 24" x 32" Watercolor

The ability of objects to set the mind and imagination in motion is important to me when I select subject matter. As children, we see toys in vivid but imaginary settings — and as adults we continue this obsession with: curios (a word derived from curious), mementos (objects that mark a point or event in time), antiques (souvenirs from the past), collections (groupings of things) and objects in general — all of which we study, arrange and interpret in imagined settings.

Estuary features a cluster of shells — based in plaster — which become a stage center with fish (actually salt shakers) fastened on sticks and stationed around the composition. These three-dimensional elements are placed on top of a two-dimensional scenario depicting menacing octopus and squid forms. Thus a two-dimensional network and a three dimensional grouping exist in varying states of order and disorder altogether on a flat surface with a vibrating undercurrent of what takes place in the fictitious, mythical world.

I think of an estuary as a place where warm waters nourish an abundance of life. In order to create a feeling of warmth, I favored pink colors because I so often avoid this hue. Actually the color may be better termed: rose, salmon, ochre or magenta. In the end the viewer takes the information I've served up here and forms his opinion.

Portraits

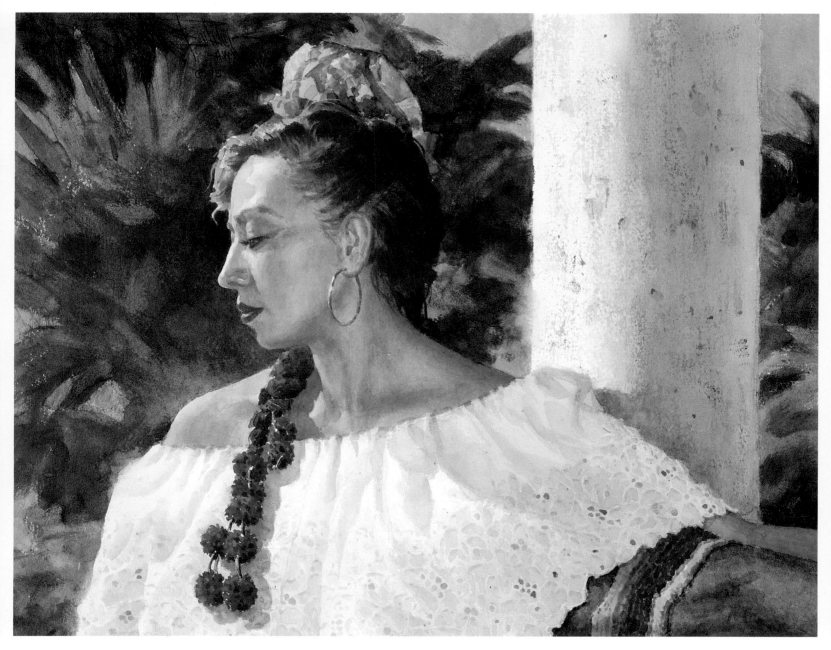

Joseph Bohler, AWS *Corina* 17" x 21" Watercolor

While teaching a workshop last spring on a private estate in Acapulco, I met Corina.

To take a break from landscape painting, I wanted to include several days of figure study, so I asked Corina to model for us. I posed her on the balcony with the Mexican sun softly gracing her face. She was a natural model, and several watercolor sketches eventually resulted in this painting of a beautiful woman!

I took care in applying the flesh tones. The background greens were painted with a moist sponge, so that the edges in the background would be soft and not detract from the figure. This is a transparent watercolor. No opaque white was used. The lace on the white blouse was suggested with a negative-positive application of light grays and white paper. Corina, thank you!!

120

When I begin to feel bored or stale, I seek to revitalize my work. I may draw with my left hand or change my medium.

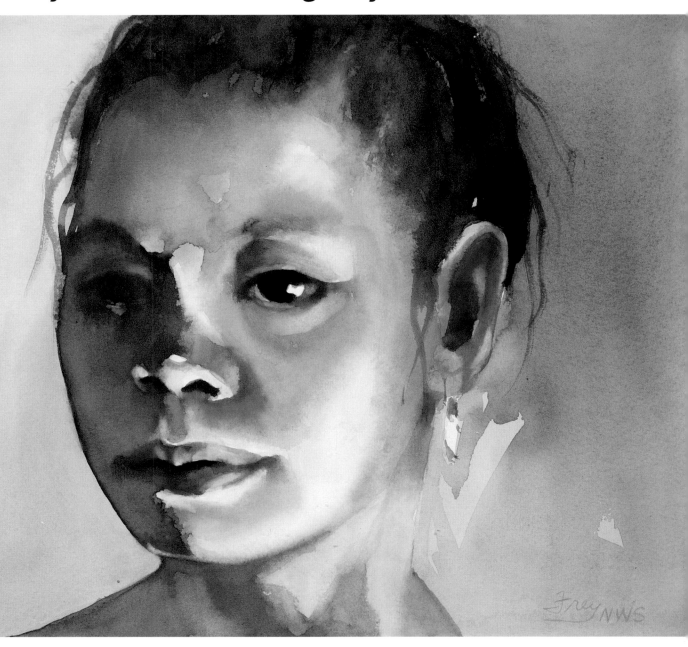

Karen Frey, NWS *Nona* 10" x 14" Watercolor

I am a studio painter. I chase light and imagery with my camera and often work from photos. I therefore find it very important to work from life on a regular basis. I need to be the one to translate volume onto a two dimensional surface.

I have been involved with a drawing group for over twenty years. When I begin to feel bored or stale, I seek to revitalize my work. I may draw with my left hand or change my medium. Last year I took up portrait studies. ***Nona*** is the result of one of these drawing sessions. I am particularly pleased when I capture the character of the model.

I wanted to tell the story of the legacy.
A mother teaching her daughter and she in turn sharing with her daughters.

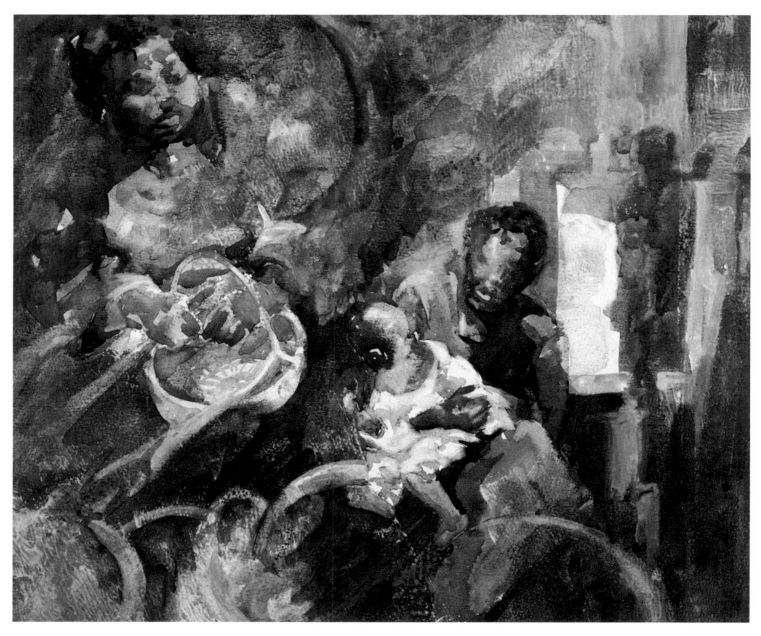

Lena Massara *Her Legacy* 18" x 24" Watercolor

This art work evolved from a story I was told by a basket weaver in Charleston, where my husband and I visited several years ago. There is a huge market place called the "Straw Market" which at one time was used as a slave market. Today, it is a center where artisans display and sell their work.

There are many Gulah natives, weaving "sweet-water" baskets. I asked one lady if I could take her picture. She agreed on condition that I purchase one of her baskets. In the course of our conversation, she told me that each family has its own basket pattern, handed down from one generation to the next. The idea of this tradition impressed me.

My first painting in this series was a pastel of the basket weaver which seemed inadequate. Each subsequent study became more finely tuned. I wanted to tell the story of a legacy. A mother teaching her daughter and she in turn sharing with her daughters.

For interest, the figure in the left background represents a daughter resistant to the tradition. The series has been painted in water color, pastel, acrylic, and oil pastel. The piece shown here is painted in water color and gouache.

I wanted to show workers on a hazy, foggy day.

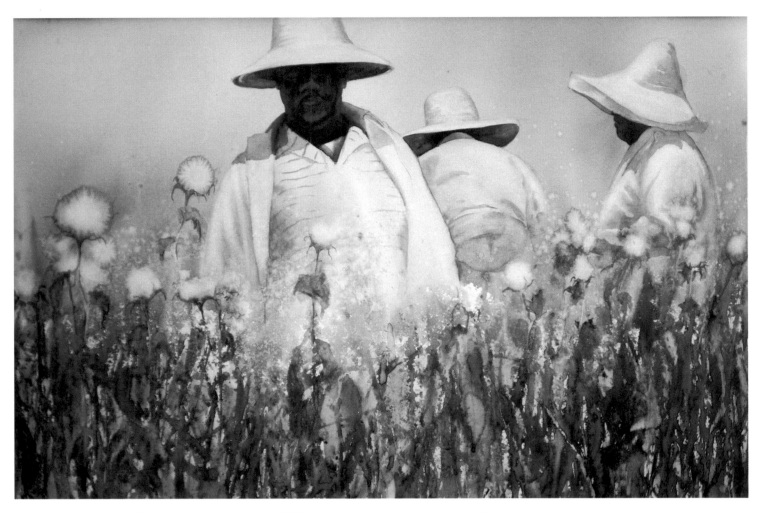

James L. Koevenig, NWS *Prewashed Cotton I* 20" x 30" Watercolor

My interest in agriculture began early and I have done many paintings of agricultural products and workers in transparent watercolor. In this painting, I wanted to show workers on a hazy, foggy day. This is a high key painting, mainly mid-value with large white shapes and small spots of dark. The figures of the workers were penciled in on Crescent illustration board and then covered with white mask. An effort was made to connect the shapes and make them different and interesting. The mid-value was accomplished by a single pouring using Nita Engle's basic palette and technique of wetting the board with a water spray, pouring on Winsor Newton yellow, then red, and finally cobalt blue. I then tilted the board back and forth until the desired effect was achieved. The cotton bolls in the background were created by dropping water onto the nearly dry paint, causing back runs and then by blotting. After removing the mask from the dry painting, the figures and foreground were painted directly with the color triad plus a small amount of Aureolin yellow, Antwerp blue, and Holbein's rose madder. The board was tilted upwards at about 60 degrees. Some paint spattering, spritzing with water, and blotting with Kleenex created random texture in the foreground.

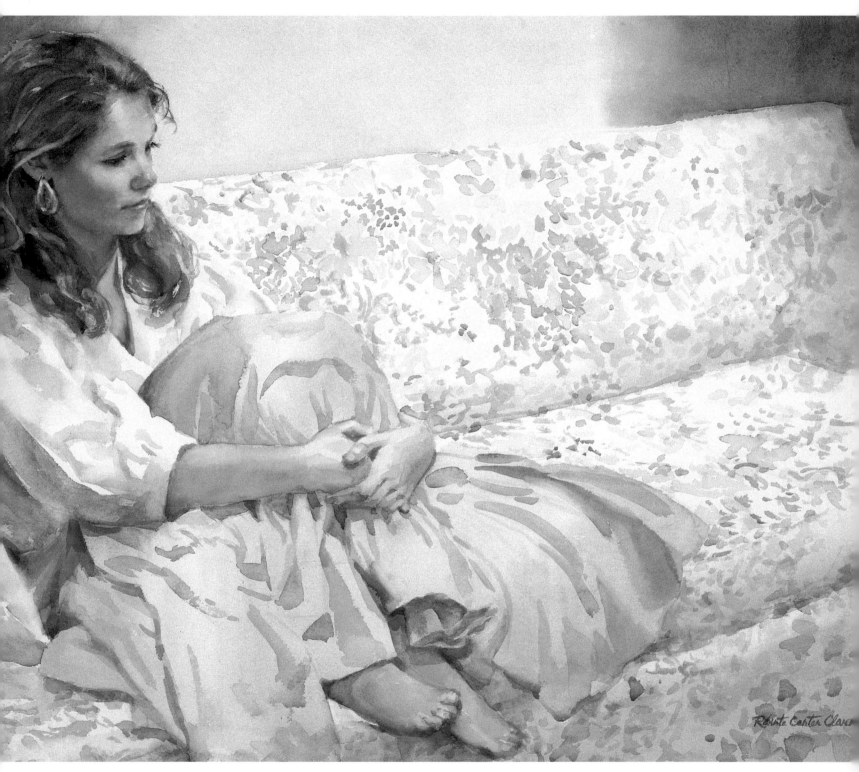

Roberta Carter Clark, AWS *Ann Alone* 22" x 30" Watercolor

I was commissioned to paint Ann, along with her two sisters, in a large family oil portrait. I went to their home to do this work and I was painting them from life. Of course, whenever you work from life, the people who are posing have to take rest breaks periodically, and every time Ann was resting she just fell into a natural and highly "paintable" pose. I don't know what there was about her. Perhaps it was her natural grace. I took some photos of her when she was not posing because I had some ideas in mind for other paintings. *Ann Alone* evolved from one of these photographs. I thought the drama of this very unbalanced composition would make a challenging picture idea; it's no fun if you don't take some risks. In fact, Ann's mother was sitting at the other end of the sofa and, as you can see, I just left her out.

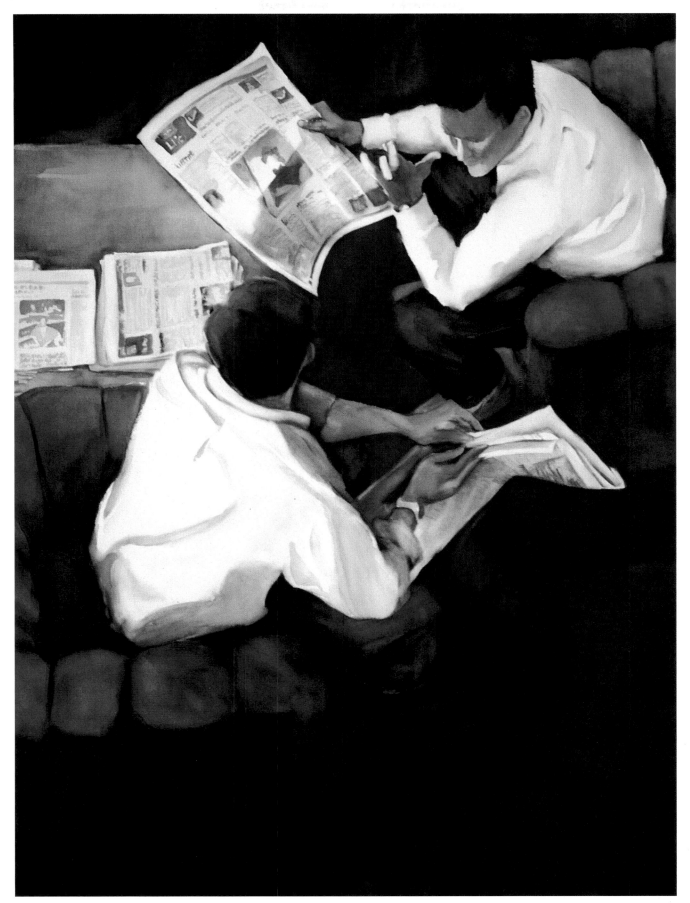

Donna Zagotta *The Morning News* 22" x 30" Watercolor

While teaching a workshop at the University of Michigan School of Art, I came across this scene in the student lounge. The large window and staircase in the room provided strong lighting and a dramatic viewpoint — luckily I was carrying my camera!

Although the subject and its colors are the most obvious elements to the viewer, a realistic painting must work on the abstract level as well. Beautiful colors and realistic detailing can never overcome a weak or nonexistent design. In this painting, my creative concept was to emphasize the animated gestures of the two young men engaged in lively conversation. After deciding what I wanted to say, I concentrated totally on design. Because design is so important to my work, I spend time working out a structure of shapes and values that best enhances my creative concept. In this painting, the design structure consists of large white shapes surrounded by darks. I tried out various colors and values until I arrived at the final pattern of the interlocking white shapes meandering across the surface.

Patterns

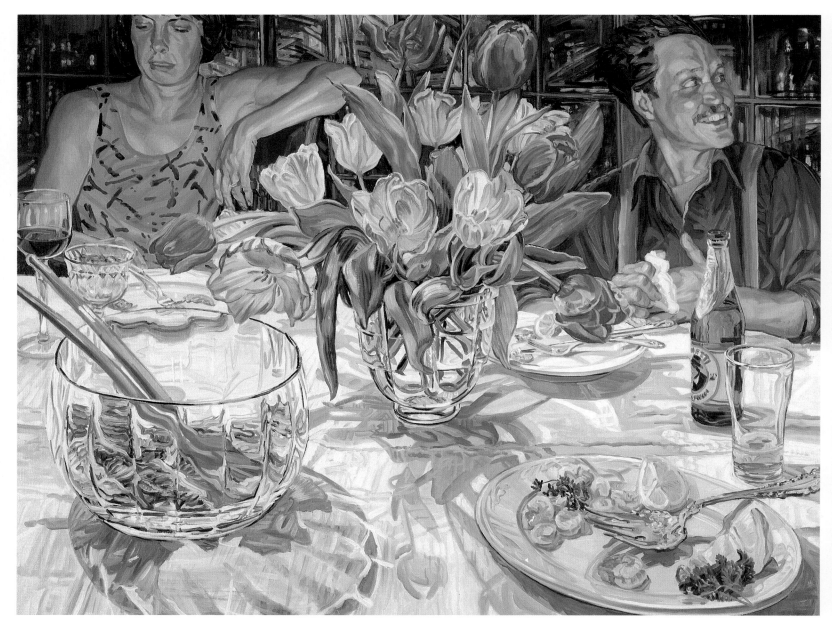

Janet Fish *Lorna and Bob* 54" X 70" Oil

Lorna and Bob is a winter painting of two friends who were never at this particular party or in this city. Lorna has often patiently posed for me. Bob would prefer not to be in a painting, but has nonetheless appeared in several. I worked directly from life, as well as from snapshots and memory. The painting took several months and underwent many revisions.

...that's when I added my old shoes.

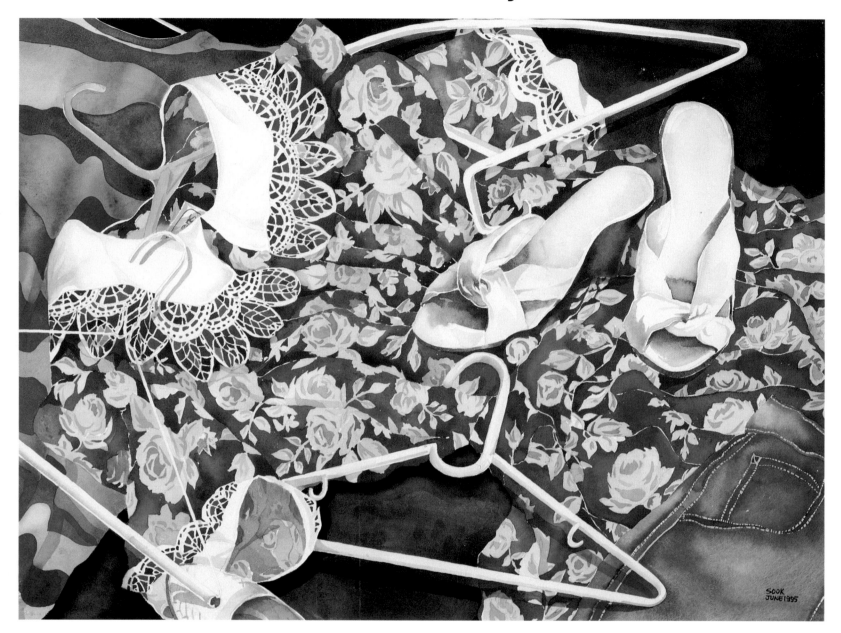

Sook-Kyung Hong *Going Out* 28" x 36" Watercolor

I started this painting with hangers, adding my favorite dress, T-shirt and a pair of jeans. I still needed to find a strong focal point though, and that's when I added my old shoes. I like the bright colors and interesting patterns in the red dress. Because of the complexity of the patterns, people ask me how long it took to paint the dress. They also ask if it was boring. Since I love to do patterns, I tell them I enjoy painting every pattern no matter how long it takes. I like cheerful, bright paintings that delight the viewer.

Connie Lucas *Spring Ritual* *28" x 36"* **Watercolor**

The oak dresser at the old Lake Leelanau lodge captured my interest and filled me with nostalgia. If that old dresser could talk — what tales it could tell! Dressers are like stages. What you chose to put on or in them reveals a great deal about the owner. I think of a young person looking in the mirror, day dreaming of the past or the future. I hope the painting will inspire you to reminisce about your own story, one that moves your spirit.

Nedra Tornay, NWS *Two Women* 22" x 30" **Watercolor**

These women are leaving their local club meeting. The little one must be the president — notice all the bags she's carrying! The bag with the broken handle must be her favorite. To me, these ladies represent love, dignity, respect and friendship. Their silhouettes convey a sense of pride and a sense of pathos. To emphasize the emotions their images evoke, I portrayed them in an isolated setting.

I'm lucky to be able to count watercolor painting and teaching among the great joys in my life.

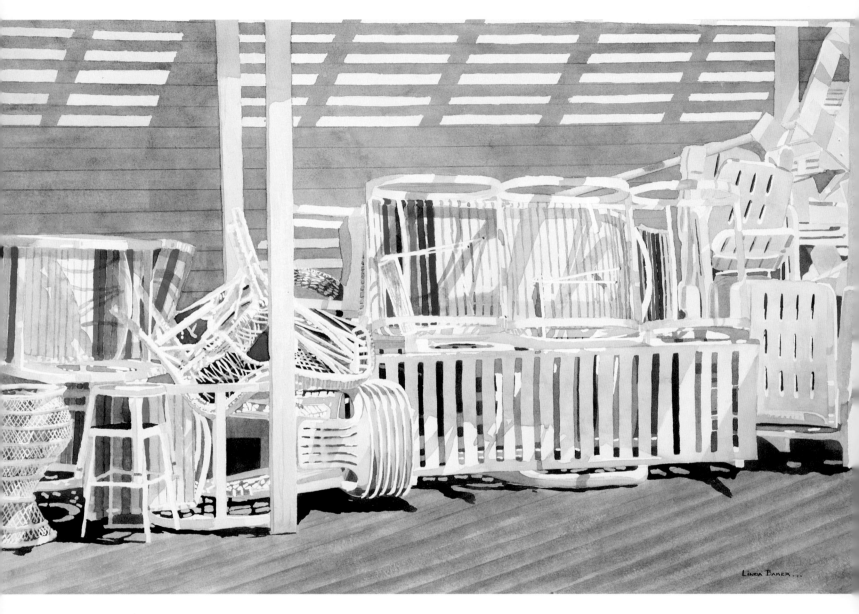

Linda Baker *Anticipation V* 22" x 30" Watercolor

Anticipation V is the fifth in a series of lawn furniture paintings. The play of light and shadow, and the way light weaves in and out of the geometry of the lawn furniture is fascinating. This scene is full of elements for contrast. The strong geometric shapes with an occasional curvilinear; the white on white with splashes of color; the intense light source which encourages deep rich shadows; and the patterns which offer an unexpectedly abstract quality not usually visible in realistic subject matter; all play a part in the success of this painting. I am challenged by dramatic lighting with minimal color. The emotional impact of changing seasons makes this a subject I enjoy painting and repainting.

I'm lucky to be able to count watercolor painting and teaching among the great joys in my life. Painting allows me to express my personal view of the world. Teaching allows me to share. My hope is that both the viewer and the student learn from my watercolor paintings.

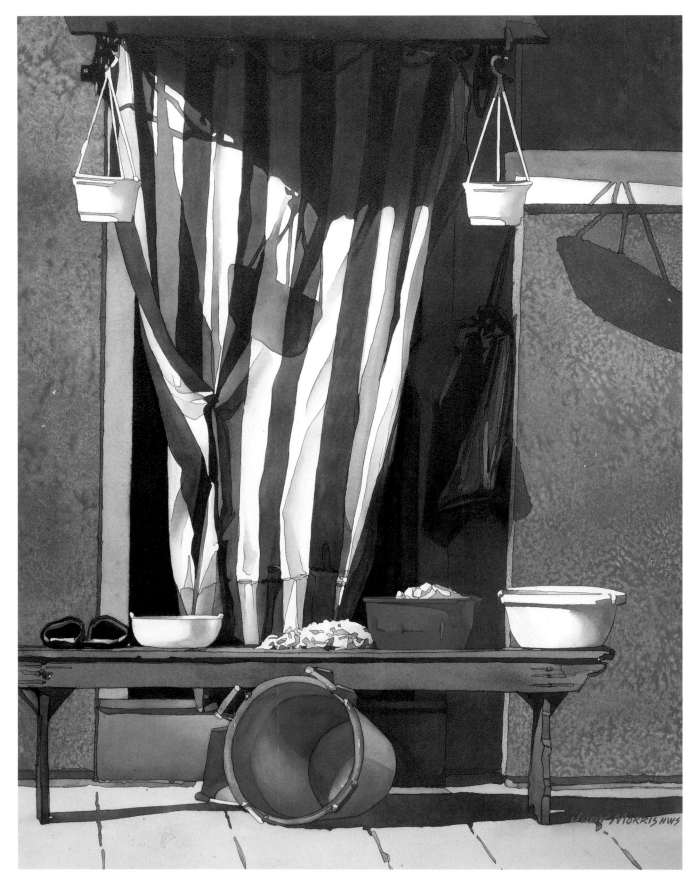

Judy Morris, NWS *Bella Burano* 22" x 29" Watercolor

Bella Burano is one inspired by a trip I made to northern Italy. My personal painting style is evident. I love contrasts — dark against light, warm against cool, smooth against texture. I often use contrasting complementary colors. The red of the bowl against the green and white stripes of the curtain and the blue bucket and orange wall were carefully chosen to intensify contrasts. Design is more important than painting realistic details. My work has been described as abstract but intimate. I hope you agree.

131

Boats

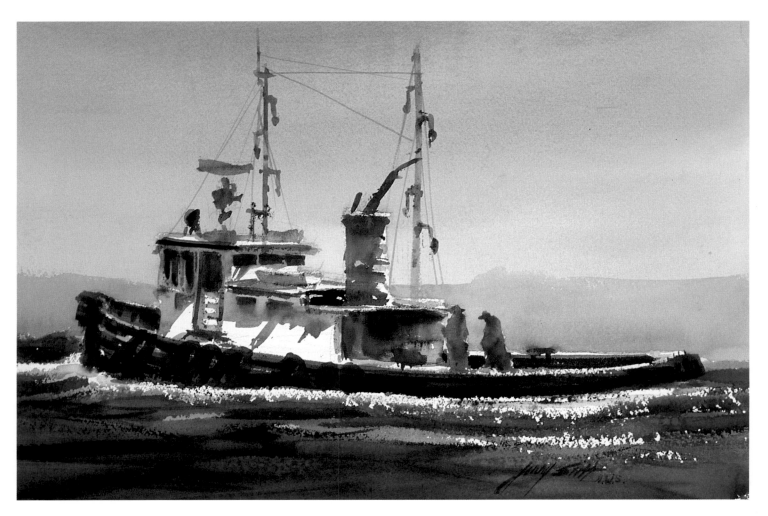

Jerry Stitt, NWS *Under Way* 22" x 30" Watercolor

 I live on a boat in Sausalito and I'm inspired by the constant activity I see around the water. My favorite watercolor technique is wet-in-wet. Being true to the medium, liquid & transparent, I think the scene should be painted as if it were melting!

I must say, as I sketched the boat and sea gulls,
my mind was on the lobster
we were planning to eat for dinner.

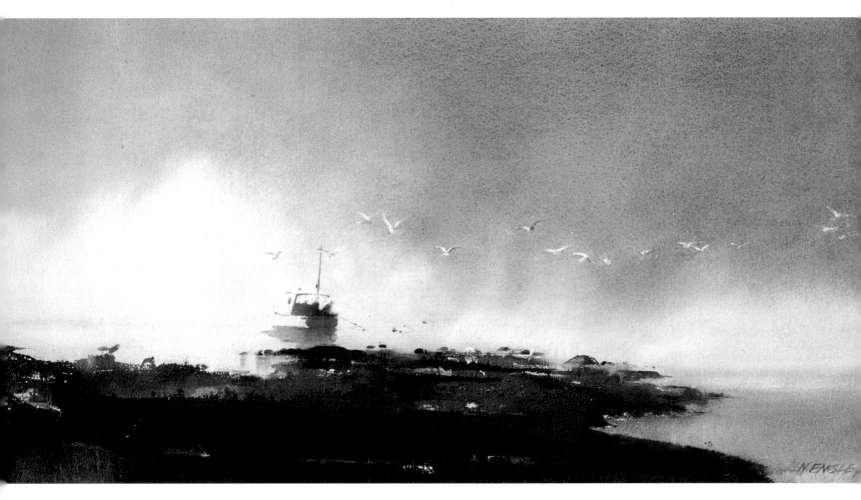

Nita Engle, AWS *Maine Lobster Boat* 20" x 28" Watercolor

One of the joys of painting the sea is to capture its many moods, and a quiet day made possible a simple composition. Only a few large elements — rock, sea and sky — are included. I watched a lobster boat at work as I considered the composition possibilities. The mood created by the atmospheric conditions compelled me to paint — and yet — I must say, as I sketched the boat and sea gulls, my mind was on the lobster we were planning to eat for dinner.

The strong diagonal lines of the boats created a dynamic composition.

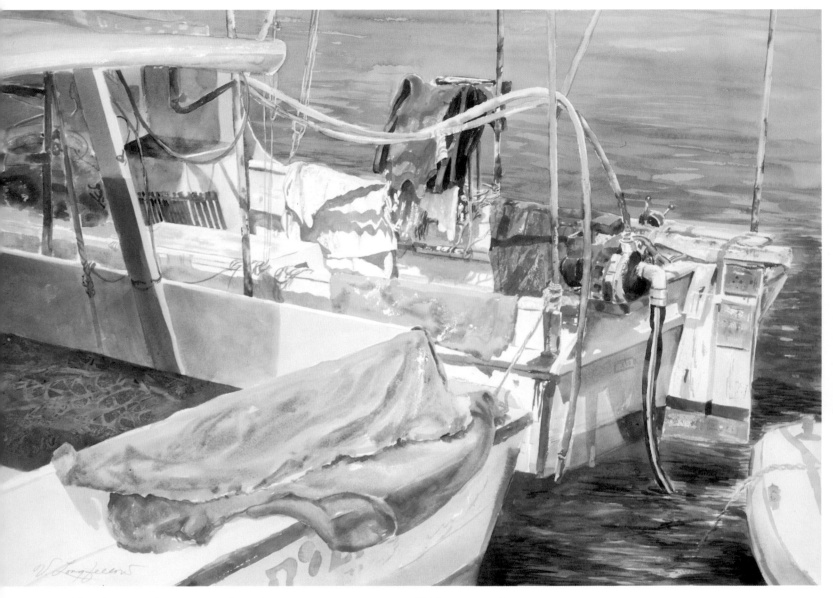

Vivian Longfellow *The Divers* 22" x 30" Watercolor

The challenge of this painting was to convey the feeling of wet chamois drying on the sponge boats. The strong diagonal lines of the boats created a dynamic composition.

I've often wondered if, sometime in my life, I would feel that "I'd arrived".

Donald J. Phillips, AWS *Cathlamet* 20" x 28" Watercolor

I've often wondered if, at sometime in my life, I would feel that "I'd arrived". In spite of some past successes, I've found that no art of any note springs to life at will. Good art is the result of sound thought, hopeful hunches, many trials, and infinite persistence. It is a pitched battle on that flat white surface to either win or lose.

***As my canoe paddle silently sliced through
the layered blanket of blazing leaves,
this old boat came into view.
It was unoccupied...***

Maggie Linn, AWS *Blueberry Rendezvous* 16" x 26" Watercolor

There are secrets of the heart as well as places of delight, unknown and unseen by the casual eye. As my canoe paddle silently sliced through the layered blanket of blazing leaves, this old boat came into view. It was unoccupied, but nestled in it was a basket of blueberries. A playful breeze tossed leaves into the boat. Wanting to keep a sense of mystery about the place, I kept on paddling past the rendezvous.

Years later, with the scene still fresh in my mind, I painted ***Blueberry Rendezvous***. The leaves' colors came straight out of the tubes, the cobalt water and sky with varying amounts of water were also layered in. Finally, a stronger and more saturated wash of cobalt was put in to emphasize "'water" and then quick tip-ins of color for the leaves were placed to the bottom and right of the boat.

Seascapes

Gwen Tomkow *Morning Omena Bay* 28" x 36" Watercolor

The sun filtered through the window and made patterns on the rose wallpaper of my room. I was at a cozy bed and breakfast nestled above Omena Bay in northern Michigan. My hosts, Charlie and Mary Helen Phillips, had already set coffee outside my room. Curling up with hot brew and an inspirational poetry book, I looked out and saw the glistening water from my second story parlor.

I had painted the bay before with its sailboats anchored in serene, calm water. However, the flowers presented complementary colors to the blue of the lake and gaiety and charm to the pristine beauty of the bay. There's a boathouse with flower boxes, a hanging basket with red impatiens, and a red roof. Too good to be true!

Perhaps it's the combination of a congenial atmosphere, the dozens of birds feeding outside while a hot breakfast is being served and the blessed morning air that sustains the artist and converts this energy into the final act of painting. The little scene was etched in my mind to be conjured up in my studio as if I had never left the Bay.

The grasses and reflections are carefully placed to create an "eye-path" through the composition.

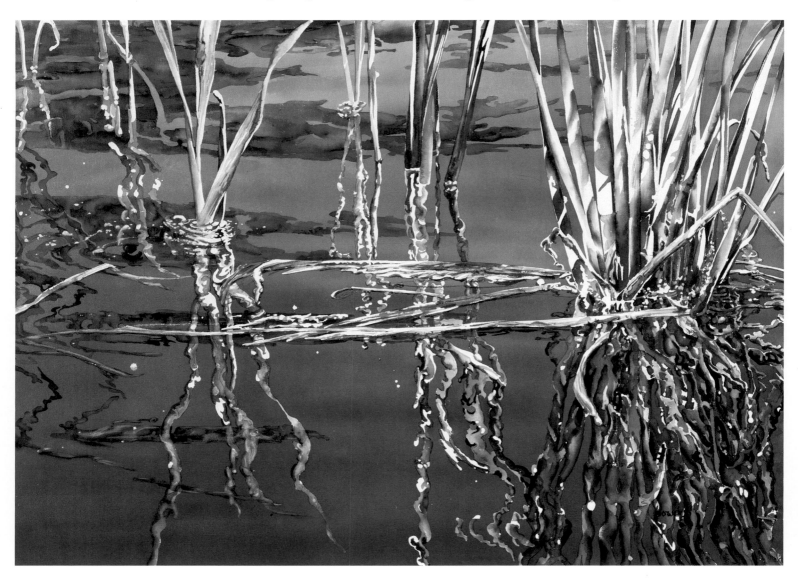

June Y. Bowers, NWS *By-The-Byways Series:* **The Weavers** 29" x 41" Watercolor

My **By-The-Byways** series was inspired by the beckoning of water scenes that I saw, while driving and walking. I was intrigued by the color range of grasses, unseen land forms, reflections, and the intricate movements of the water. I happily painted dozens of scenes. The richness and depth of the water was accomplished by ten to fifteen watercolor washes, with underlying color changes revealed through the transparent washes. The grasses and reflections are carefully placed to create an "eye-path" through the composition.

The ocean varies between turquoise,
purple and sapphire blue.
The lava rocks are unique, so dark — almost black...

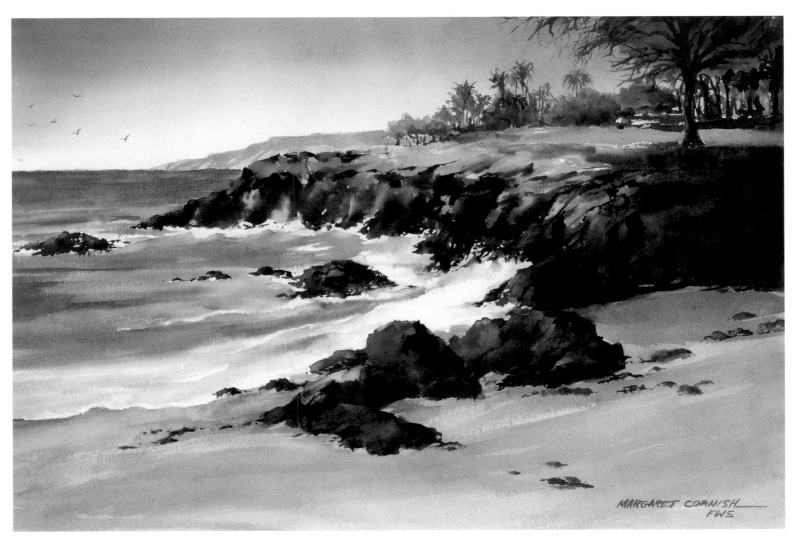

MARGARET CORNISH
FWS

Margaret Cornish *Wailea, Maui* 14 x 21" Watercolor

I know Hawaii intimately. I lived in the Islands years ago and return every chance I get. But I have never become accustomed to the intensity of color. The flowers are bigger, brighter, and more exotic than anywhere else. Hawaiian skies are truly brilliant.

Wailea in Maui is especially beautiful — a painting waits for you everywhere you look. The ocean color fluctuates between turquoise, purple and sapphire blue. The lava rocks are unique, so dark — almost black — and yet they contain rich subtle colors. I tried to capture this scene several times, finally getting what I wanted in *Wailea, Maui*.

Anyone who has been to Maui will tell you about the cool colors in the water and the warm colors in the sand — existing in perfect harmony. Because one doesn't argue with Mother Nature, I added a touch of warm color to the water and a touch of cool color to the sand.

I wanted to capture the scene as it really was — blustery, with dark cloudy skies and very little color.

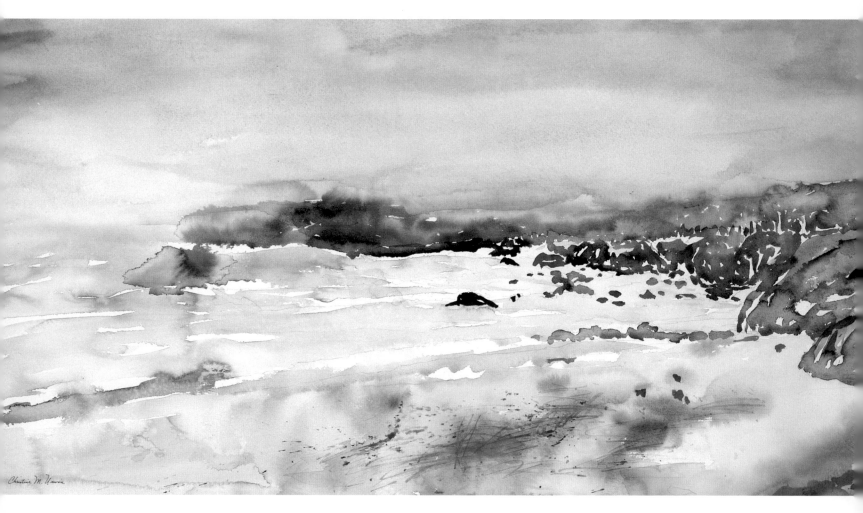

Christine M. Unwin, NWS *Bodega Bay* *16" x 30"* Watercolor

We visited Bodega Bay in January at the height of the stormy season. I wanted to capture the scene as it really was — blustery, with dark cloudy skies and very little color. This painting makes me feel like I am right there on the beach. I later did an abstract painting of this area entitled *California Coast* (see page 62) in an abstract style.

The patterns of melting ice in water are especially intriguing —

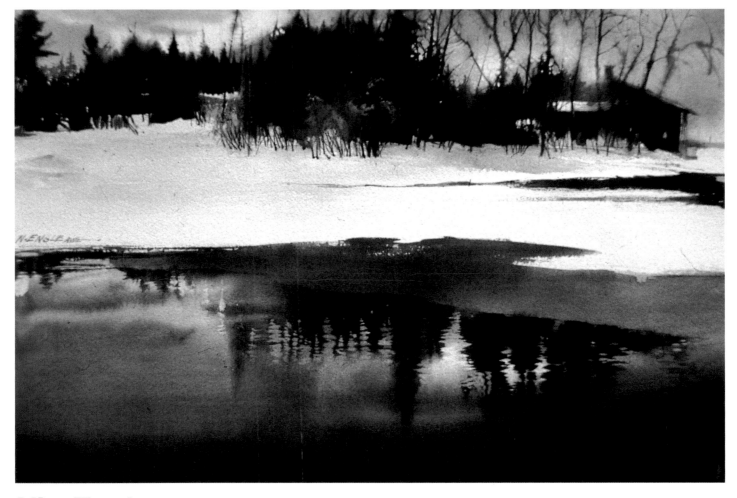

Nita Engle, AWS *Beach House in Winter* 22" x 30" Watercolor

Living on the shore of Lake Superior gives daily opportunities to observe this great lake in all of it's seasons. The patterns of ice melting in water are especially intriguing — maybe because floating ice, half-submerged, goes beyond a flat pattern and beyond conventional perspective. There are two picture planes. The artist can combine a vertical plane, the actual landscape and it's reflections, in close proximity with the horizontal plane, the ice shelves, or water lilies, or anything else that interrupts reflections in water.

The challenge here was how to float-in great areas of intense color and still maintain the hard edges of the ice shelves and the pristine white of the paper. In other words, the pristine new-fallen snow. The solution? The layers of ice were revealed by layers of masking fluid.

Ice shelves form, are broken up by water action and climate change and then reform new shelves. Fresh snowfalls which melt into the old ice in new patterns are always changing. As the sun sets or rises over it, new colors reflect and refract. In the morning, colors blaze — at sunset, all is surrendered to a quieter palette.

The Artists

Wanda Gringhuis Anderson
18180 North Shore Estates Rd., Spring Lake, MI 49456
p. 52-53 — *Moonwood* © Wanda Gringhuis Anderson
collection of James Doss, Structural Concepts Corp.

Ruth Baderian, 390 Congress Ave., East Williston, NY 11596
p. 16 — *Sunflower Blue* © Ruth Baderian
collection of the artist

Linda Baker, 17763 148th Ave., Spring Lake, MI 49456
p. 87 — *Michelle Series: Contemplation* © Linda Baker
collection of the artist
p. 130 — *Anticipation V* © Linda Baker, collection of the artist

Martha Barnes, 42366 Westmeath, Northville, MI 48167
p. 45 — *Basket of Baby's Breath* © Martha Barnes
collection of the artist

Robert L. Barnum, NWS, Watercolor USA Honor Society
9739 Calgary Dr., Stanwood, MI 49346
p. 84 — *Home Is Where The Heart Is* © Robert L. Barnum
collection of the artist

Miles G. Batt, Sr., AWS, NWS
301 Riverland Road, Ft. Lauderdale, FL 33312
p. 107 — *"a" Bay (Acapulco)* © Miles G. Batt, Sr.
collection of D. Dumont

Mary Ann Beckwith, MWS, 619 Lake Ave., Hancock, MI 49930
p. 56 — *Celestine Prophecy II* © Mary Ann Beckwith
collection of the artist

Igor Beginin, 43524 Bannockburn Dr., Canton, MI 48187
p. 57 — *Cycles* © Igor Beginin, collection of the artist

Judi Betts, AWS, P.O. Box 3676, Baton Rouge, LA 70821
p. 75 — *Mood Music* © Judi Betts
collection of McFarland Cranberry Co.
p. 97 — *High Chair* © Judi Betts
collection of Dr. & Mrs. Luis Cervantes

Donne F. Bitner, FWS, GWS, SPCA
449 Blakey Blvd., Cocoa Beach, FL 32931
p. 115 — *Field of Dreams* © Donne F. Bitner
collection of the artist

Joseph Bohler, AWS, P.O. Box 887, Monument, CO 80132
p. 120 — *Corina* © Joseph Bohler
collection of David Jones, DDS

William Borden, AWS, 2617 Raymond, Dearborn, MI 48124
p. 44 — *The Cadillac* © William Borden
collection of the artist

June Y. Bowers, NWS, 919 Krueger Parkway, Stuart, FL 34996
p. 14 — *Colorplay* © June Y. Bowers
collection of 1st National Bank & Trust Company
p. 138 — *By-The-Byways Series: The Weavers*
© June Y. Bowers - collection of Gail Morrell

Mary Alice Braukman, NWS
636 19th Ave. NE, St. Petersburg, FL 33704
p. 66 — *Sunscape* © Mary Alice Braukman
collection of the artist

Al Brouillette, AWS, 1300 Sunset Court, Arlington, TX 76013
p. 61 — *Horizons II* © Al Brouillette, collection of the artist

Donna Brown, 2496 Meadow Rd., Baileys Harbor, WI 54202
p. 15 — *Open Arms* © Donna Brown, collection of the artist

Pat Cairns, 4895 El Verano, Atascadero, CA 93422
p. 89 — *Jazz Alfresco* © Pat Cairns, collection of the artist

Joan Cawthorn, 5597 Chehalis Pl., Blaine, WA 98230
p. 18 — *Summer Solstice* © Joan Cawthorn
collection of the artist

Marjorie Hogan Chellstorp
29923 Ravenscroft, Farmington Hills, MI 48331
p. 13 — *Zinnia* © Marjorie Hogan Chellstorp
collection of the artist

Roberta Carter Clark, AWS
47-B Cheshire Square, Little Silver, NJ 07739
p. 91 — *Courtney with Geraniums* © Roberta Carter Clark
collection of Mr. & Mrs. Richard Ayres
p. 124 — *Ann Alone* © Roberta Carter Clark
collection of Mr. & Mrs. Woody LaForge

Kathleen Conover-Miller
2905 Lake Shore Blvd., Marquette, MI 49855
p. 28 — *Winter Shadow* © Kathleen Conover-Miller
collection of Patricia Conover

Margaret Cornish, FWS
1316 Belcher Dr., Tarpon Springs, FL 34689
p. 139 — *Wailea, Maui* © Margaret Cornish
collection of the artist

Johnnie Crosby, 17460 Cedar Lake Circle, Northville, MI 48167
p. 50 — *Ballet Warm Up* © Johnnie Crosby
collection of the artist
p. 69 — *Color Me Blue* © Johnnie Crosby
collection of Judith & Earl Lapp

Jeanne Dobie, AWS, NWS
160 Hunt Valley Circle, Berwyn, PA 19312
p. 94 — *Aegean Shadows* © Jeanne Dobie
collection of — private collection

Melissa Dominiak, 1127 E. Ann St., # 1, Ann Arbor, MI 48104
p. 92 — *Spello Lane* © Melissa Dominiak
collection of the artist

Jan Dorer, 736 S. Freer Rd., Chelsea, MI 48118
p. 60 — *Aquifuge* © Jan Dorer, collection of the artist

Lily Dudgeon
p. 40 — *Remembrance* © Lily Dudgeon
collection of — private collection

Nita Engle, AWS, 177 County Rd. # 550, Marquette, MI 49855
p. 133 — *Maine Lobster Boat* © Nita Engle
collection of — private collection
p. 141 — *Beach House in Winter* © Nita Engle
collection of — private collection

Jeri Fellwock, 33098 Oak Hollow, Farmington Hills, MI 48334
p. 113 — *Multiple Chairs* © Jeri Fellwock
collection of Oakland Community College

Z. L. Feng, AWS, NWS, 1006 Walker Dr., Radford, VA 24141
p. 25 — *Rocky Pond* © Z. L. Feng
collection of the artist
p. 51 — *Morning Star* © Z. L. Feng
collection of Mr. & Mrs. Louis S. Waldrop

Janet Fish
p. 8-9 — *Blue Cloth/Strawberries* © Janet Fish
collection of — private collection
p. 126 — *Lorna and Bob* © Janet Fish
collection of the artist

Karen Frey, NWS, 1781 Brandon St., Oakland, CA 94611
p. 121 — *Nona* © Karen Frey
collection of Pat & Jack Frey

Jean Grastorf, AWS, NWS, MWS
6049 4th Ave. North, St. Petersburg, FL 33710
p. 31 — *Sun-Ripened* © Jean Grastorf
collection of — private collection

Tom Hale, AWS, NWS, 37986 Tralee, Northville, MI 48167
 p. 42 — *Mercedes SSK* © Tom Hale
 collection of the artist
 p. 43 — *Duesenberg* © Tom Hale
 collection of — private collection
Scott Hartley, 5334 Nollar Rd., Ann Arbor, MI 48105
 p. 93 — *Detroit Alley* © Scott Hartley
 collection of the artist
Martha Hayden, 143 Prairie St., Sharon, WI 53585
 p. 67 —*The Lantern* © Martha Hayden
 collection of Judith & Patrick Flaherty
Marsha Heatwole, Route 2, Box 123, Lexington, VA 24450
 p. 70 — *Ostrich Wave* © Marsha Heatwole
 collection of Dennis & Marge Hatchell
 p. 77 — *Duma Watoto* © Marsha Heatwole
 collection of Dennis & Marge Hatchell
Brent Heighton, FCA
 13331 55A Ave., Surrey, BC Canada V3X 3B5
 p. 26-27— *Frequent Visitor* © Brent Heighton
 collection of — private collection
 p. 105 — *Paris Streets* © Brent Heighton
 collection of the artist
Mary Hickey, 2204 N. Elizabeth, Dearborn, MI 48128
 p. 76 — *Cat Quilt* © Mary Hickey, collection of the artist
Penny Hill, 607 First St. NE, Buffalo, MN 55313
 p. 117 — *Waiting* © Penny Hill
 collection of Carla O'Connor
Sook-Kyung Hong, 34601 Princeton, Farmington Hills, MI 48331
 p. 38 —*Three Apples* © Sook-Kyung Hong
 collection of the artist
 p. 127 — *Going Out* © Sook-Kyung Hong
 collection of the artist
Deborah L. Hoover, 7377 Louise Ave., Jenison, MI 49428
 p. 49 — *Dance Circle* © Deborah L. Hoover
 collection of — private collection
 p. 118 — *Blues Break* © Deborah L. Hoover
 collection of — private collection
Rebecca Houck, 4440 S. Nine Mile, Auburn, MI 48611
 p. 114— *The Autumn of my Spring Chicken Years*
 © Rebecca Houck, collection of the artist
Yumiko Ichikawa, 1706 Downey St., Radford, VA 24141
 p. 80 — *Contemplation* © Yumiko Ichikawa
 collection of the artist
Bill James, AWS, NWS, PSA
 15840 SW 79th Ct., Miami, FL 33157
 p. 116 —*The Throwaway* © Bill James
 collection of the artist
Edee Joppich, 26701 Holly Hill, Farmington Hills, MI 48334
 p. 81 — *Summers Child* © Edee Joppich
 collection of Katherine Edahl
 p. 85 — *To Go Beyond* © Edee Joppich
 collection of the artist
Danguole Jurgutis, 32484 Chesterbrook St.,
 Farmington Hills, MI 48334
 p. 59 — *Summer Bouquet* © Danguole Jurgutis
 collection of the artist
M. C. Kanouse, 6346 Tahoe Lane SE, Grand Rapids, MI 49546
 p. 74 — *Three Chickens* © M. C. Kanouse
 collection of — private collection
 p. 88 — *Painting Class* © M. C. Kanouse
 collection of the artist

kemper, 2159 Shurtleff Ave., Napa, CA 94559
 p. 108 — *shot* © kemper, collection of Daniel Finnegan
 p. 109 — *corn dog* © kemper,
 collection of Chris, Celibeth & Madison Donnelly
Marci Kitch
 p. 82 — *Kindred Spirits*, collection of Richard A. Kitch
 p. 83 — *Garden Dreamer*, collection of Richard A. Kitch
James L. Koevenig, NWS, 845 Keystone Circle, Oviedo, FL 32765
 p. 123 — *Prewashed Cotton I* © James L. Koevenig
 collection of Anita & Larry Maxwell
Margaret Graham Kranking, NWS, MWS, SWS, SW
 3504 Taylor St., Chevy Chase, MD 20815
 p. 79 — *Table Setting* © Margaret Graham Kranking
 collection of the artist
John Krieger, P. O. Box 2355, Midland, MI 48641
 p. 30 — *Garden Path* © John Krieger
 collection of John & Colette Sirhal
Lillian Langerman, 15985 Harden Circle, Southfield, MI 48075
 p. 39 — *California Sunshine* © Lillian Langerman
 collection of Mr. & Mrs. David Drews
 p. 86 — *Study in Red Silk* © Lillian Langerman
 collection of Ms. Jean Valentine
Maggie Linn, AWS, 921 N. Front St., Marquette, MI 49855
 p. 136 — *Blueberry Rendezvous* © Maggie Linn
 collection of Mr. & Mrs. Cory Olson
Vivian Longfellow, 14401 Huron, Taylor, MI 48180
 p. 71 — *Free Lunch* © Vivian Longfellow
 collection of the artist
 p. 134 — *The Divers* © Vivian Longfellow
 collection of the artist
Connie Lucas, 1933 Bellingham, Canton, MI 48188
 p. 128 — *Spring Ritual* © Connie Lucas
 collection of Drs. Thomas & Patricia Sell
Lena Massara, 3 Leeward Ct., Salem, SC 29676
 p. 122 — *Her Legacy* © Lena Massara
 collection of Mr. & Mrs. Bog Luyckz
Anne Adams Robertson Massie, AWS, NWS
 3204 Rivermont Ave., Lynchburg, VA 24503
 p. 100-101 — *River Festival on Jefferson Street*
 © Anne Adams Robertson Massie, collection of the artist
Joan McKasson, WW
 7976 Lake Cayuga Dr., San Diego, CA 92119
 p. 46-47 — *Corn from the Earth* © Joan McKasson
 collection of the artist
Mark E. Mehaffey, AWS, NWS, MWS, WW, RMWS, LWS
 5440 Zimmer Road, Williamston, MI 48895
 p. 104 — *Rainy Day Chicago* © Mark Mehaffey
 collection of the artist
Edward Minchin, AWS, P.O. Box 160, Rockland, MA 02370
 p. 58 — *Celestial Travel* © Edward Minchin
 collection of the artist
Judy Morris, NWS, 2404 East Main St., Medford, OR 97504
 p. 131 — *Bella Burano* © Judy Morris, collection of the artist
Linda L. Stevens Moyer, NWS, WW, WCWS
 9622 Zetland Dr., Huntington Beach, CA 92646
 p. 22 — *Magenta Glory* © Linda L. Stevens Moyer
 collection of the artist
Alice A. Nichols, 33002 Maplenut, Farmington, MI 48336
 p. 72-73 — *Camouflage* © Alice A. Nichols
 collection of the artist
Linda Banks Ord, 11 Emerald Glen, Laguna Niguel, CA 92677
 p. 90 — *Young Woman Series, #9* © Linda Banks Ord
 collection of the artist

Donald J. Phillips, AWS, WW
 1755 49th Ave., Capitola, CA 95010
 p. 135 — *Cathlamet* © Donald J. Phillips
 collection of Mr. & Mrs. Goldenson
Carlton Plummer, AWS, AAA
 10 Monument Hill Road, Chelmsford, MA 01824
 p. 29 — *Acadia Figures* © Carlton Plummer
 collection of the artist
Joan Plummer, NEWS
 10 Monument Hill Road, Chelmsford, MA 01824
 p. 35 — *Beets All* © Joan Plummer
 collection of the artist
Claude Ponsot, NWS
 80-47 235th St., Queens Village, NY 11427
 p. 106 — *Summer Long Island* © Claude Ponsot
 collection of the artist
Heide E. Presse, FWS
 15914 Farringham Dr., Tampa, FL 33647
 p. 41 — *The Last Hydrangea* © Heide E. Presse
 collection of Mr. & Mrs. Joe Reekie
Cathy Quiel, 494 Stanford Place, Santa Barbara, CA 93111
 p. 96 — *Chromatic Bounce* © Cathy Quiel
 collection of the artist
Audrey Sanders Ratterman
 6763 Yarborough, Shelby Township, MI 48316
 p. 20 — *Flowers by Design* © Audrey Sanders Ratterman
 collection of the artist
Marilyn Schutzky, WW
 7340 East Turquoise Ave., Scottsdale, AZ 85258
 p. 17 — *Sun Worshipper II* © Marilyn Schutzky
 collection of the artist
 p. 48 — *Haiku* © Marilyn Schutzky
 collection of the artist
Mei Shu, 1006 Walker Dr., Radford, VA 24141
 p. 23 — *Lilac and Lace* © Mei Shu
 collection of the artist
Electra Stamelos, NWS
 38131 Vista Drive North, Livonia, MI 48152
 p. 11 — *Koi Garden* © Electra Stamelos
 collection of George Mousmoules
 p. 12 — *Tiki Plant* © Electra Stamelos
 Courtesy of Indigo Gallery, Boca Raton
Sara Steele, P.O. Box 18889, Philadelphia, PA 19119
 p. 19 — *Heliconia* © Sara Steele
 collection of The Leydens
Jerry Stitt, NWS
 1001 Bridgeway #225, Sausalito, CA 94965
 p. 132 — *Under Way* © Jerry Stitt
 collection of — private collection
Jacqueline Stubbs,
 5016 Stony Creek Drive, Midland, MI 48640
 p. 78 — *Hide & Seek* © Jacqueline Stubbs
 collection of the artist
Warren Taylor, AWS, NWS
 P.O. Box 50051, Midland, TX 79710
 p. 119 — *Estuary* © Warren Taylor
 Courtesy of Sexton Gallery, Vero Beach, Florida
Gwen Tomkow, PO Box 2263, Farmington Hills, MI 48333,
 p. 24 — *Spring Glory* © Gwen Tomkow
 Courtesy of Joppich's Bay Street Gallery
 p. 137 — *Morning Omena Bay* © Gwen Tomkow
 collection of Mr. & Mrs. Rodney Sabourin

Nedra Tornay, NWS, 2131 Salt Air Dr., Santa Ana, CA 92705
 p. 95 — *#77 Mykonos* © Nedra Tornay
 collection of Mr. & Mrs. Paul G. Tornay
 p. 129 — *Two Women* © Nedra Tornay
 collection of Ms. Twig Ertl
Christine M. Unwin, NWS
 6850 Brookshire Dr., West Bloomfield, MI 48322
 p. 2 — *Iris* © Christine M. Unwin, collection of the artist
 p. 6 & 7 — *Santa Fe* © Christine M. Unwin
 collection of the artist
 p. 34 — *Green Peppers* © Christine M. Unwin
 collection of the artist
 p. 36 & 37 — *Grapefruit* © Christine M. Unwin
 collection of the artist
 p. 54 — *Hawaiin Surf* © Christine M. Unwin
 collection of the artist
 p. 55 — *Alaskan Waters* © Christine M. Unwin
 collection of the artist
 p. 62 — *California Coast* © Christine M. Unwin
 collection of the artist
 p. 63 — *Southwest* © Christine M. Unwin
 collection of the artist
 p. 68 — *Sierra Nevada* © Christine M. Unwin
 collection of the artist
 p. 140 — *Bodega Bay* © Christine M. Unwin
 collection of the artist
Karen Carter Van Gamper
 5085 Buckingham Place, Troy, MI 48098
 p. 32 — *Birch Grove* © Karen Carter Van Gamper,
 collection of Marjorie J. Stein
Susan Vitali
 27617 Kingsgate Way, Farmington Hills, MI 48334
 p. 98 — *At the Watch Kiosk* © Susan Vitali
 collection of the artist
 p. 99 — *Window Shopping* © Susan Vitali
 collection of the artist
 p. 102 & 103 — *Another Man's Treasure* © Susan Vitali
 collection of the artist
Donna M. Vogelheim, NWS
 36419 Saxony, Farmington, MI 48335
 p. 110 — *This Way In* © Donna Vogelheim
 collection of the artist
 p. 111 — *Nocturnal Blooms* © Donna Vogelheim
 collection of — private collection
Joan T. Welsh
 26801 Van Buren Rd., Dearborn Heights, MI 48127
 p. 33 — *Patterns 1* © Joan T. Welsh, collection of the artist
Ellen Wilt, 1328 Broadway St., Ann Arbor, MI 48105
 p. 112 — *Watershed* © Ellen Wilt
 collection of J. Sugihara
Patricia Woodworth
 7904 W. 137 Terr., Overland Park, KS 66223
 p. 65 — *Oriental Vases* © Patricia Woodworth
 collection of the artist
William C. Wright, P. O. Box 21, Stevenson, MD 21153
 p. 21 — *April Bouquet with Bowl* © William C. Wright
 collection of — private collection
Donna Zagotta, 7147 Winding Trail, Brighton, MI 48116
 p. 125 — *The Morning News* © Donna Zagota
 collection of Redlands Community Hospital
Peggy Zehring, 832 31st Ave. S, Seattle, WA 98144
 p. 64 — *Buddha's Message* © Peggy Zehring
 collection of the artist